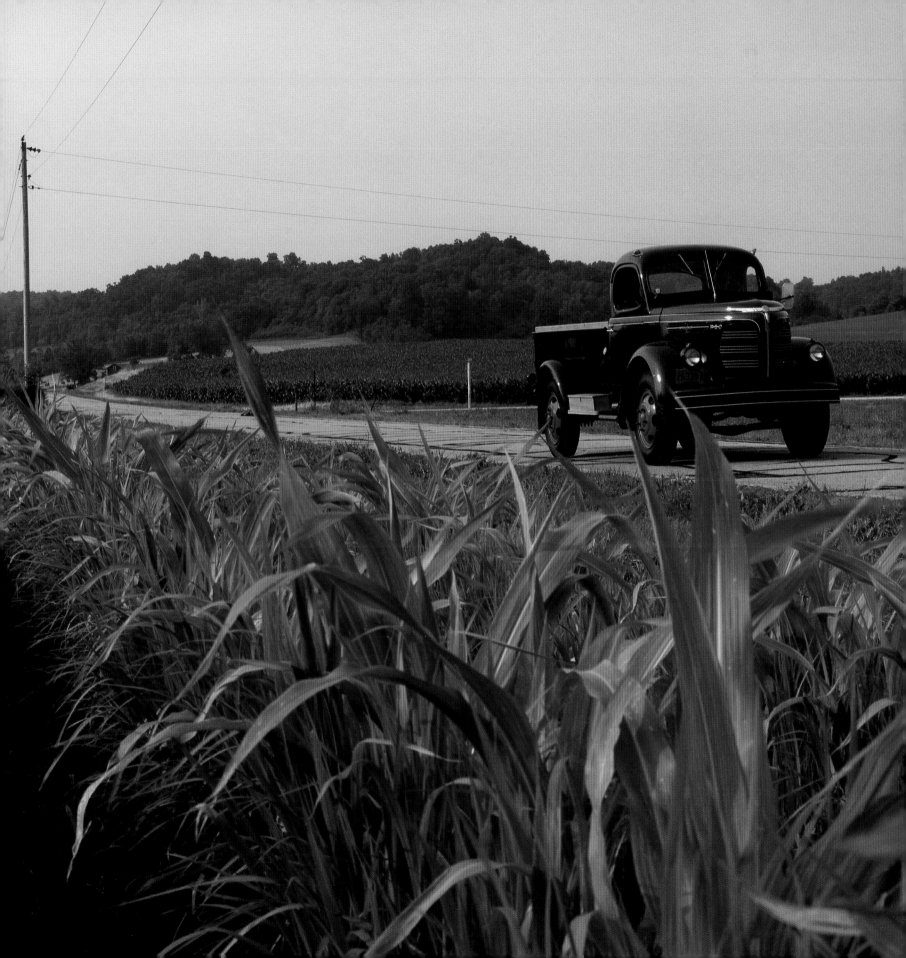

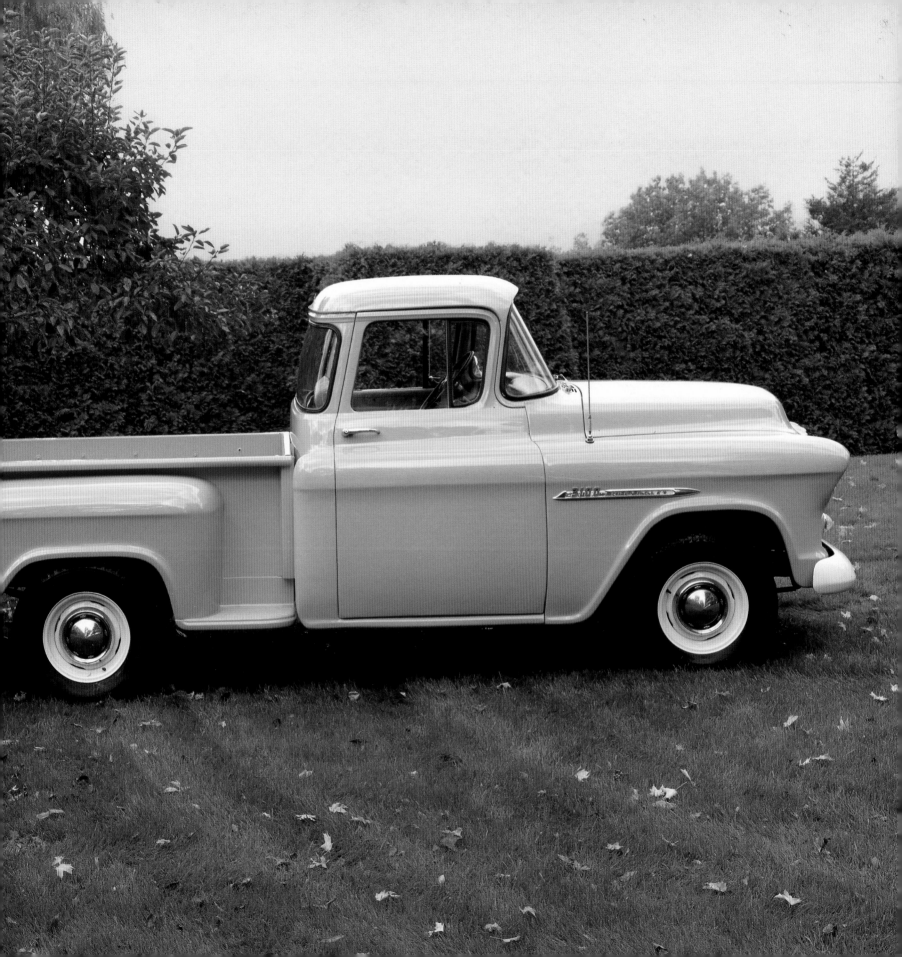

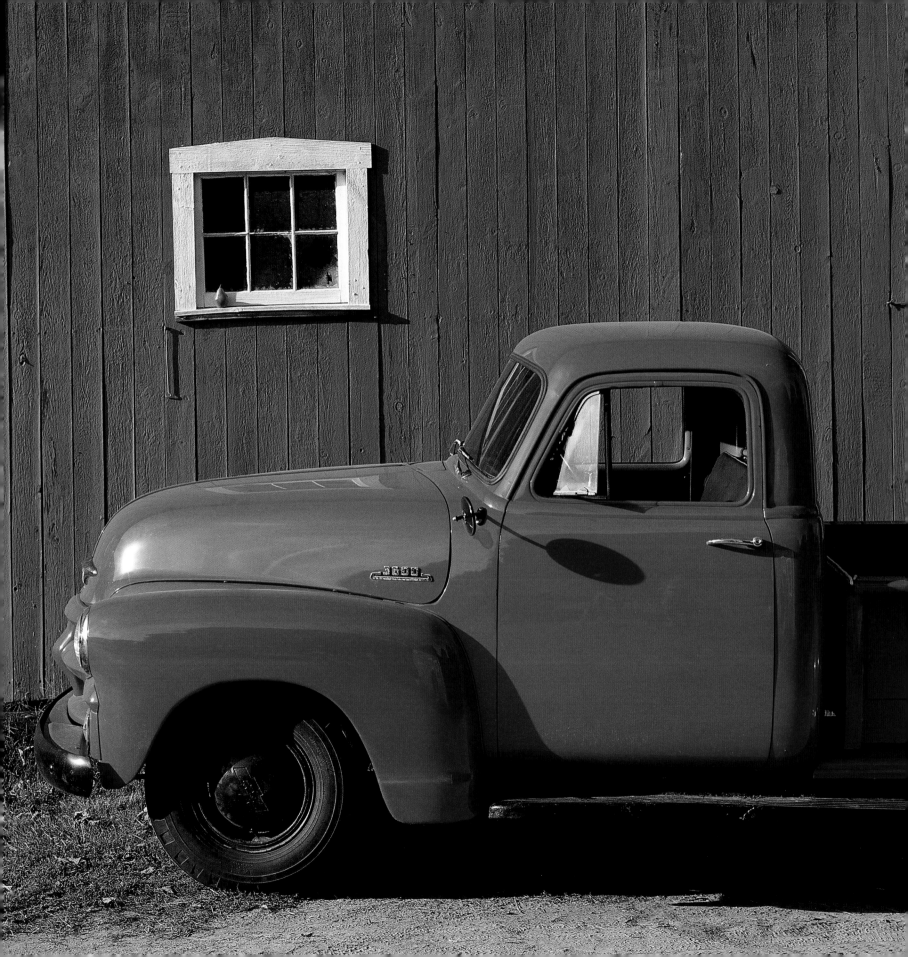

# Pickups

## Classic American Trucks

**Photographs by William Bennett Seitz**

**Text by Harry Moses**

R a n d o m   H o u s e  N e w   Y o r k

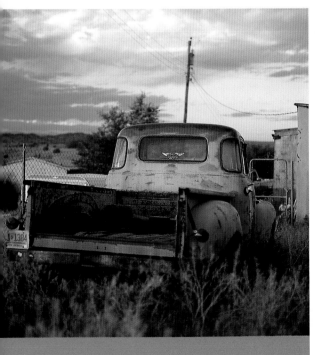

DESIGN BY BTD/BETH TONDREAU

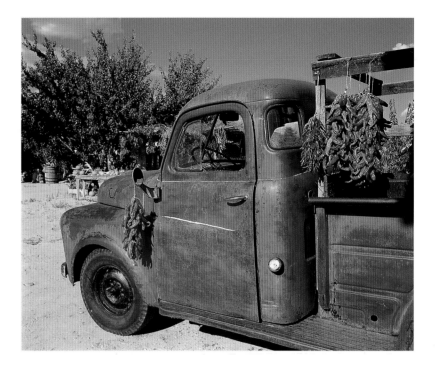

To my daughter Amanda, whose artistic input
and creative eye helped enhance the final product, and
whose company and laughter on our road trips made
being on the road more fun.

—W. B. SEITZ

To my wife, Judith Moses, without whose help
this book would not have been possible.

—H. MOSES

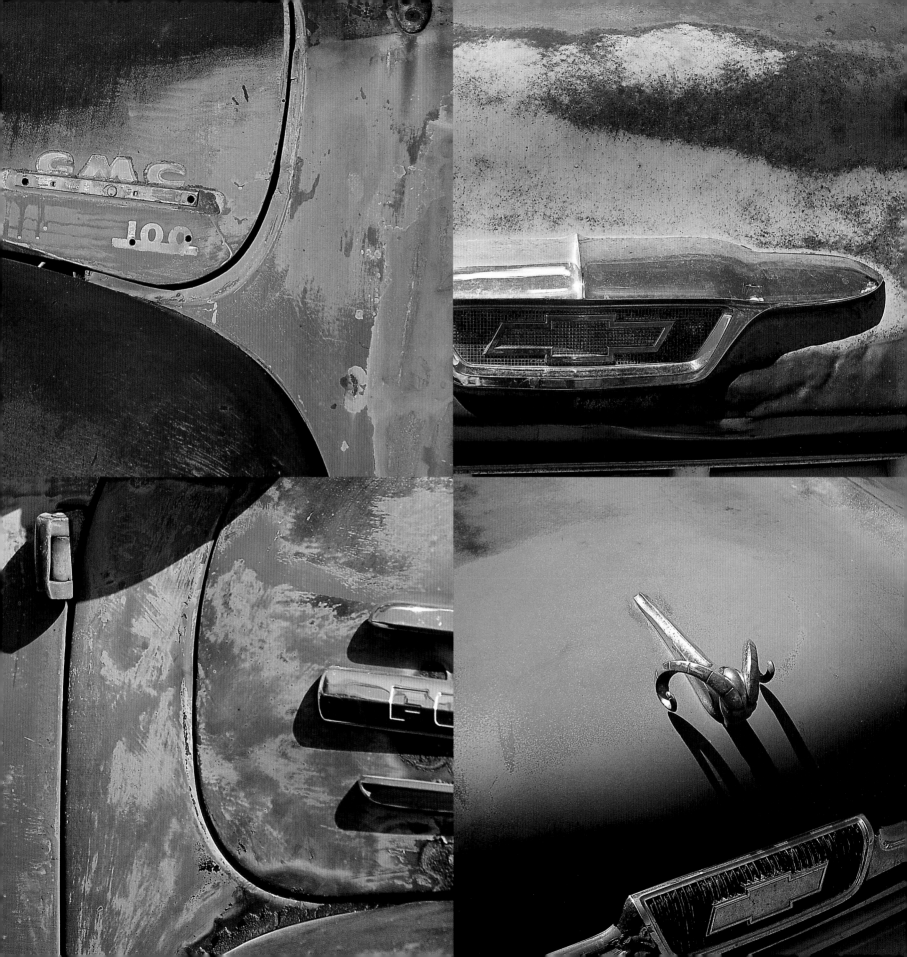

# Acknowledgments

**W**e would like to thank all of the truck owners for their enthusiasm and generosity toward this project.

We would also like to thank Sam Vaughan, whose ardor for the book never flagged and whose critical acumen made it more than the sum of its parts; Karen McGuinness, who was there when we needed her; Carol Schneider, glow-in-the-dark friend and publicist extraordinaire; Regina Ryan, for her perseverance throughout the long and winding journey; Beth Tondreau, for a design that both honors and enhances its subject matter; Judith Moses, whose inventive research turned up more trucks than we knew what to do with; Carolyn Moon and family, whose Iowa 80 Truckstop belongs in the *Guinness Book of World Records;* Les Snyder, Diamond T craftsman and restorer, whose help and hospitality were greatly appreciated; Kevin McNamara, our truck spotter in Maine; Peter Henry, ditto in New Mexico; Jay Ritter, our main man in Sante Fe; Marietta Moles, who knows how to locate every old truck in West Virginia, and did; Cathy Vanaria and Mark Savoia, for their beautiful work at Connecticut Photographics; Jack Muller and Steve Solley, our tour guides at the Macungie Truck Show; and Joanna, Amanda, Frieda, and Joe, whose love and support lasted the length of this book and continues.

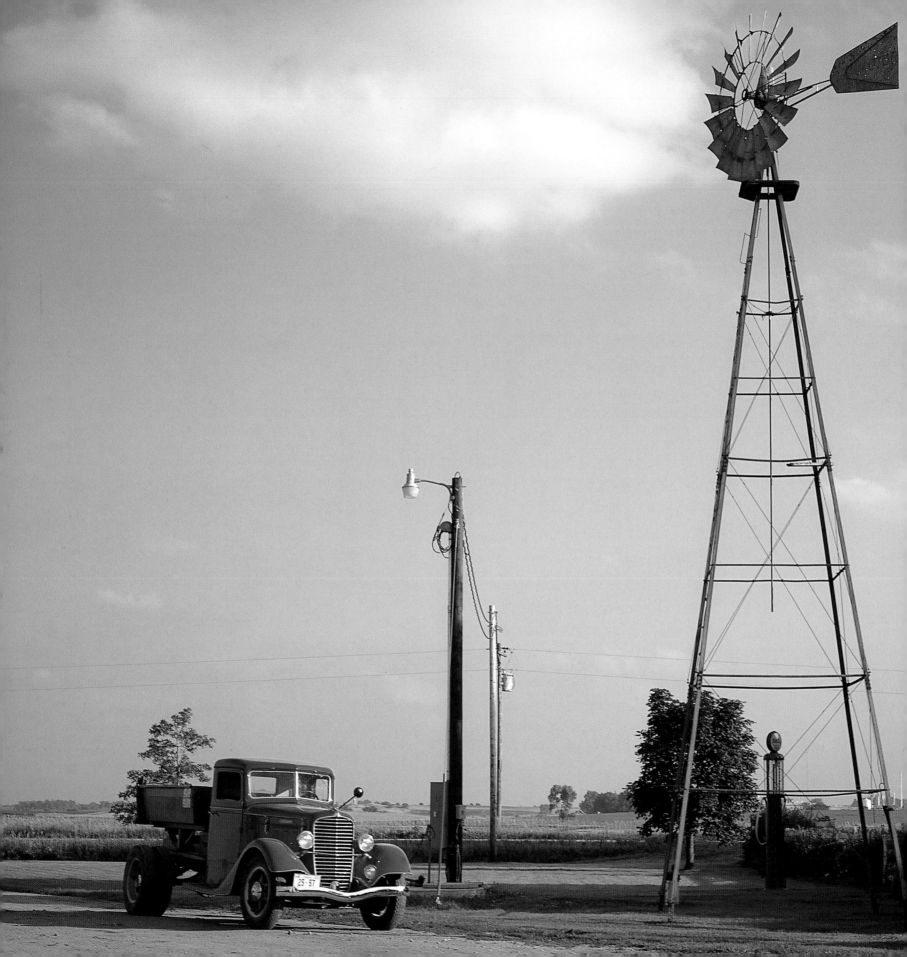

# Introduction

<span style="font-size:2em;">T</span>**his is a book about pickup trucks built in the United States from 1913 to 1960, a time when high technology didn't exist and America got along without it.**

Old pickup trucks don't merely recall a simpler America or a better America. They *are* America. Pickups reflect the country's essence in its purest and most concentrated form. An old truck is a novel by Faulkner, a drawing by Rockwell, a building by Wright. It is Spencer Tracy in *Bad Day at Black Rock,* Henry Fonda in *The Grapes of Wrath,* Gary Cooper in *High Noon.*

These basic, rugged, reliable vehicles have a remarkably widespread appeal. In researching this book we found old pickup trucks owned by farmers, lawyers, furniture makers, doctors, innkeepers, actors, plumbers, and musicians . . . to name just a few. Some drive their trucks every day. Others have lovingly restored their pickups and drive them sparingly. But all of the owners share the same singular experience: Whenever they take their pickups out for a spin, people stop and tell them that truck of theirs is the most beautiful thing they have ever laid eyes on.

Although we list the model and engine of every vehicle we write about, this book won't tell you a lot about how they work. Our purpose is more basic: to show you some beautiful trucks that evoke feelings that may be too rare in the rest of your life.

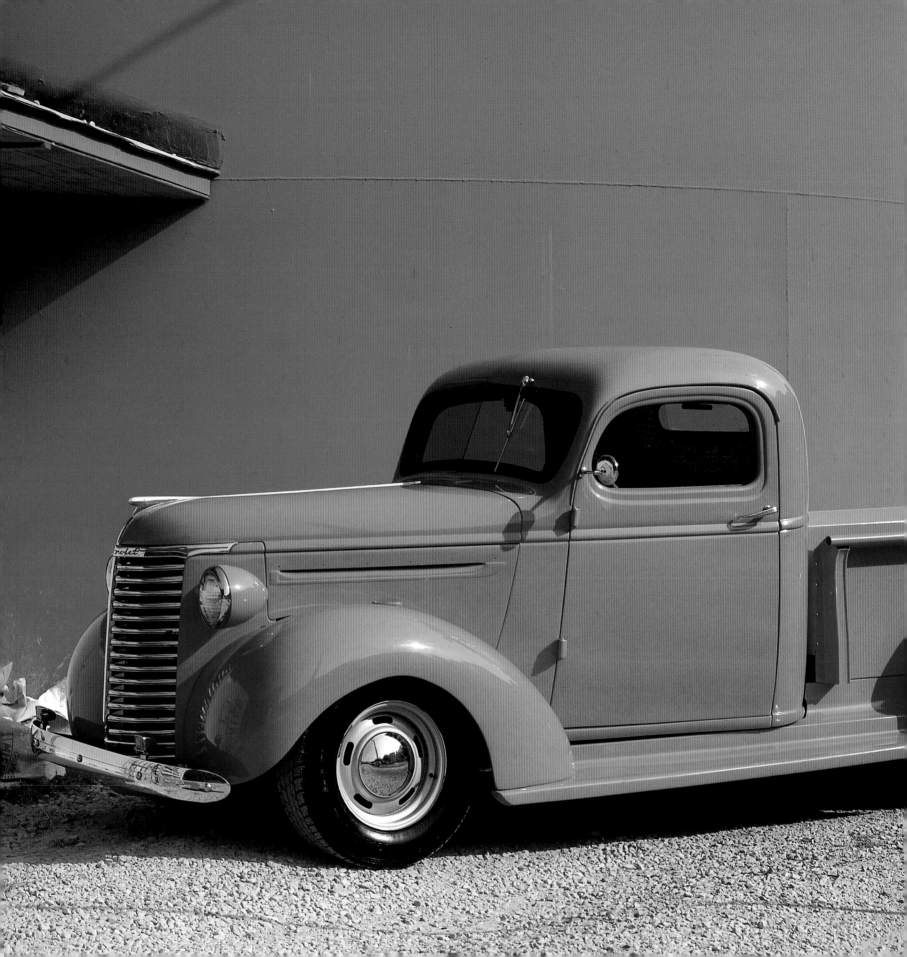

# A Brief History of the Pickup

**T**he nation's love affair with pickups is at an all-time high. In 1995, almost 2.7 million of them were sold, about as many as the ten best-selling cars in America put together. The popularity of pickups is easy to explain. They're useful, they're comfortable, and their appeal cuts across economic and class lines. One insightful commercial shows a handsome young jeans-clad guy bouncing over dusty roads by day in his pickup. As night falls, our hero dons a tuxedo and drives his gorgeous girlfriend to a fancy formal affair where—except for his trusty truck—all the vehicles are luxury cars.

No one could have predicted this scenario, given the pickup truck's very humble beginnings. The industrial revolution of the nineteenth century—whose factories manufactured everything from soup cans to nuts and bolts—created an enormous need for transporting products; thus the pickup. First out of the box was a box on wheels named the King High-Wheeler. Built in 1896 by a Chicago, Illinois, machinist named A. W. King, the High-Wheeler appears to have been the world's, or at least America's, first pickup truck. Resembling a wagon with a flatbed rear deck, this open-air contraption seated two people in close quarters and hauled light cargo when the weather cooperated. By 1900, the King High-Wheeler had come and gone, but dozens of other companies had entered the automotive marketplace.

In 1901, the Grant-Ferris Company of Troy, New York, sold a quarter-ton van with a top speed of twelve miles per hour. That same year, the Stearns Motor Co. of Cleveland, Ohio, advertised its Utility Wagon as "a truck that makes no sound but the slight 'tif-tif' of the engine."

The Stearns truck came with a five-gallon gas tank, side curtains, twin oil lamps, and a "well-modulated gong" to ward off oncoming traffic.

Three years later, a Kenosha, Wisconsin, bicycle maker named Thomas B. Jeffery introduced his Rambler Delivery Wagon. A 1904 ad claimed that the Rambler's "four full elliptic springs insure safe convenience for delicate packages." Thomas Jeffery's Rambler featured a detachable top, brass sidelamps, and a horn, and was priced at $850—if you went to Kenosha to get it.

In 1905, Ford marketed its first commercial vehicle, the Model C Delivery Van. It had two forward speeds and one reverse, and sold for $950. Lights were extra. The Model C Delivery Van was not a booming success. Exactly ten were made; after that, production was halted.

Ford didn't reenter the truck business until 1912, with its Model T Delivery Car, heralding it as "tougher than an army mule and cheaper than a team of horses."

Cheaper, maybe, but not necessarily better. When only 1,845 people were willing to pony up the seven hundred dollars needed to purchase the Delivery Car, Ford pulled out of the truck business for the second time. When it came back for good five years later, Ford faced stiff competition from an upstart named Dodge.

Dodge's first automobile came off the assembly line in 1914, followed the next day by its first truck chassis. But it was the car that catapulted Dodge into full-scale truck manufacturing. Known for its ruggedness, the Dodge was used by General Pershing in his campaign against Mexican revolutionary Pancho Villa. Pershing's unabashed enthusiasm for the vehicle paid off. Dodge got orders from the military for thousands of light-utility trucks, which were used as troop carriers during World War I. In 1917, Dodge marketed its first civilian truck, a virtual duplicate of the one it made for the army. By the end of 1920, Dodge had sold almost 30,000 of these "Delivery" pickups.

Chevrolet didn't begin to produce pickups, which it called

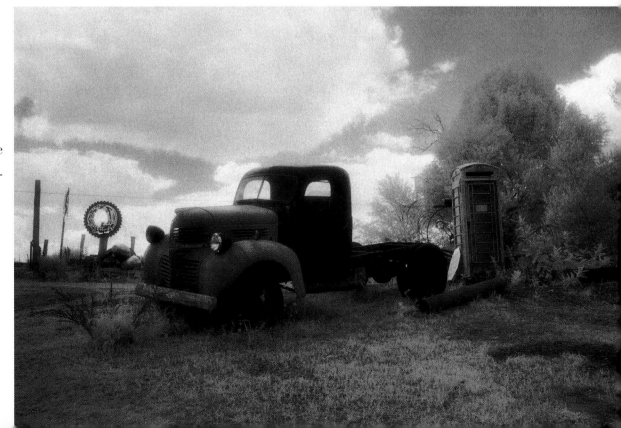

"Light Delivery" trucks, until World War I had ended. It made up for the late start with a vengeance. By 1929, half a million Chevy light-duty trucks had been manufactured. Four years later, half of all pickups sold in America were Chevrolets.

Between then and 1960, Chevrolet and Ford—along with Dodge, Studebaker, Reo, International, and Diamond T—were competing for the hearts, minds, and wallets of the American driver. The battle was one of styling as well as performance. The boxcar look of the twenties and early thirties was replaced by trucks with more graceful contours and distinctive vertical grilles. In the forties (after time out for World War II), the pickup was redesigned as a cute, stubby little vehicle that would have been at home in an animated cartoon.

That look lasted until 1953, when Ford introduced its revolutionary F-100 series. The F-100 was straight as a gate, had considerable chrome, and featured "counter-shock seat snubbers" for a softer, smoother ride. For truck owners who wanted automobile styling and comfort, the competition was on.

In 1955, Chevrolet fought back with a limited edition "dream truck" christened the Cameo. The Cameo wasn't sure it wanted to be a truck. A fiberglass tailgate panel concealed hinges and latches, the spare tire was tucked away in a hidden compartment, and the rear window—a wrap-around—was billed as "panoramic."

Two years later, Ford countered with its half-ton Ranchero, a standard station wagon converted into a pickup. The schizophrenic trend continued to the end of the decade, when Chevrolet came up with the El Camino, a half-car, half-truck, tailfinned brute that signaled the beginning of the age of high tech.

It is no accident that an El Camino is the most recent truck in this book. Like the nation that spawned it, the pickup changed radically as it entered the tumultuous sixties. The no-frills utilitarianism of earlier models has been replaced by CD players, cruise control, and other fancy gewgaws that would have startled Messrs. King, Stearns, and Dodge and Co. The pickup of today is faster, yes, and sleeker too, and without a doubt more popular than ever. But its innocence is gone.

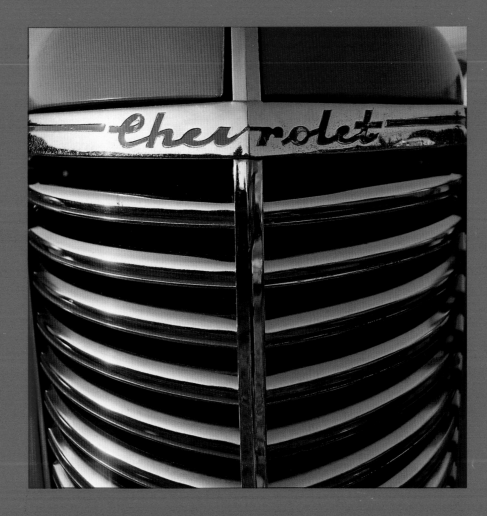

Chevrolet

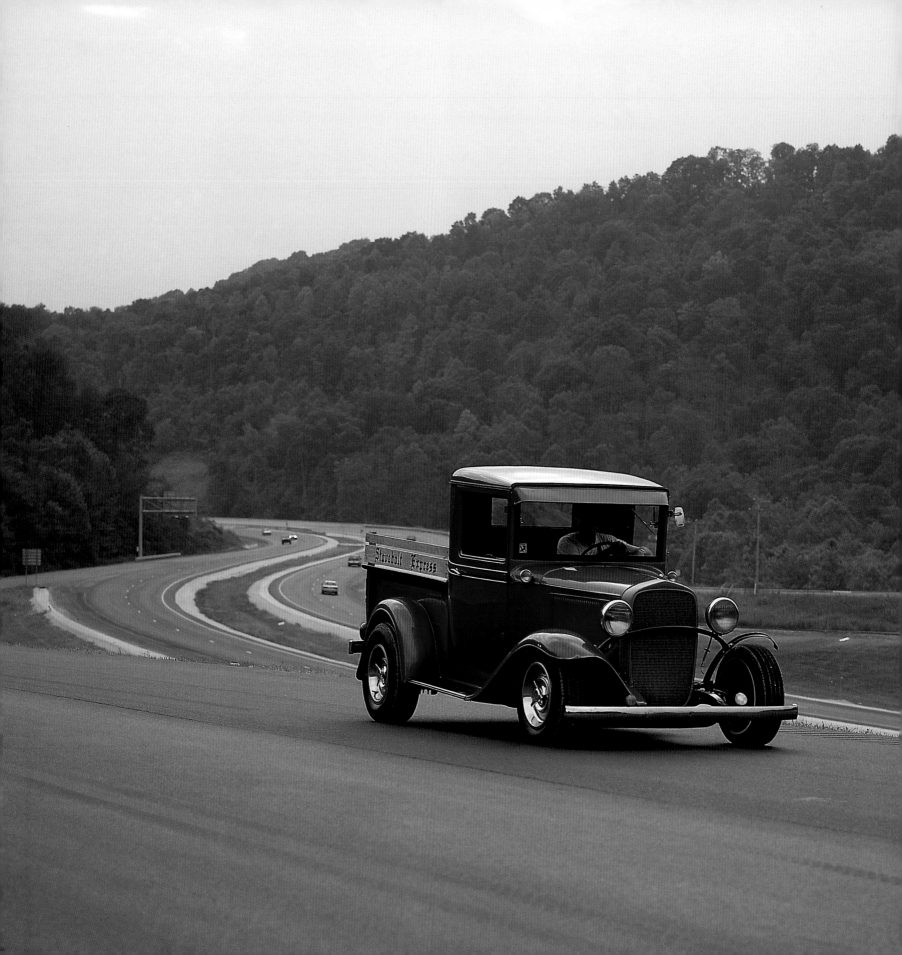

# Ron Jones's 1933 Chevrolet

**R**on Jones of Elkview, West Virginia, writes about his '33 Chevy half-ton pickup: "I'm a barber in a small town where my son played Little League ball. The boys loved to ride to and from practice in it. These boys are in their midthirties now and still talk about the fun they had riding in that old truck."

Ron Jones has been able to trace his pickup all the way back to its original owner. "Bernard Samples purchased the pickup new from McMillian Chevrolet for $440 in 1933. Bill Schoonover purchased it from Sample's widow. Schoonover traded the pickup to Henry Payne for a .22 rifle. Payne traded it to Frank Miller for a shotgun. Miller sold it to Jim Auxier for $500. Auxier traded it to me for a '64 Chevy pickup in 1972."

Ron took two years to restore his Chevrolet and has put more than 40,000 miles on it since then, mostly going to car and truck shows. A few years ago, this almost came to an end.

"I was driving the truck home when a five-point buck deer jumped out of the weeds just as I was coming out of a curve. The truck hit the deer, turned sideways, and slid down a very steep bank into a small stream. It carried the deer across the grille and front fender, where it died a few minutes later. I've spent about three thousand dollars in parts to put the truck back in good condition again."

Ron is now planning to give his Chevy a new paint job so it can return to the shows.

"I have only seen a total of five 1933 Chevrolet pickups out of thousands of entries at these shows. When you see car and truck enthusiasts taking pictures of the truck for their scrapbooks, it gives you a great feeling."

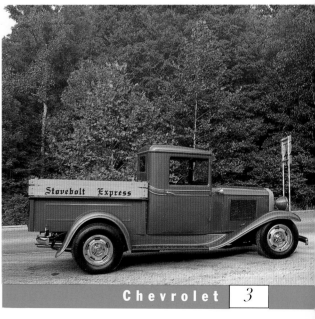

*Engine: Chevrolet six-cylinder V-8*

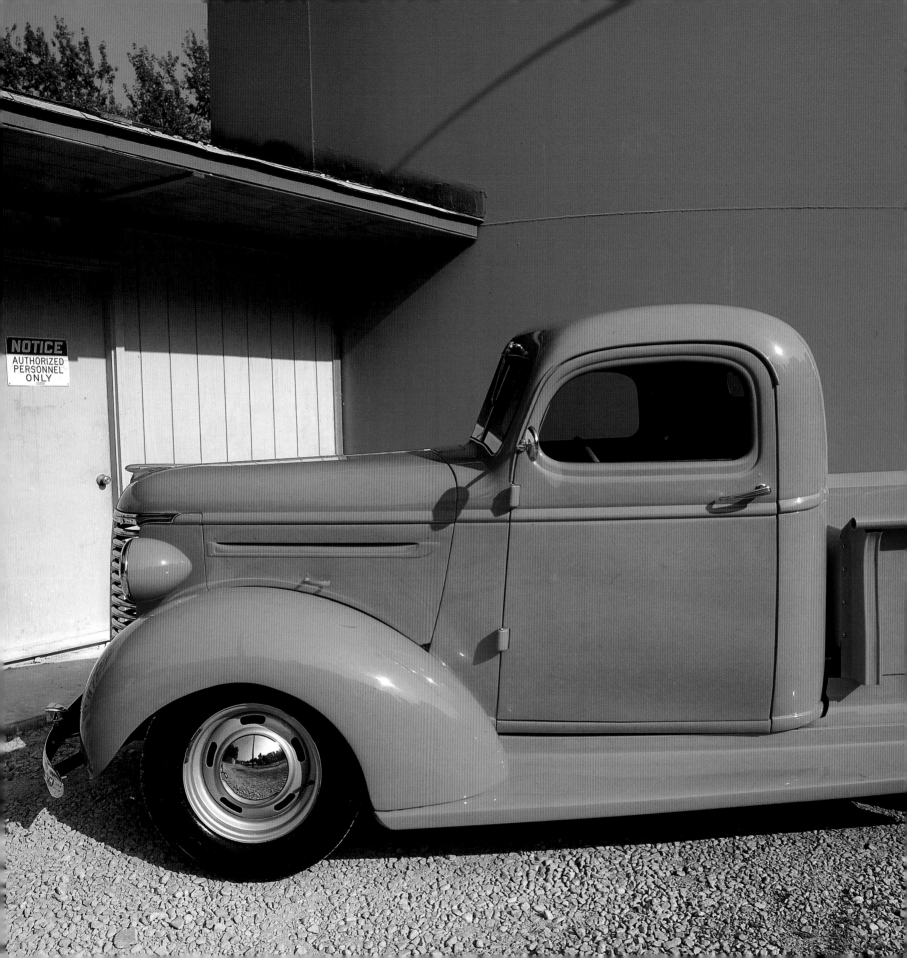

NOTICE
AUTHORIZED
PERSONNEL
ONLY

## Danny Shinn's 1939 Chevrolet JC

**F**orty-five-year-old coal miner Shinn got interested in pickups when he reworked his father's '46 Chevy as a teenager in Pinch, West Virginia. "I took to it," says Danny, "so I always wanted one for myself."

Danny's dream was answered when he heard that Jimmy Kinder, in Upper Pinch, had a '39 Chevy pickup he might be willing to part with. "It wasn't much," says Danny, referring to how the truck looked. "There were two bolts holding the cab on, four bolts holding the front fender, two bolts holding the bed, and the floor boards had rotted clear out underneath it." Undeterred, Danny Shinn gave Jimmy Kinder $3,500 for the old Chevy and took it back to Pinch to "rework" it. Fourteen thousand dollars later, all that's left of the original pickup is its body and frame. The engine is a '69 Corvette, the front end comes from a '70-something Mustang, and the rear end is by way of an '86 Monte Carlo. Its color is rose pink because Ivan Reed down at NAPA Auto Parts gave Danny the paint, thinking the result might drum up some business for him. "It does catch the eye," admits Danny.

Danny Shinn's five-year-old son thinks so, too. "He loves the truck," Danny says, which is understandable, since "he was probably conceived in it."

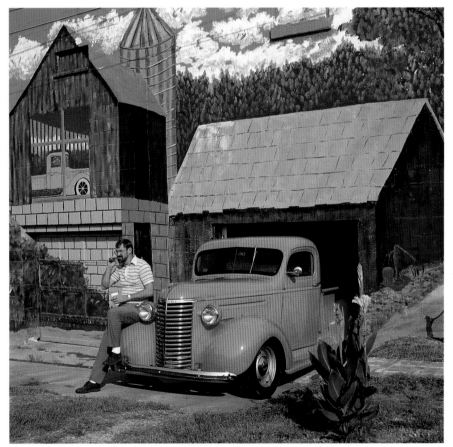

*Engine: 1969 Corvette 350*

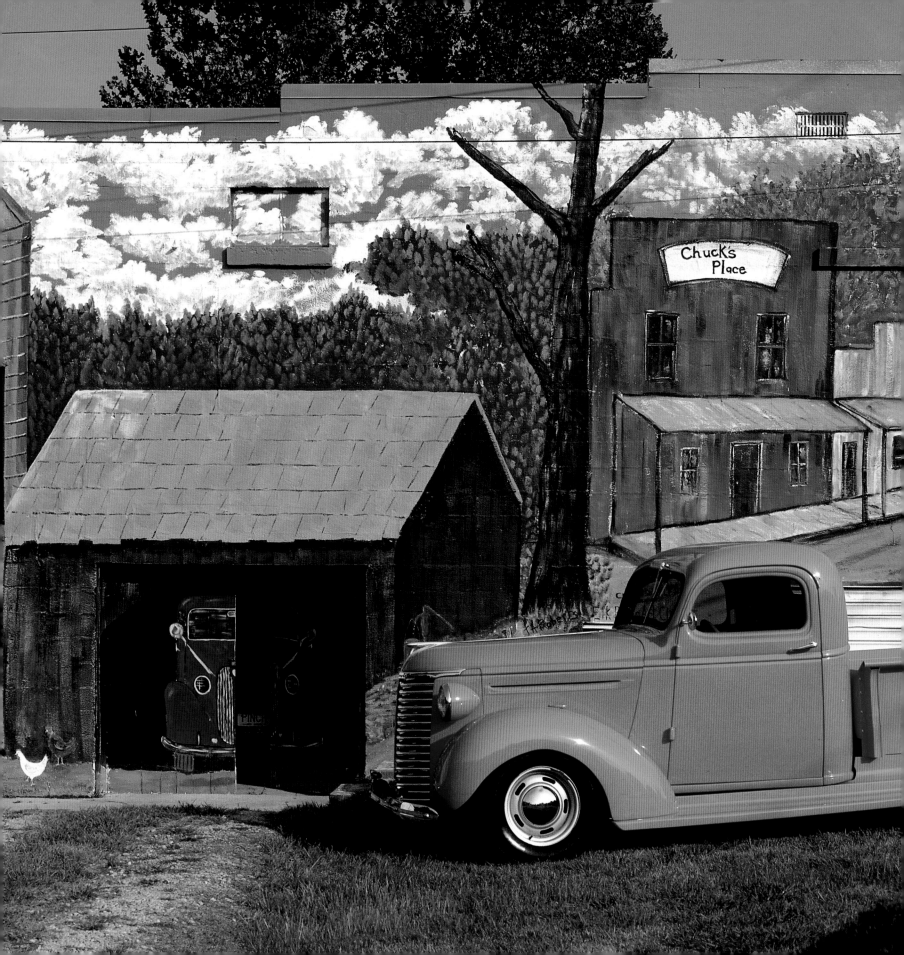

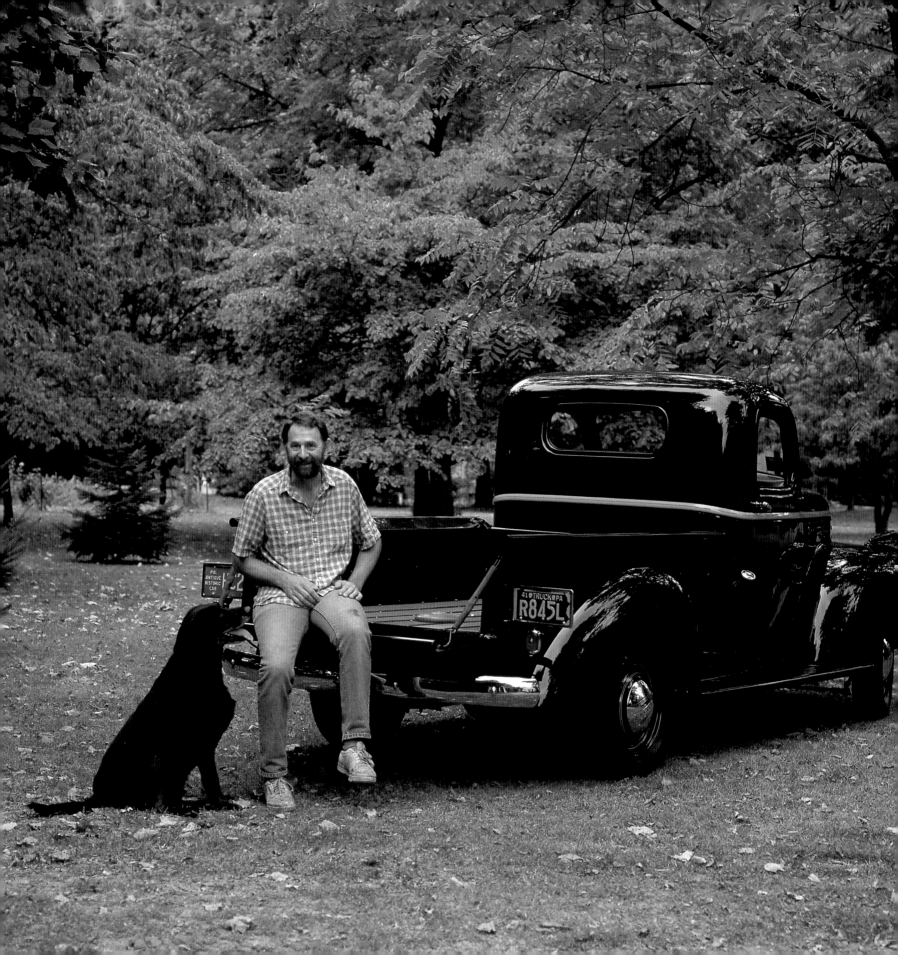

# Ray Troutman's 1941 Chevrolet AK

Fifty-one-year-old Ray Troutman's love of pickups has nothing to do with his past. In that respect Ray is unusual—if not downright unique. "My dad never even owned one," says Ray, "but I always wanted an old Chevy, even though I can't explain why."

Ray's longing went unsatisfied until 1988, when he read about an auction in Blue Bell, Pennsylvania. Among the items for sale was a 1941 Chevrolet half-ton pickup. Ray took the day off from work and went to the auction, taking his mother along for moral support. When Ray bid $1,300 for the Chevy, he thought he was home free. Then the auctioneer "started begging for one more bid," as Ray puts it. This really annoyed Ray's mom, who announced in a voice that everyone could hear, "Come on, sell the damn thing!" The auctioneer did—but Ray had to go to $1,350 to get it.

Ray Troutman towed the old Chevy back to his home in Pottstown, Pennsylvania, and began to fix it up. At first, Ray wasn't overly concerned about authenticity. "I just wanted a decent-looking pickup truck that I could take out for an ice-cream cone," Ray admits. Then Ray's friend Sam—who was helping Ray work on the pickup—remarked that the Chevy was looking so good Ray might consider entering it in the car and truck show in Hershey, Pennsylvania, which is the World Series of antique car and truck collectors. When Ray heard that, he decided to restore his pickup from the ground up.

Two years later, Ray Troutman drove his gleaming '41 Chevy pickup to the big competition in Hershey. Ray was eliminated in the finals when a judge found that Ray had used modern, plastic-coated wiring under the dashboard, instead of the cloth-covered stuff from the forties.

Ray took his Chevy back to Pottstown and replaced the wiring. Over the next twelve months, Ray inspected every inch of the truck to make sure there were no more anachronisms. Then he drove back to Hershey and won.

Since then, Ray's '41 Chevy has garnered so many awards that the Danbury Mint has made a model of it for sale to collectors all over the country. "I'm not making any money on the deal," says Ray, "but I don't care. The pride I feel is enough."

*Engine: Chevrolet six-cylinder*

# Carl Smith Jr.'s 1945 Chevrolet

Forty-nine-year-old Carl Smith, Jr., owns an antique restoration and salvage yard in Elkview, West Virginia. Carl bought his Chevy in 1984 for $100, planning to sell it as parts. The old Chevy was good to Carl. In five years he'd sold everything from it he could.

Then Carl woke up one day and realized that a pickup truck would be a handy thing to have for his business. Carl looked around his yard. The only pickup there was the '45 Chevy, which was lacking an engine, a transmission, wheels, and other basics.

Carl didn't see the point of spending money on a new pickup. So he took the only thing that was left of the Chevy—its body—and put it on the chassis of a '77 Olds Cutlass whose exterior had rusted out. The result looked pretty good to Carl except for the paint, which had faded badly. To complicate matters, the Chevy was originally an army vehicle. It was olive drab and had military stars on it, which would be costly to redo. In the nick of time, a friend offered to give Carl a can of green paint he had left over from touching up his tractor. Carl seized the opportunity. As he puts it, "The price was right."

Carl now drives his pickup every day. "It's brought me an awful lot of business," Carl says. "When I park it at the supermarket, someone is always looking at it when I come out of the store. They ask me where I got it and I tell them that I welded it together myself. Then they tell me they've got this old pickup that needs some work and would I be interested in doing it? The next thing you know, I'm restoring their truck."

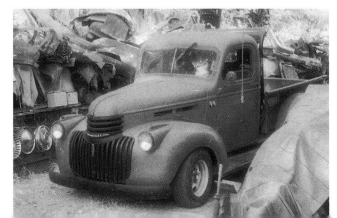

*Engine: 1976 Oldsmobile 350*

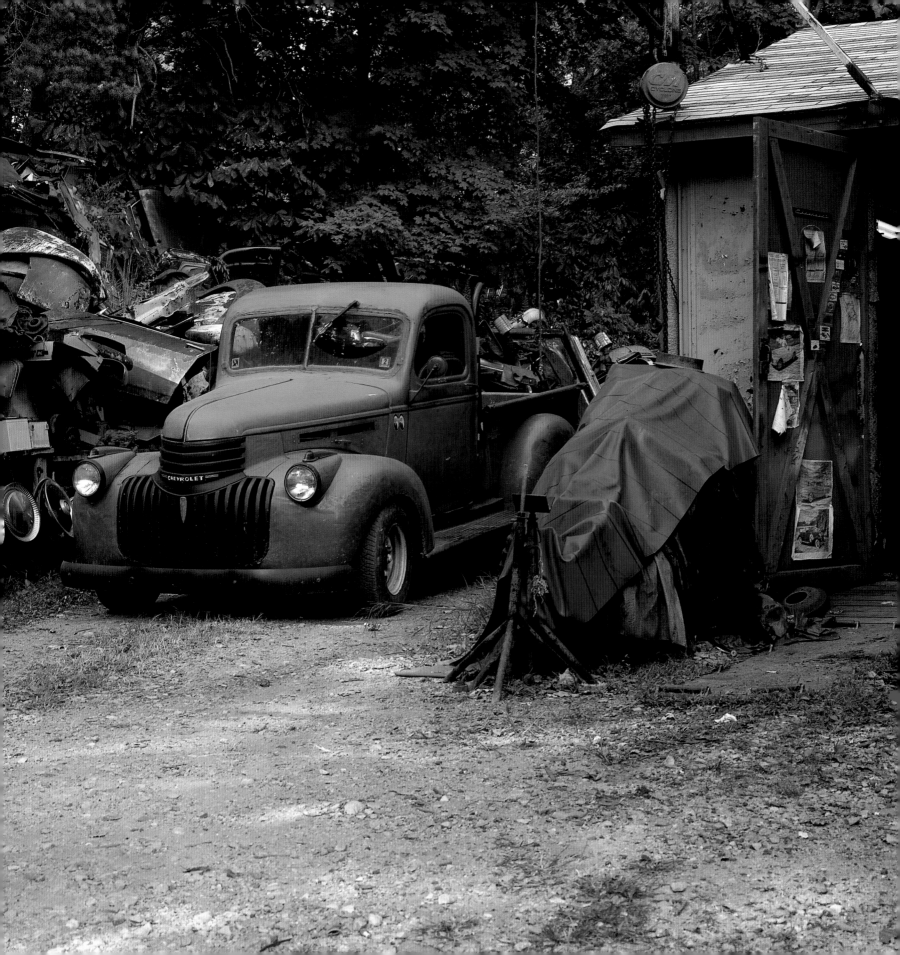

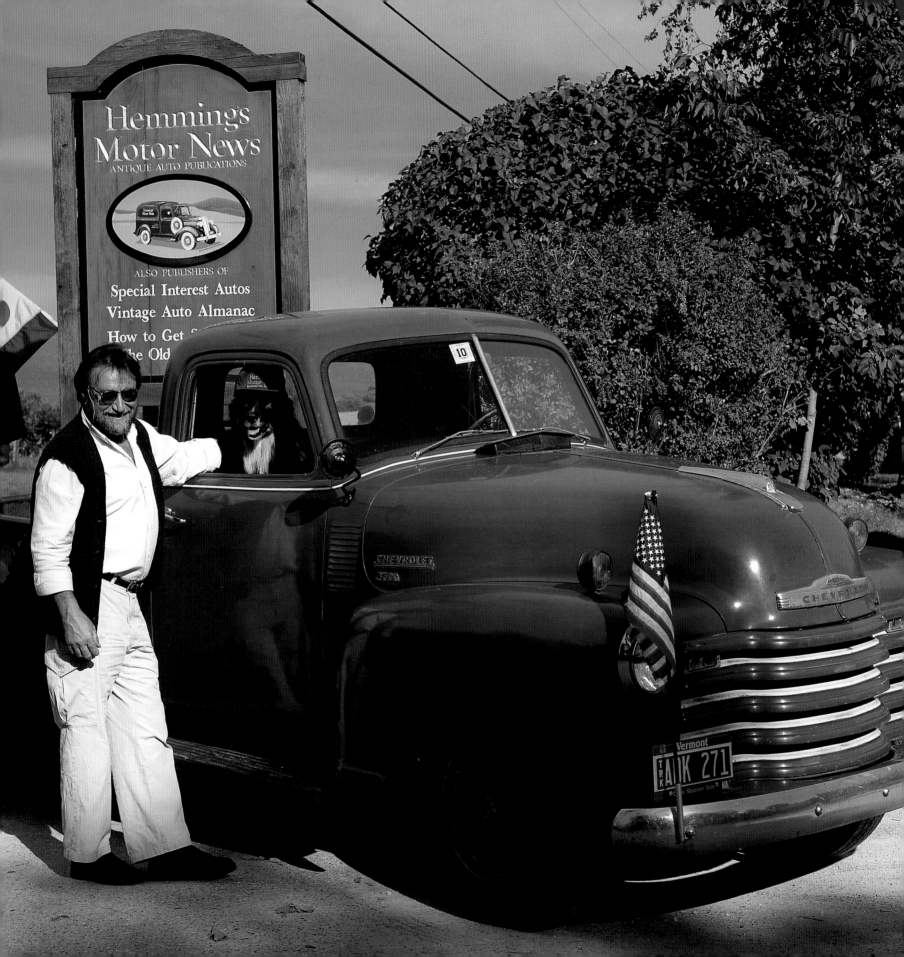

# Terry Ehrich's 1949 Chevrolet 3600

The dynamic duo with the unrestored '49 Chevy are its owner, fifty-five-year-old Terry Ehrich, and Terry's dog Buckwheat. When Buckwheat is not riding around in the Chevy, he hangs his hat at the Bennington, Vermont, headquarters of *Hemmings Motor News*, known to its readers as "the bible of the old-car hobby."

Terry Ehrich has been the editor and publisher of the magazine ever since 1969, when he and some business partners acquired it from its original owner, Ernie Hemmings. At that time, Harvard-educated Terry was the advertising sales manager for the esoteric *New York Review of Books*, which is about as far removed from the nuts-and-bolts world of cars and trucks as you can get.

But for Terry—who had bought a Model A Ford for thirty-five bucks when he was thirteen—the opportunity was irresistible. Twenty-seven years later, Terry Ehrich has transformed *Hemmings Motor News* from a tiny publication into a two-pound, 800-plus page behemoth whose listings of old cars, old trucks, parts, and services are devoured by 265,000 loyal subscribers each and every month.

According to Terry, interest in pickups has grown enormously over the last five years; so much so that Ford now sells more light-duty trucks than it does Tauruses, America's best-selling automobile. Terry credits this to a combination of utility and affordability that appeals to "the testosterone-fueled dreams of wannabe he-men perched on their riding mowers."

Terry Ehrich found his '49 Chevy six years ago at the now-defunct Mt. Philo Motors

*Engine: Chevrolet six-cylinder*

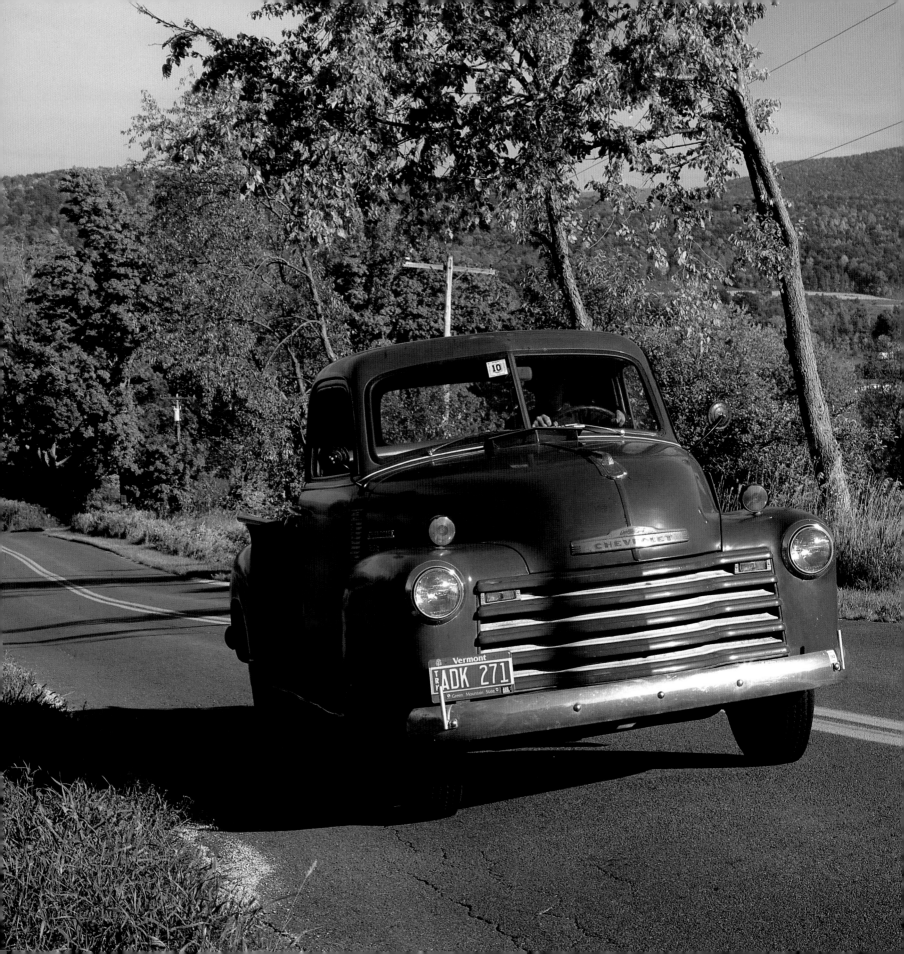

in North Ferrisburg, Vermont. Except for having the brakes redone and converting the electrical system to twelve volts, Terry left the three-quarter-ton pickup exactly as he found it. "I never considered getting a new truck," Terry says. "The Chevy has a lot more character, runs fine, and only cost four thousand dollars."

*Hemmings* readers would no doubt approve.

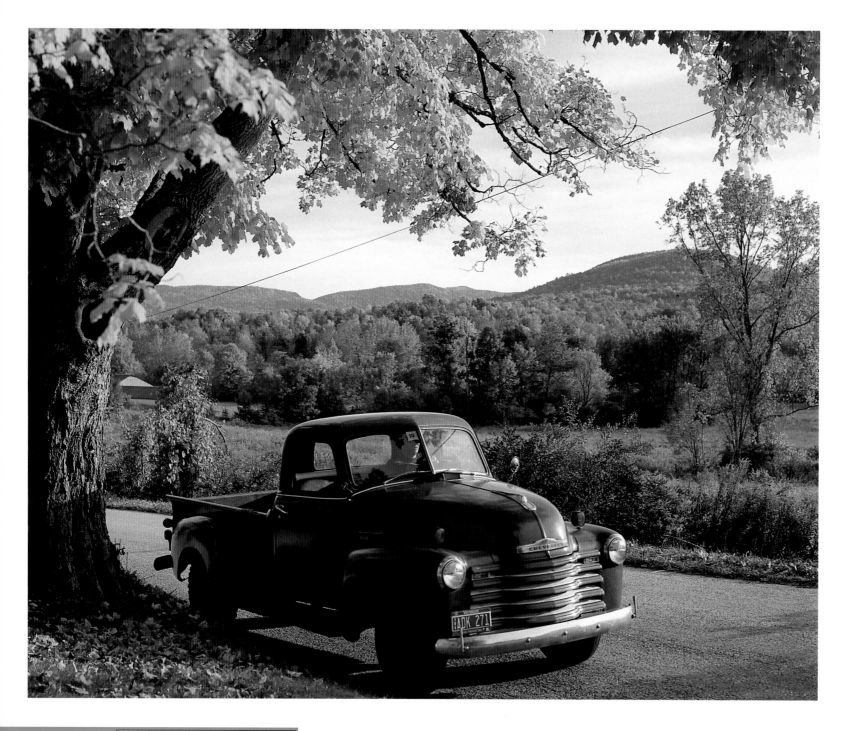

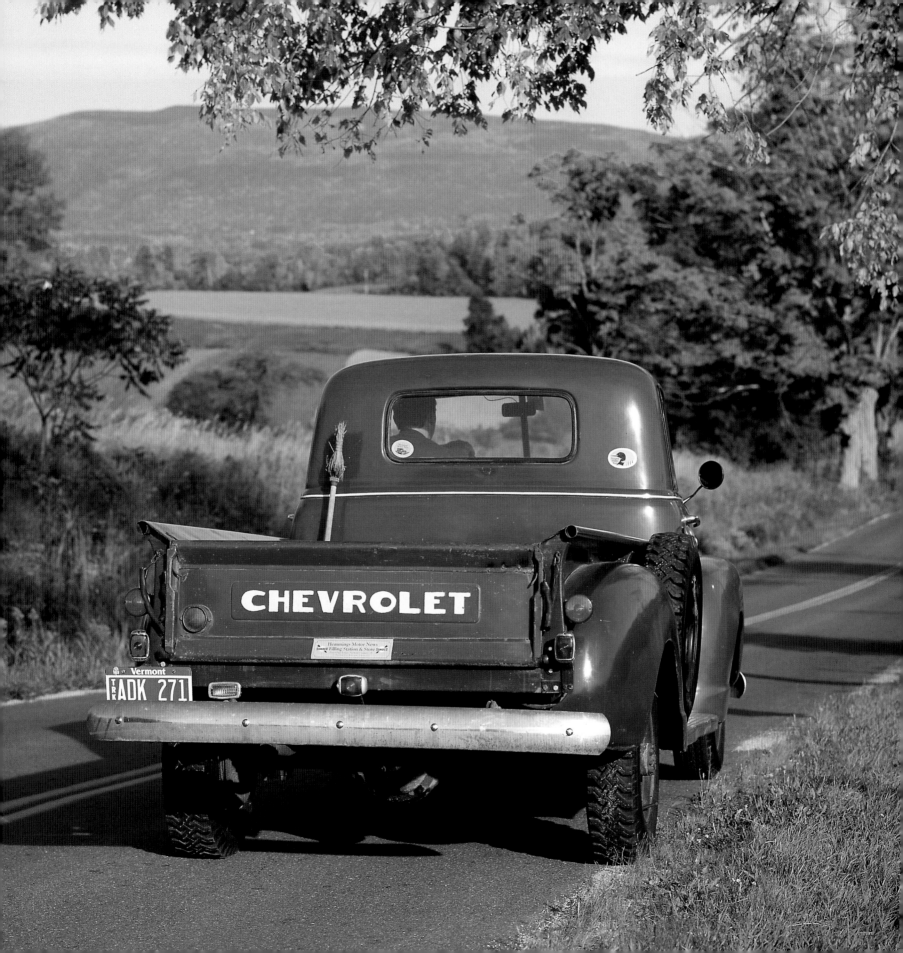

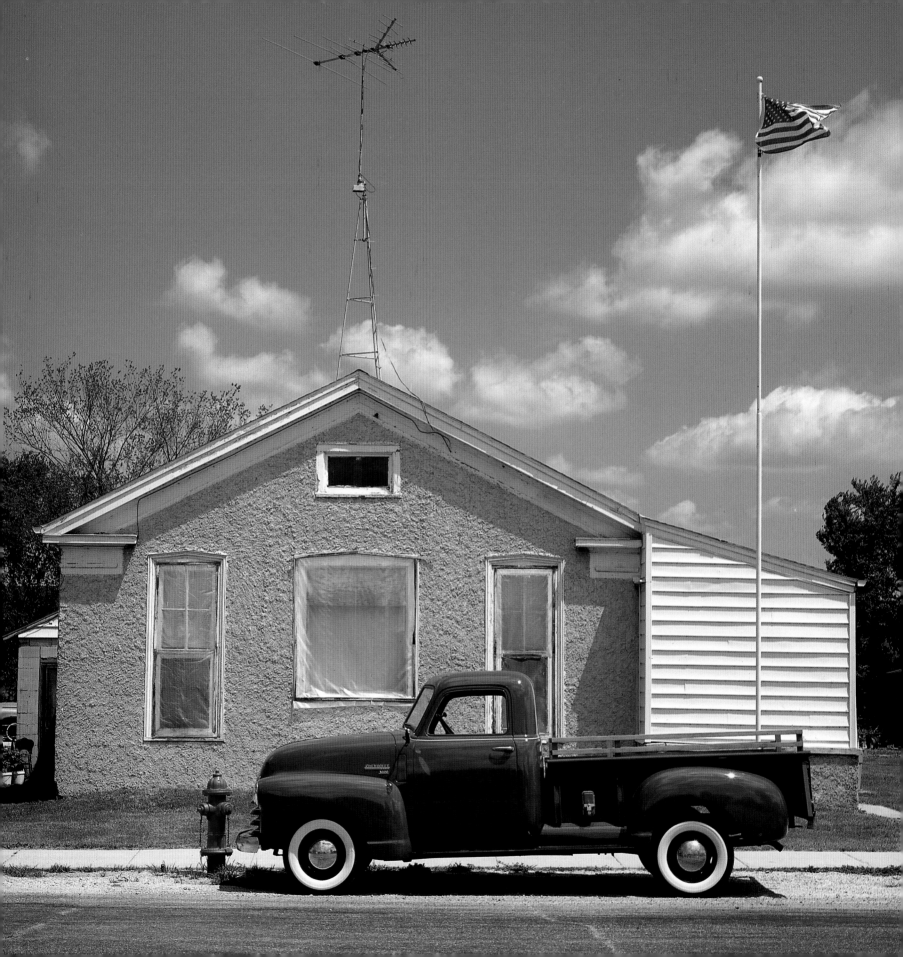

# Leon Moeller's 1950 Chevrolet 3600

**T**his is what the 1950 Chevrolet operator's manual says about the **3600.** *When you purchased your new Chevrolet truck it was a business investment on your part. You can rightly expect it to pay dividends on the investment by handling your transportation and hauling requirements.*

That was not Leon Moeller's experience. But in fairness to Chevrolet, perhaps it's because the truck's original owners used it on their Dixon, Iowa, farm for twenty-nine years before Leon took it off their hands for $400. The problem was, the brake lines were rusted out so Leon couldn't go anywhere in it, much less use it for hauling. An even bigger problem was Leon's wife, Rita, who was struggling to raise a growing family. Rita was furious at Leon for spending money they didn't have on a truck they didn't need. "Why would you buy a pickup that can't stop?" she asked Leon.

"Because I wanted it," Leon answered.

Leon and his pickup were in the doghouse for almost a year. Then Leon fixed the brakes and started using it as a work truck. By 1985, Leon's business was booming—he's a traveling salesman—and Leon decided he would restore his beloved pickup. In 1992, he finished the job, right down to the original cardboard door panels.

Leon has turned down $3,500 for his truck and claims he wouldn't sell it at any price. "It's part of our family," he says. Rita is not quite as enthusiastic.

"Let me put it this way," she responds. "The only thing I know about that truck is that it's green."

*Engine: Chevrolet six-cylinder*

**Chevrolet** 21

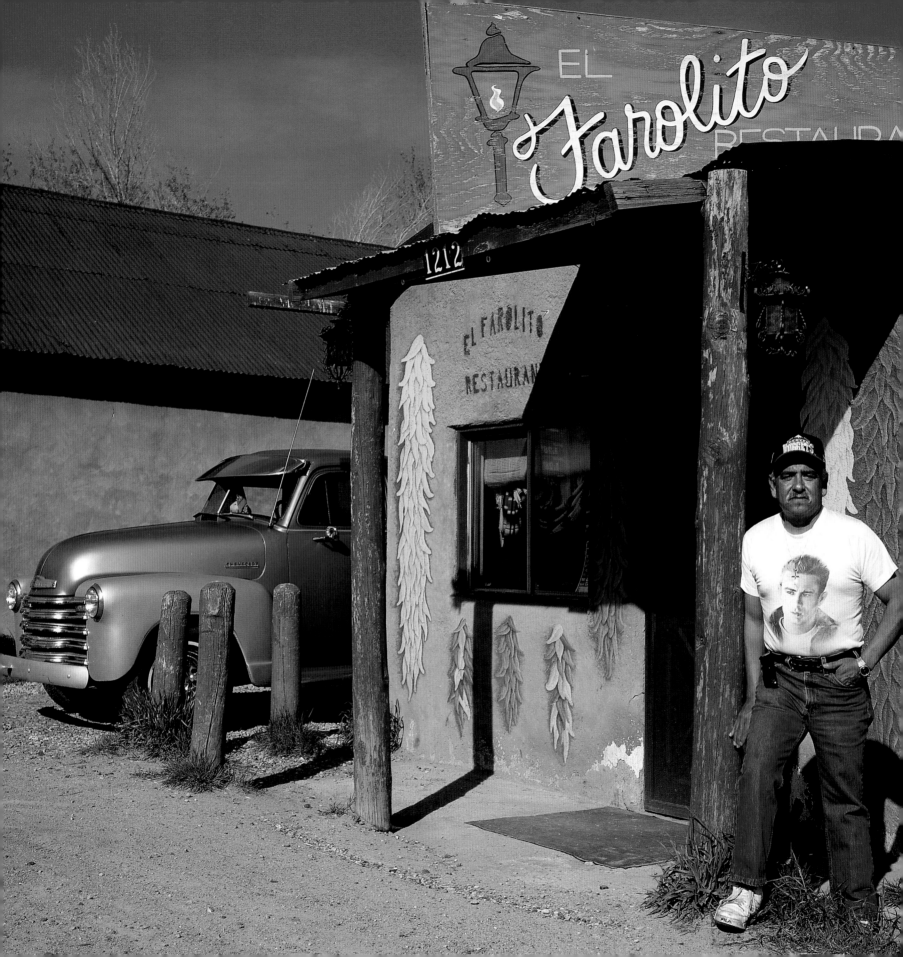

## Dennis Trujillo's 1953 Chevrolet Deluxe 3600

I n El Rito, New Mexico, there are two things you notice right off. The first is El Farolito, a tiny restaurant that serves killer enchiladas. The second is a gleaming '53 Chevy Deluxe half-ton pickup, which is usually parked outside El Farolito. Dennis Trujillo owns both.

Like a lot of old-truck owners, Dennis got his pickup for sentimental reasons. His dad taught him to drive in a Deluxe, which he bought new when Dennis was thirteen. (It's called a Deluxe, Dennis says, because it has roll-down windows.) When his father died in 1971, Dennis promised himself that one day he'd find a pickup just like it. Twelve years later, Dennis spotted a classified ad from someone in Espanola who was looking to sell his '53 Chevy Deluxe. When Dennis got there, the guy had two Deluxe pickups sitting in his backyard, but only one of them had an engine. Dennis bought both for $800 and took the parts from the second (the one with the engine) to use on the first, whose chassis was in better shape.

It took Dennis two years to restore his pickup, which was perfect except for one thing. Although it ran okay, the engine wasn't original. That was unacceptable to Dennis, who didn't want to drive the pickup until it was *exactly* the same as his dad's. Three months later, Dennis located a '53 Chevy Deluxe engine sitting in a friend of a friend's garage in Monte Vista, Colorado. Dennis paid $400 for it and his dream was complete.

There's a postscript to the story. One day, a man from California was driving by El Farolito and saw Dennis's pickup. He introduced himself to Dennis, whipped out his checkbook, and offered to buy the truck on the spot . . . for $15,000. Dennis turned the man down, but he did sell him lunch.

*Engine: Chevrolet 232 V-6*

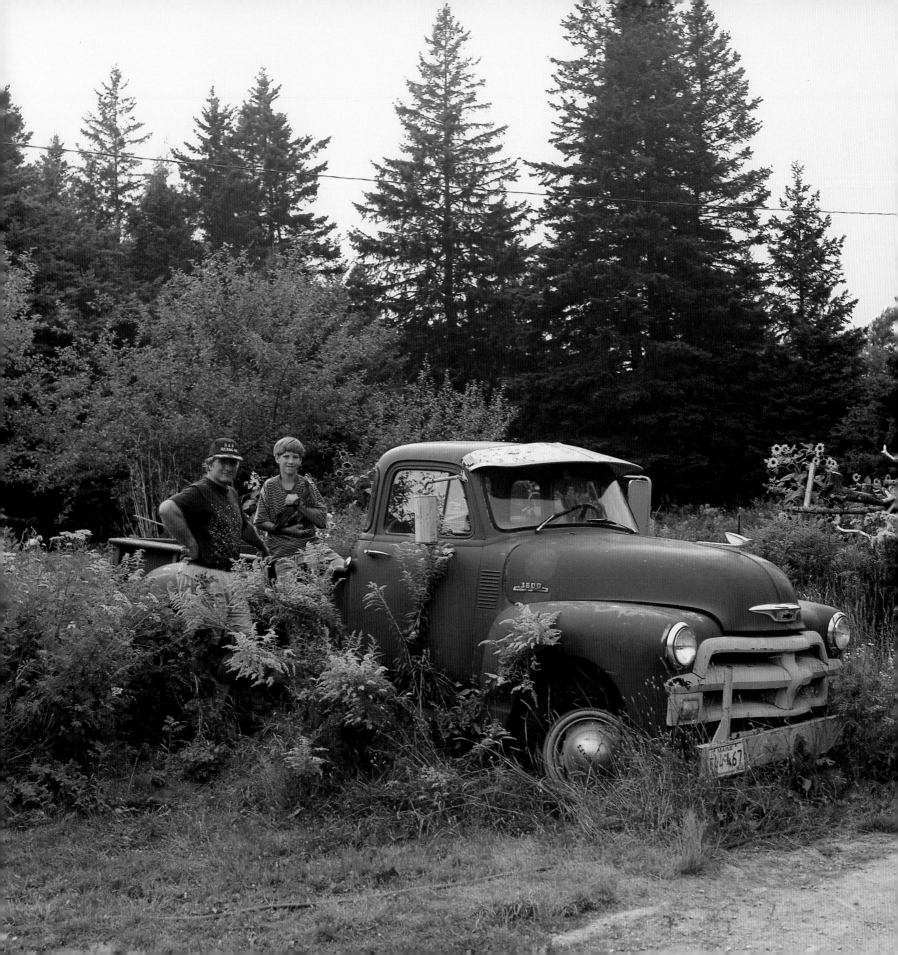

# Bruce Bulger's 1954 Chevrolet Express 3800

orty-seven-year-old Bruce Bulger is a furniture maker in Deer Isle, Maine. Bruce bought his one-ton Chevy pickup from a friend for $1,000 back in 1983 and put it to immediate use delivering the tables, chairs, and bookcases he'd designed.

Because its engine had been rebuilt, the pickup was in good condition. Bruce drove it everywhere. In the process, he got attached to it. How Bruce Bulger feels about his '54 Chevy says a lot about who we are and where we've come from. Take a listen: "When I grew up, things were made well. My father drove a '57 Chevy. It had those great big tail fins, but it was a dependable piece of machinery.

"Back then, the people at Chevrolet were geniuses. The engine in my pickup is one of the finest American-made engines ever. I live on an island and quite a few people around here have it on their boats. It was built to last a long time. Things ought to be that way now, but they're not.

"Today you have to go in debt to buy a pickup. And when you do, what have you got? You bump into something and everything crinkles. Look at the bumpers on my Chevy. You can't put a dent on it. It could be used as a bulldozer.

"For the last year, the Chevy has been sitting in my yard because I want to restore it and I haven't had the time. Even so, I like looking at it. The huge wheels. The proportions. It has a mystical solidity.

"My son Larkin is about ready to get his driver's license. Then it'll be his truck. It's a safe vehicle for him to go to high school in."

Amen.

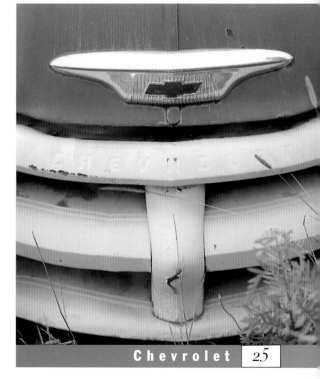

*Engine: Chevrolet six-cylinder*

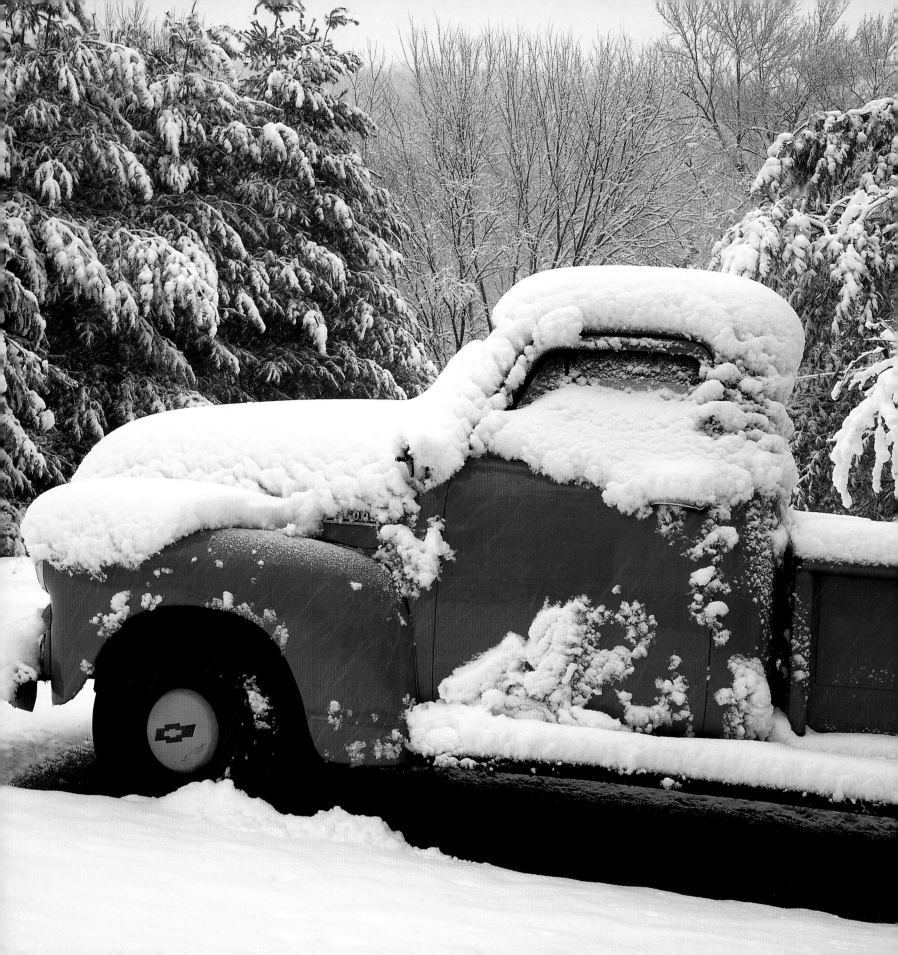

# Steve Kambanis's 1954 Chevrolet 3100

According to its original bill of sale, Steve Kambanis's three-quarter-ton Chevy pickup cost $1,778.79 when it was bought on January 15, 1954, by one Chester Smalley, from H.O.B. Motors in Plainfield, New Jersey. Extras were a rear bumper ($10.70), directional signals ($35.00), spare tire ($35.00), heater and de-froster ($52.50), and an item referred to only as "Prestone" ($7.40)—presumably antifreeze.

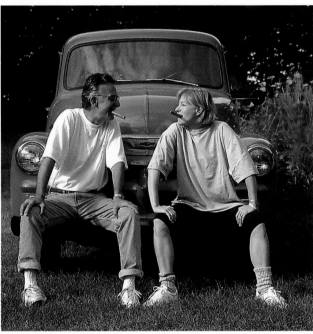

Kambanis—who's an art director for a New York ad agency—got the truck as a birthday present from his wife, Wendy. Because Wendy had no idea how to find an old pick-up, she called her old high-school sweetheart, Skip, who did. Skip bought the Chevrolet from a policeman in New Jersey for $300, planning to turn it over to Wendy for the same price. But Skip became so attached to the pickup that Wendy had to pay him $900 to part with it.

Because his '54 Chevy was completely rusted out, Steve Kambanis spent seven years searching for parts. "It's like looking for organ transplants," he says. "You know they're out there, you just don't know where."

Whenever Steve's pickup is serviced, it comes back with stickers from people want-ing Steve to sell it to them. Steve Kambanis thinks he knows why. "Driving this truck is like driving a cartoon. Who wouldn't want to do that?"

*Engine: Chevrolet six-cylinder*

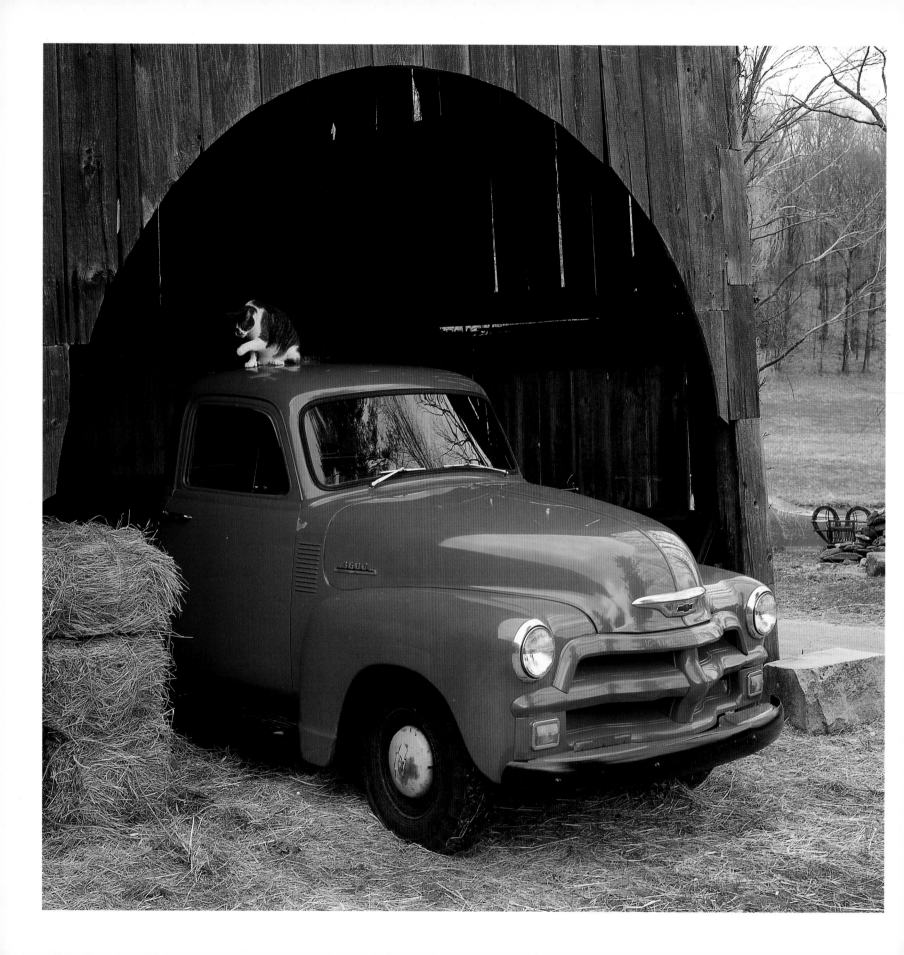

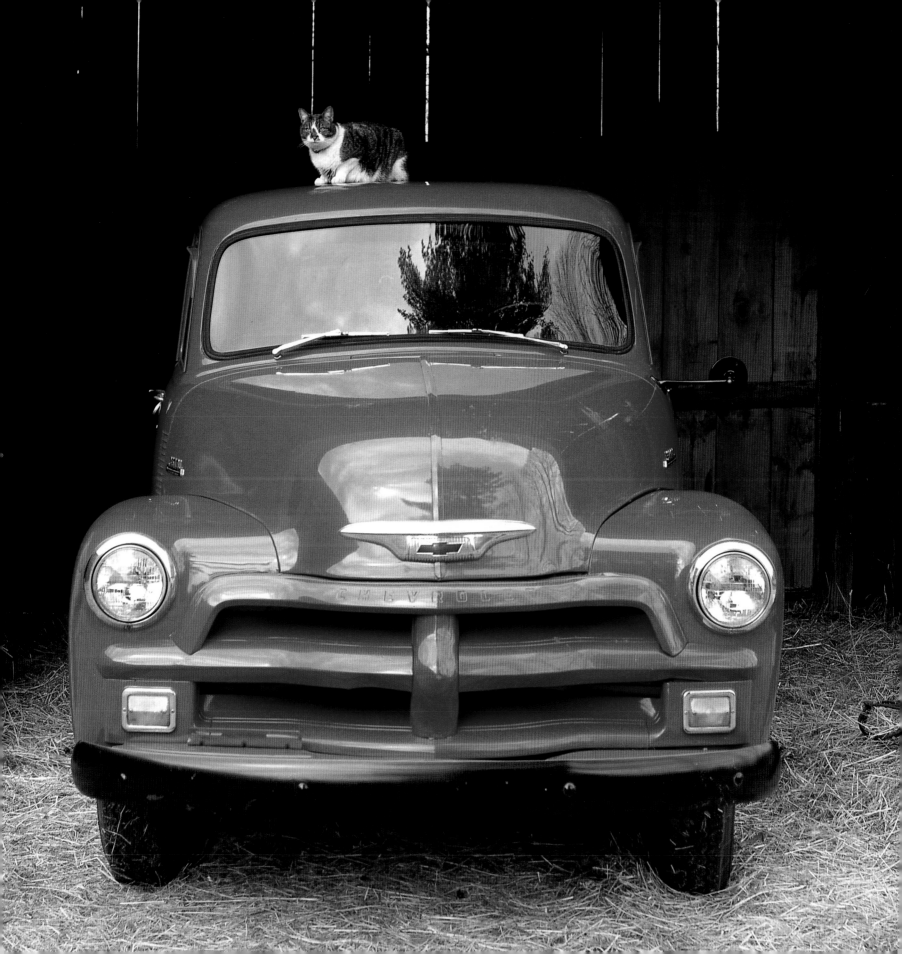

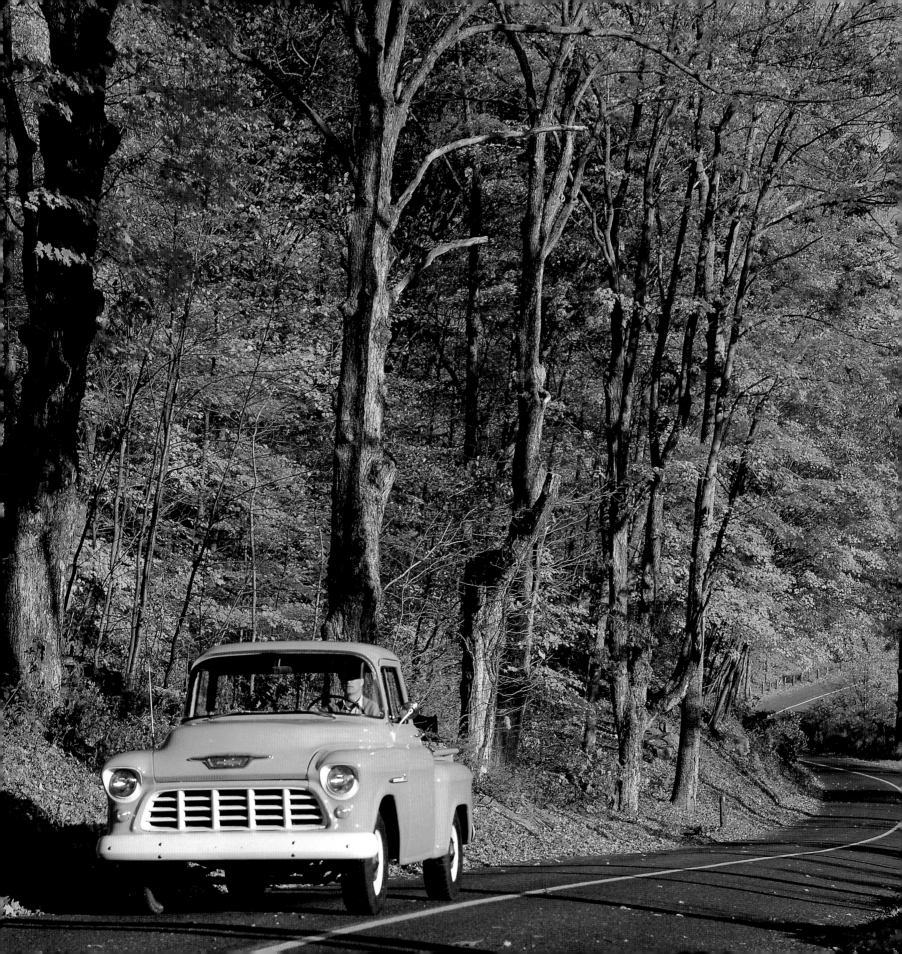

# Peter Wooster's 1955 Chevrolet 3100

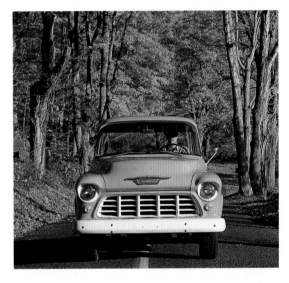

Peter Wooster, a forty-nine-year-old designer from Roxbury, Connecticut, was somewhat shocked by the state of his '55 Chevy pickup, which he acquired from a friend of a friend in nearby Bethel. "Everything was wrong with it," says Peter. "It had mag wheels, a 5-speed Toyota transmission, bucket seats, and one of those tiny steering wheels you see on racecars."

Fortunately, the owner had kept the truck's original parts, so Peter handed him a check for $1,000 and drove away with the pickup, determined to give it back its dignity. For that, Peter turned to an unnamed body shop that was highly recommended ·by his mechanic. The experience has made Peter Wooster a sadder, wiser, and poorer man. "Out of the four years I've had the truck, it has spent one entire year inside that shop," Peter groans. "So far I've spent $20,000 and I haven't even touched the inside."

Peter has replaced the fenders, the transmission, the rear end, the springs, and the bed and has had his Chevy pickup painted four times because the body shop continues to overlook rust. "They keep screwing up," says Peter. "If I were the Unabomber, they'd be my first target."

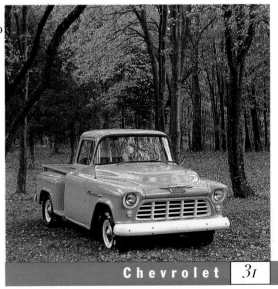

Peter says he's stayed with the shop because they've stopped charging him for their mistakes, which still occur like clockwork. "They're my lot in life," he sighs, sounding suspiciously like the Ancient Mariner.

So, would Peter Wooster sell his pickup if the price was right? "Of course I wouldn't," he says, genuinely surprised at the question. "I love it. It's fun. It makes things festive."

*Engine: Chevrolet six-cylinder V-8*

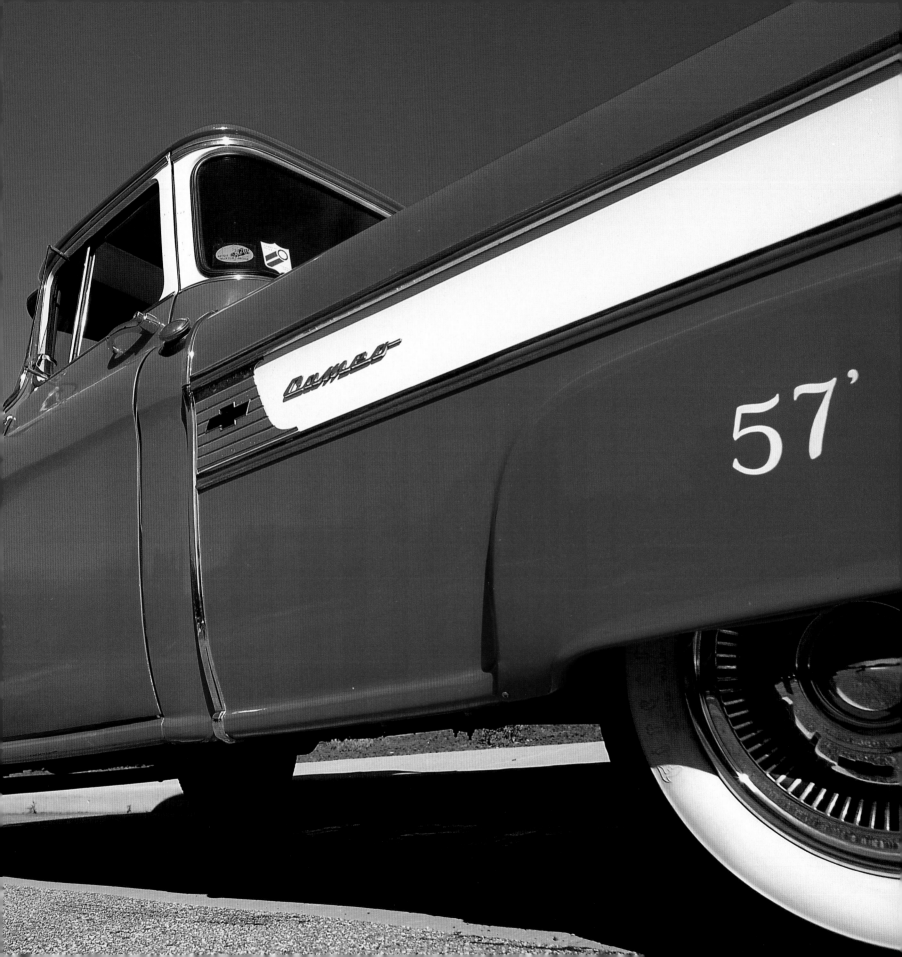

# Lynn Amaducci's 1957 Chevrolet Cameo 3100

Since pickup trucks seem to be pretty much a "guy" thing, it's refreshing to meet Lynn Amaducci of Hanover Township, New Jersey. Lynn not only loves old pickups, she's the president of the Antique Truck Club of America—which has eighteen hundred members, almost all of them men.

Lynn admits that "when you see a truck, you automatically think that a man should be driving it," but she believes that women who exclude themselves from owning one are missing out on a lot of fun. Lynn wasn't passionate about pickups until she accompanied her husband, Tom, to an antique truck show many years ago. What hooked her, she says, was "the uniqueness of each truck. A truck can be sitting next to the exact same model yet be very different from it. That's not true with cars."

The experience motivated Lynn to work her way up the ladder of the Antique Truck Club rung by rung, holding every major office, until she was elected president. "I have paid my dues," Lynn says proudly, adding that she's also paid attention to the trucks themselves—even the obscure ones. "Once I was driving down the road with my seventeen-year-old son and I identified a Kenworth from the rear. He went, 'Gosh, I'm impressed, Mom!' " says Lynn, laughing. "I think it blew him away."

Lynn Amaducci's Chevrolet Cameo is in fact three different trucks that were pieced together to make the one she now drives. The biggest piece, which was found lying in a field in Norristown, Pennsylvania, cost Lynn $200. Two years and $6,000 later, the restoration was complete, with most of the money spent on "duded up chrome," as Lynn puts it.

Lynn Amaducci loves the way her Cardinal red and Bombay ivory pickup looks going down the road. "I can't conceive of a man driving it," she says. "It's a very feminine truck."

*Engine: Chevrolet six-cylinder V-8*

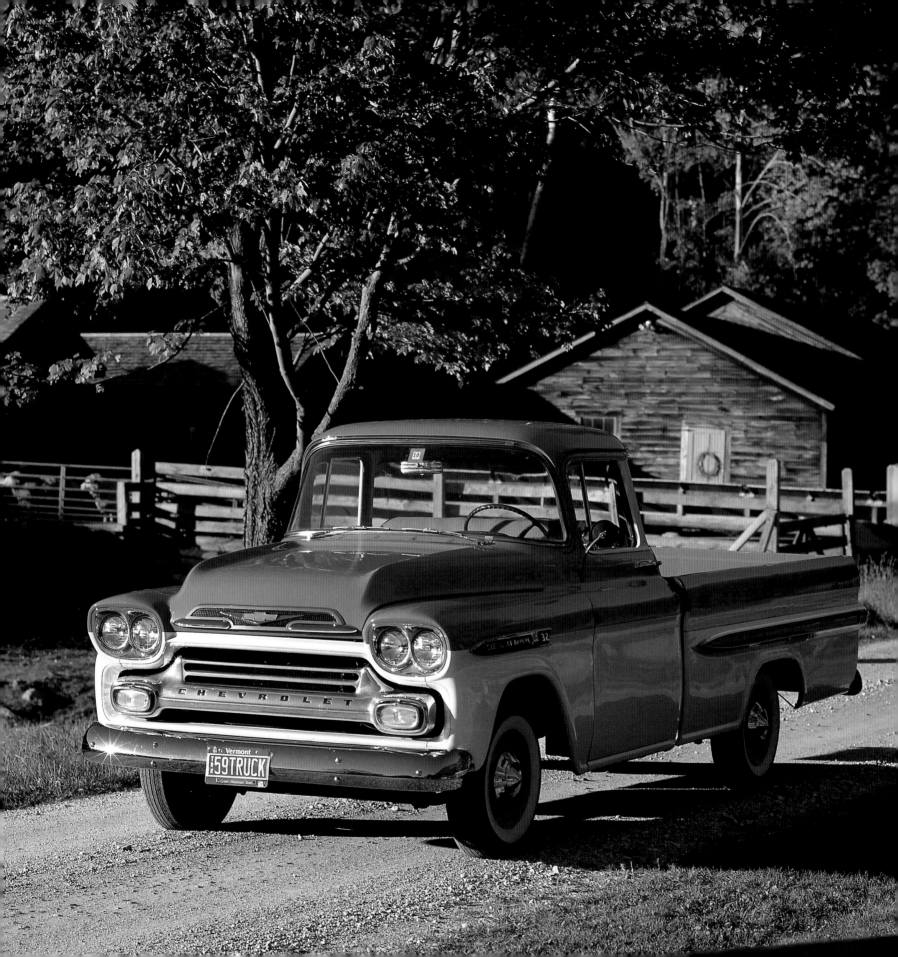

# Scott MacKenzie's 1959 Chevrolet Fleetside

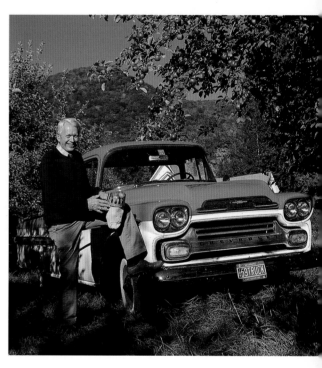

**S**ixty-two-year-old Scott MacKenzie of East Dorset, Vermont, traces his love of old pickups to his father's dairy business, which relied on Chevrolet trucks from the fifties to deliver its milk.

For the first half century of his life, this memory was buried in the recesses of Scott MacKenzie's brain. Then one day Scott saw a '57 Chevy with a FOR SALE sign on it by the side of the road in Mt. Philo, Vermont, and his life changed. "Right then and there, I knew I had to have it," recalls Scott. "It spoke to me."

So Scott bought the truck and, in the process of restoring it, he became hooked. "I decided I would concentrate on Chevrolets made between 1955 and 1959," says Scott. "In the past, I'd collected antiques, so owning a few old pickups seemed like a natural extension of that."

Scott acquired his 1959 Fleetside by responding to an ad in *Old Cars Weekly* that showed a picture of the truck and a price tag of $1,800. Scott called the owner in Milliken, Colorado, bargained him down to $1,200, and arranged for the truck to be trailered east—sight unseen. "Since I don't travel, almost every truck I've restored has been bought this way," says Scott, "and I've yet to have a bad deal."

Then Scott MacKenzie began the arduous task of making his '59 Fleetside as authentic as possible. Scott knew that his biggest problem would be replacing the seat covers, which were in tatters. After months of searching, he located a bolt of the original fabric in Oregon and had seven yards of it shipped to Vermont at $35 per yard. This enabled him to complete the restoration, which cost him around nine thousand dollars. "I've never made any money on any of my trucks," says Scott, "but that's okay. The way I look at it, I'm preserving the past."

*Engine: Chevrolet Optional 348*

No one would deny that. Although it's hard to believe, Scott MacKenzie's '59 Chevy Fleetside is one of sixteen restored Chevrolet pickups that Scott owns, all manufactured between 1955 and 1959. "I count them every morning," Scott says, laughing, "to make sure they haven't multiplied overnight."

# Jerrol Foster's 1960 Chevrolet El Camino 1280

**Nineteen-sixty not only marked the beginning of a new decade, it signified the start of a new design in trucks.** From any angle, Jerrol Foster's El Camino looks more like a rocket ship than a pickup—which suits its owner just fine.

Fifty-one-year-old Foster got his El Camino because it took him back to his high-school days, when the smoothest guys drove vehicles that looked like they were headed for Mars. "The Chevy transmission was something else," laughs Jerrol. " 'Slip and slide with Powerglide,' we used to say."

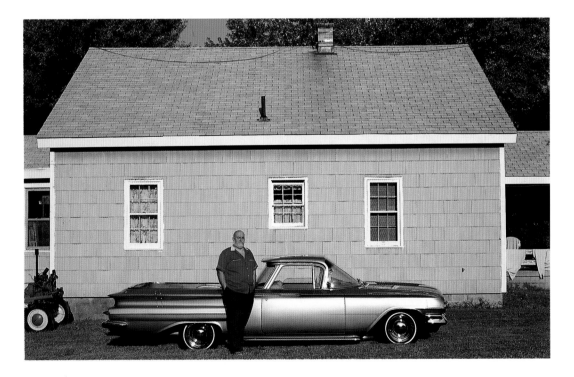

*Engine: Chevrolet 283 Power Pack*

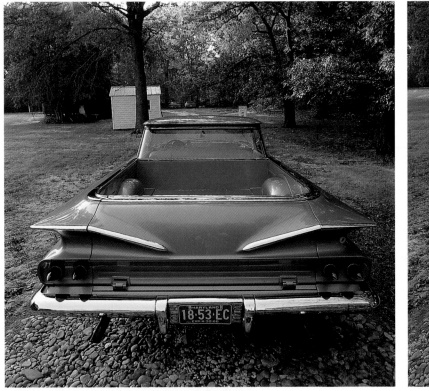

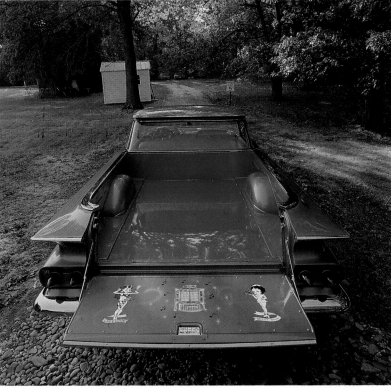

Like most red-blooded American males back then, Jerrol yearned for his own personal rocket ship, even though he couldn't afford it. A few years ago, Jerrol decided to ease his pain. He took an ad in *Hemmings Motor News,* seeking to find a 1960 El Camino. When a Chicago man responded, Jerrol hopped a train and arrived in the Windy City two days before Christmas. The long trip was worth it. The El Camino was the pickup Jerrol had been fantasizing about ever since high school.

After the snows cleared in May, Jerrol Foster forked over $3,500 and trailered the pickup back to his home in Friendly, Maryland. It took Jerrol three years and more than $24,000 before he was through customizing. He shaved the hood, deck, and door handles to give it a cleaner look, put in a tube grille, and replaced the taillights with ones from a '59 Caddy. "I fixed it up just like we did in high school," Jerrol says proudly. "When I drive it to truck shows, I turn the radio to an oldies-but-goodies station and slip and slide down the highway. It's like a little time machine."

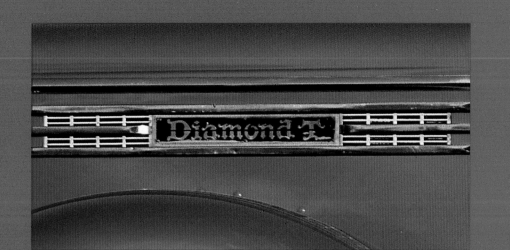

Diamond T

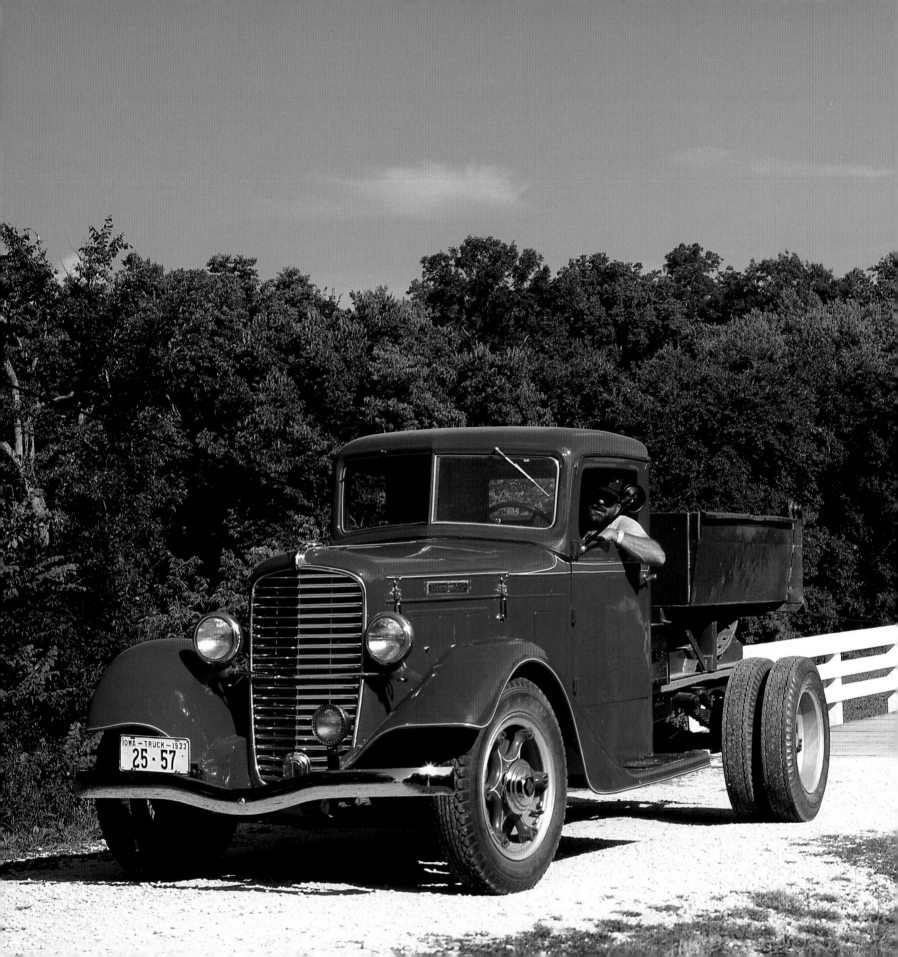

# Lee Snyder's 1934 Diamond T 211 FF

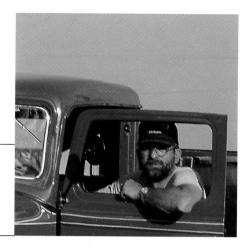

**L**ee and Deanette Snyder of Minburn, Iowa, share a common interest. Says Lee, "We both collect things that are old, rusty, and heavy." In the case of wife Deanette, that means cast-iron kitchen utensils. With Lee, it's Diamond T trucks.

Lee found his 1934 Diamond T ten years ago. It was sitting in a creek pasture east of Yale, Iowa, and its bumper had a tree growing through it. The tree trunk was six inches in diameter, so Lee figured that the Diamond T had been there for at least thirty years.

Lee paid the farmer who owned it $500, extracted the pickup from the tree and took it back to his garage. The restoration—Lee's first—took four years and cost $20,000, a quarter of which went for chrome. Lee had such a good time doing it that he became a serious collector of Diamond T's. Today he owns a dozen of them, including a '35 bus and a '32 pickup with a wooden cornsheller. Lee says he likes the Diamond T because it's considered "the Cadillac of trucks, with more chrome, bigger frames, and better styling than other trucks of its day."

What began as a hobby for Lee is now a business. As his reputation spread, people started bringing Lee their old pickups to restore. Although Lee specializes in Diamond T's, he'll work on other pickups too. But Lee warns that it isn't cheap. "If you're willing to buy a brand-new truck off the lot," he says, "then we can start talking price." Lee's average restoration runs $25,000 and takes a year to complete.

Incidentally, Lee Snyder's '34 Diamond T is photographed on Roseman Bridge, made famous by *The Bridges of Madison County.* Not shown are the gift shop and the hordes of tourists in search of Clint Eastwood and Meryl Streep, who weren't there either.

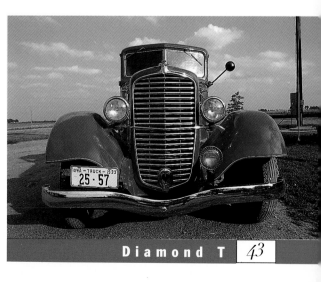

*Engine: Hercules flathead six-cylinder*

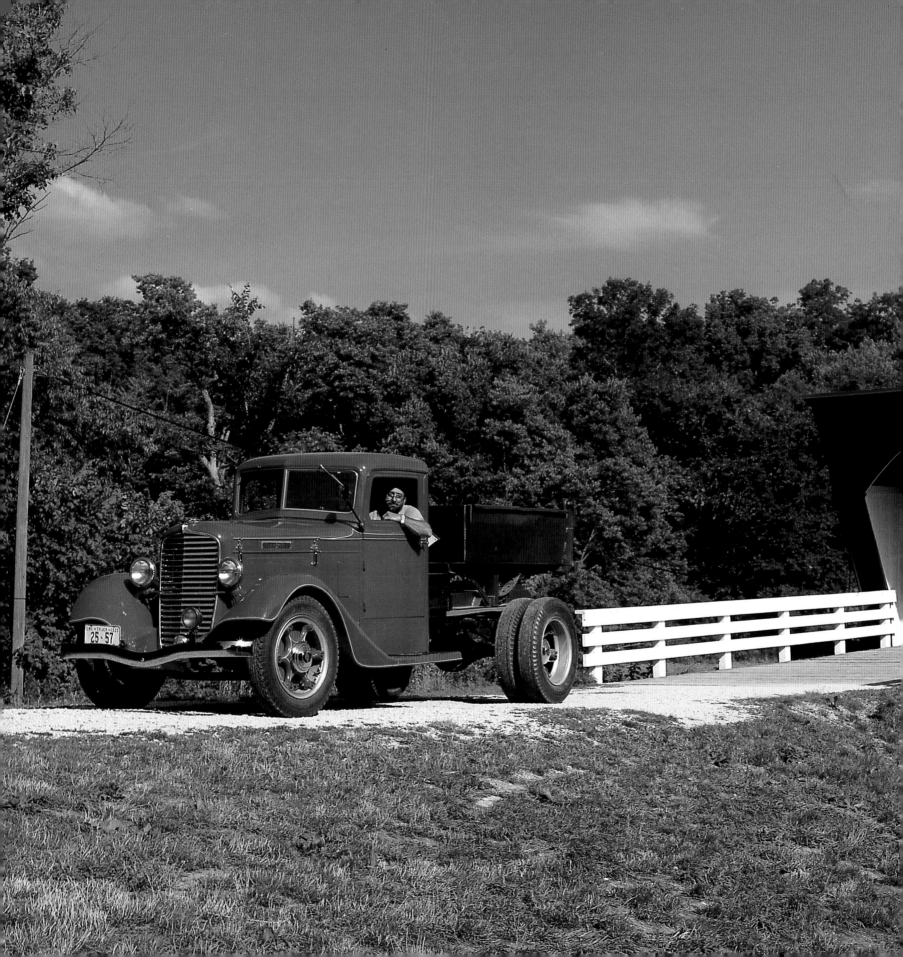

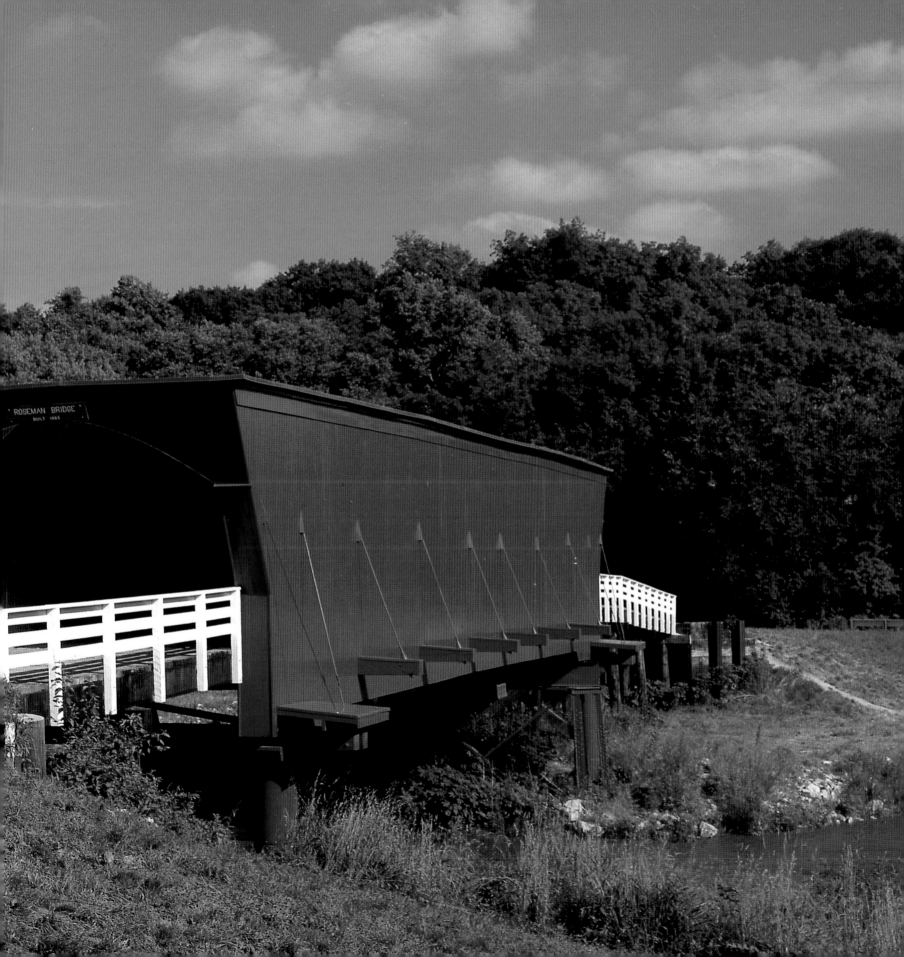

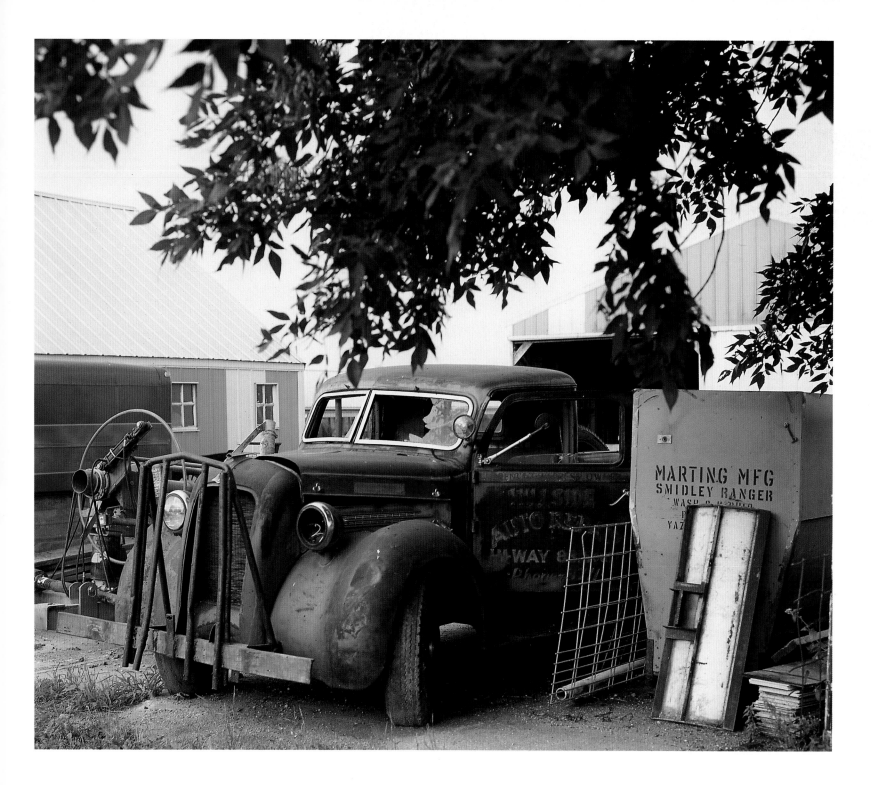

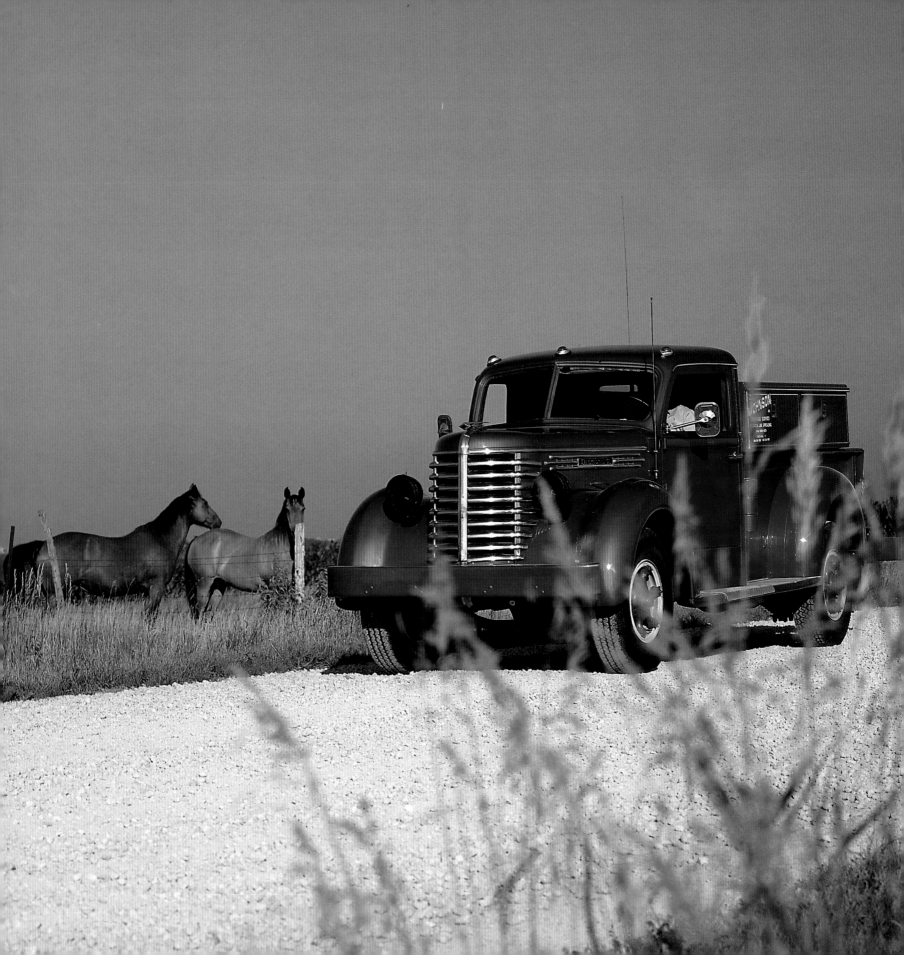

# Carl Johnson Jr.'s 1949 Diamond T 201

**C**arl Johnson's deep country drawl makes you understand why pickup trucks are peculiarly American. "They're basic to rural people's lives," Carl says. "If you don't have a pickup, then you can't haul livestock or hay or fertilizer, or get rocks out of a field. For a lot of folks, their pickup is their car. They depend on it for chores and errands and they drive it to church on Sundays. It's part of who they are."

Pickup trucks are also part of Carl Johnson, Jr. Carl, who is fifty, grew up on a farm in rural Cynthiana, Kentucky, and lives there still. "My dad had a bunch of Diamond T's," Carl says, "so I knew how good they were. You paid more for one than a Chevy or a Dodge, but in the end it was worth it."

Carl had been looking for a Diamond T ever since he got out of the service in 1968. Ten years later, Carl spotted an ad in a motor news publication from a man in Missouri who had a one-ton Diamond T for sale. It was a 600-mile drive, so Carl wouldn't go until he got a letter from the man's lawyer saying that "what the ad said about it was true." Carl wasn't disappointed. The pickup was in good condition and had only 54,000 miles on it. Carl tore it down, sandblasted the body and completely restored it. After showing it for many years, Carl is now using his '49 Diamond T in his hauling business, which is pretty much in keeping with what Diamond T wrote in its owner's manual way back when: *Diamond T Motor Trucks are designed and built to give satisfactory performance at minimum cost for an indefinite period of time.*

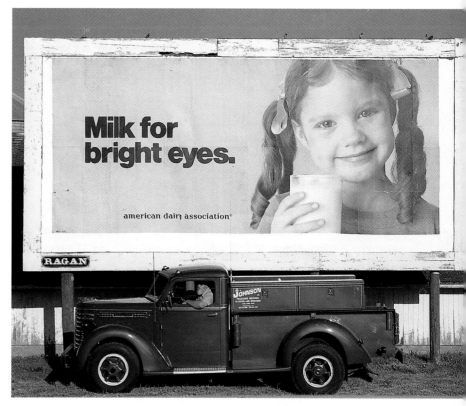

*Engine: B. T. Cummins four-cylinder diesel*

# Steve Solley's 1941 Dodge WC-1

**S**teve Solley farms hay in Washington, Connecticut. That's one of his fields behind his truck. Steve has painted the truck red, but its original color was army green. There's a reason for that, as Steve, who's a military history buff, tells you: "Dodge built the truck as a troop carrier. Altogether, more than half a million were made. This particular truck was one of the first off the assembly line. It was shipped to England. From there it went to North Africa, where it was used by the British against Rommel."

The truck's official nomenclature goes as follows: *A half-ton, closed-cab, four-wheel-drive pickup.* That doesn't capture what it must have been like to steer it through the sands of the Sahara while being fired on by Rommel's marksmen. "When ammo comes into an enclosed cab it ricochets," Steve explains. "That means if it doesn't get you the first time, it has a good chance of getting you the second."

It took Steve Solley several years of searching to find his pickup, which was parked in the driveway of a man who lives somewhere in Pennsylvania. Steve won't get any more specific than that. "The guy wasn't aware he owned a piece of history. I felt like I'd discovered a Rembrandt in someone else's attic."

*Engine: Dodge six-cylinder*

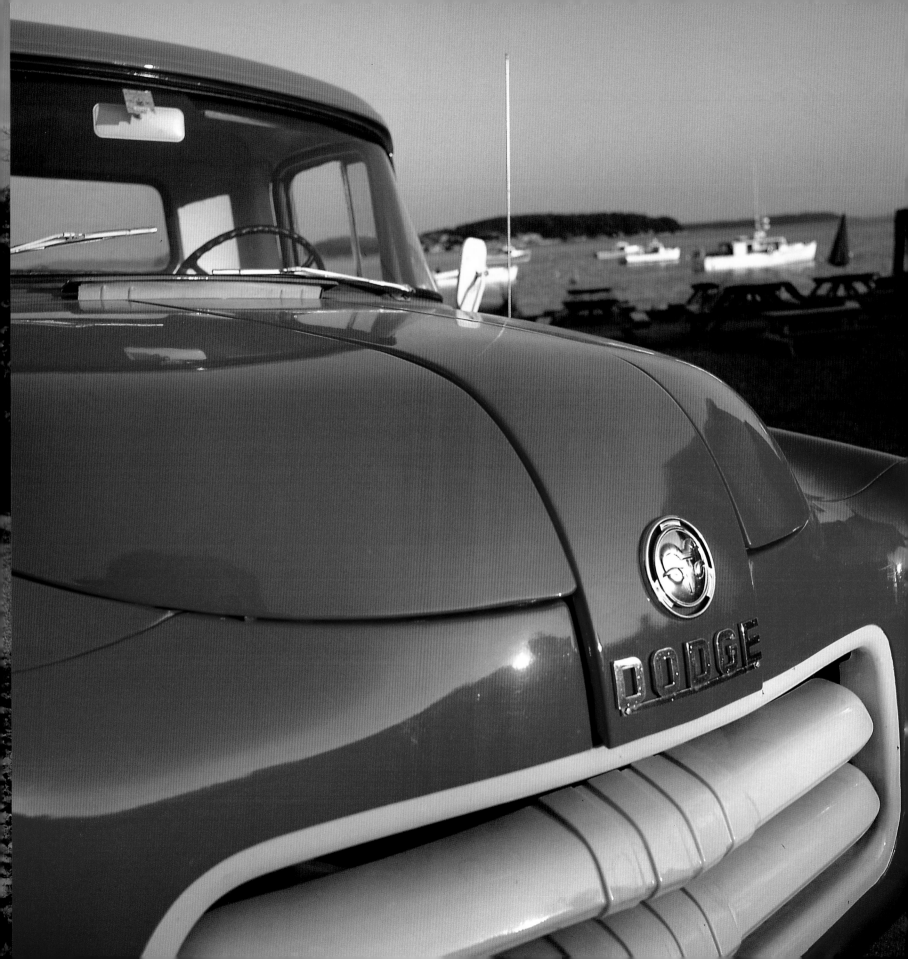

# Vern Seile's 1956 Dodge C-4-B

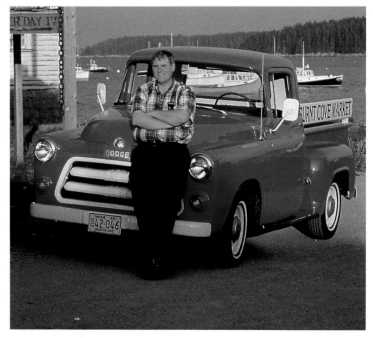

**V**ern Seile got his '56 Dodge for practical reasons. He needed a pickup for his store, the Burnt Cove Market, in Stonington, Maine, and a new truck would have cost Vern a minimum of $10,000.

Then Vern got word that a local garage was looking to sell the Dodge for a couple of thousand dollars. Vern looked at it, bought it, and spent an additional $2,500 on paint and body work. The hand-carved BURNT COVE MARKET sign you see on the rear of the pickup was made by Vern himself. "People like looking at old pickups," Vern says. "I thought it would be good advertising."

Vern's son and daughter didn't see it that way. They pointed out that the truck was almost forty years old and could fall apart at any moment. "My kids thought I was crazy when I bought it," Vern admits. "They thought I'd lost my marbles for sure."

But that was before actor Mel Gibson came to town. It turns out the superstar was filming *The Man Without a Face* in Stonington (pop. 2,500) and had seen Vern's pickup. The next thing you know, Mel Gibson saunters into Vern Seile's market to buy staples. (Vern was out at the time, but says that the visit caused quite a commotion.)

Shortly thereafter, one of Gibson's prop men arrived at Vern's door looking for mutton. "There's this scene in the movie where Mel Gibson cooks up a leg-of-lamb supper," says Vern, "and his dog takes it off the platter before anyone can eat it." Vern showed the prop man his choicest leg of lamb, which the fellow promptly purchased, along with two

*Engine: Dodge six-cylinder V-8*

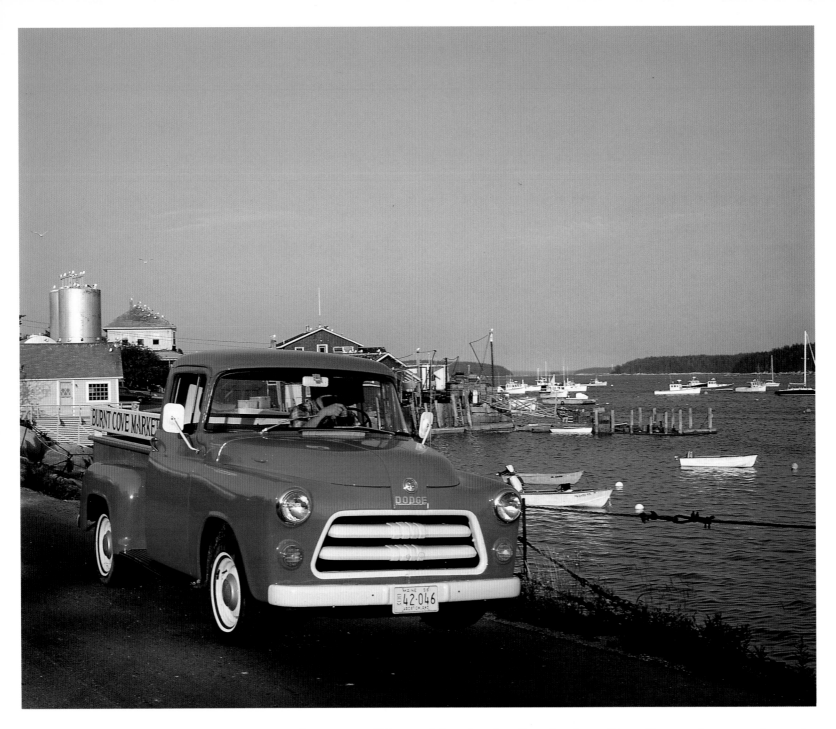

dozen more. "They said they do a lot of retakes," says Vern. "I guess they wanted to make sure they had enough."

Now, would Vern Seile have sold twenty-five legs of lamb and had Mel Gibson visit his store if Vern's pickup was a brand-new one? The only reason Vern didn't ask his kids that question is because he's a real nice guy.

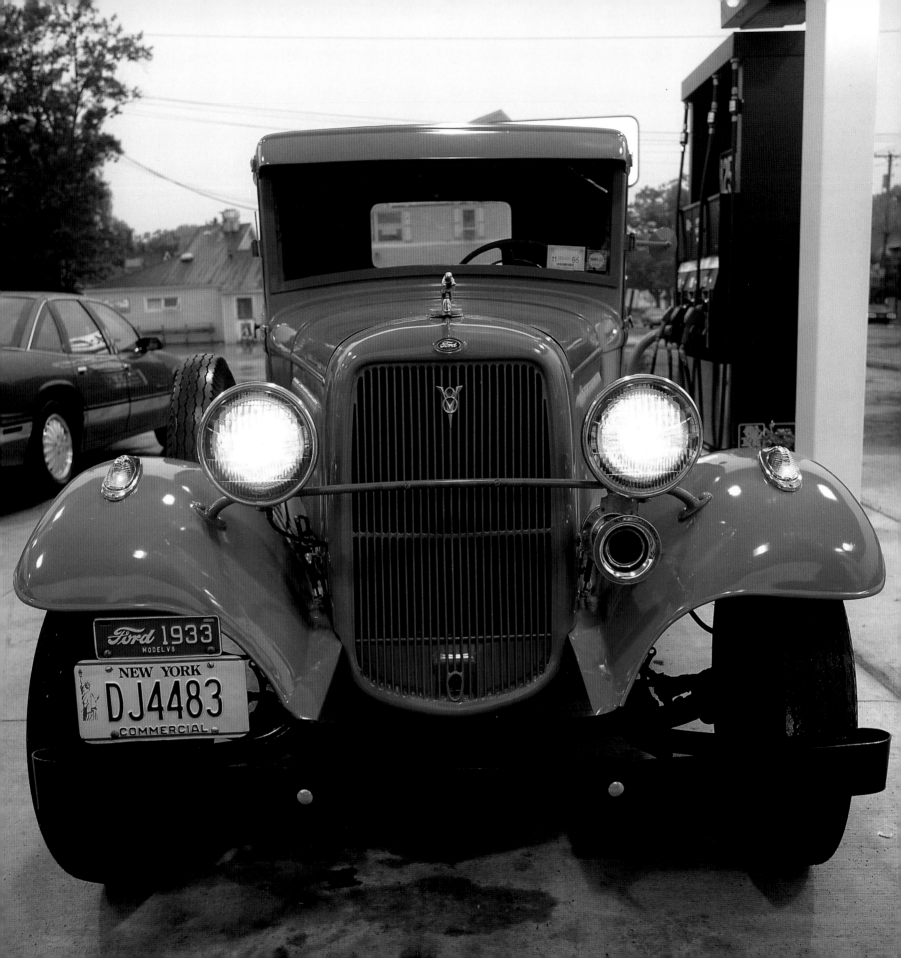

## Bob Groll's 1933 Ford V8

**B**ack in 1954, Bob Groll was looking for a pickup truck he could use for chores. In a field not too far from his house was the Ford V-8. After passing it a dozen times and more or less admiring it, Bob's wife said, "Why don't you see if it's for sale?"

It was. Bob paid the plumber who owned it $35, which Bob thought was a fair price, considering that the windows were cracked and the vehicle was in a general state of disrepair. So Bob Groll fixed what was broken and set about using his Ford—for the next forty-two years. Bob has four kids, and all of them learned to drive in it . . . each of them complaining bitterly that it didn't have an automatic transmission.

About seven years ago, one of Bob's sons "pushed me into restoring it," which Bob then did. Although Bob Groll is happy with the results, he is no perfectionist. "I bought it because I wanted something to drive. That's still the way I feel. I don't want to own a showpiece."

Bob Groll grudgingly admits that his "semi-restored" 1933 Ford pickup is turning some heads in Clarence, New York, where he lives. (Clarence is a suburb of Buffalo, although Bob insists it used to be the other way around.) "There are some famous people

from Clarence," says Bob. "One is Wilson Greatbatch, who invented the cardiac pacemaker."

When asked to name another Clarence celebrity, Bob is quick to respond. "Robert Groll," answers Bob, his tongue planted firmly in his cheek.

*Engine: Ford V-8*

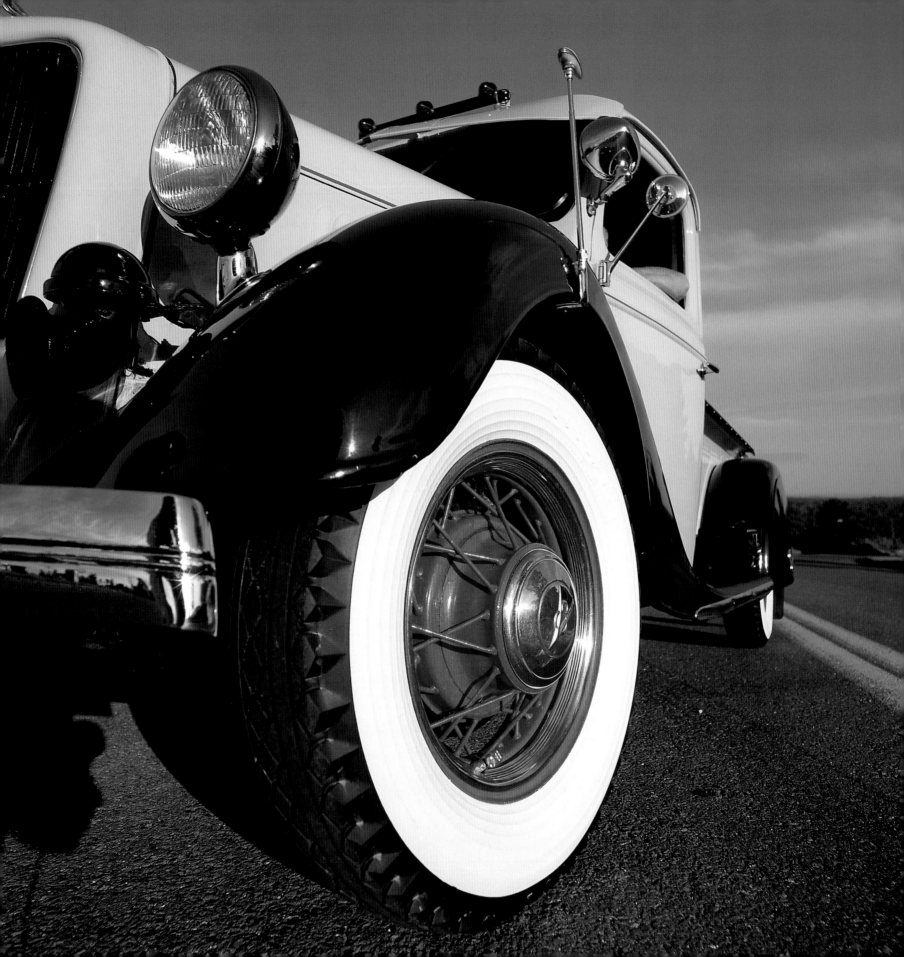

# Dick Conklin's
# 1935 Ford V8 50-830

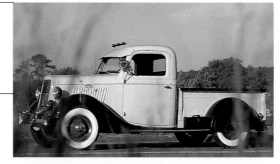

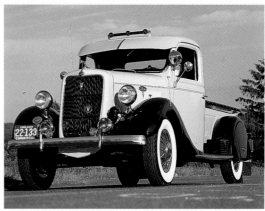

**W**hen Dick Conklin takes his '35 Ford pickup to an old car and truck show, the most wistful responses invariably come from the old-timers. The dialogue goes something like this: "Nice pickup you got there, son. Used to have one myself. Dropped the rear end just like you did, gave it a new paint job, then cruised Main Street looking for girls." At which point the old-timer sighs, pats the truck, and ambles off into the sunset.

The response pleases Conklin no end. That's because his Ford V8 is an idealization of what a teenager from the forties might have done with his dad's old pickup. And Dick Conklin didn't stop there. He turned his garage into a kind of forties shrine, complete with period gas pump, hub caps, oil cans, headlights, and old automotive ads. Even Conklin's wife has gotten into the act. She's made a macrame V8 emblem into a seat for an aluminum folding lawn chair that they take with them to shows.

Dick Conklin paid $8,000 for his pickup. "When I got it," he says, "it had four wheels and it drove." So Conklin put another $4,000 into it, replacing the doors, windows, wheel cylinders, shocks, gauges, and tires, and rechroming everything until it glistened.

Was the expense worth it? "Which would you rather do?" Dick Conklin says. "Drive a hot rod or look at your bank book?"

*Engine: Ford V-8 flathead*

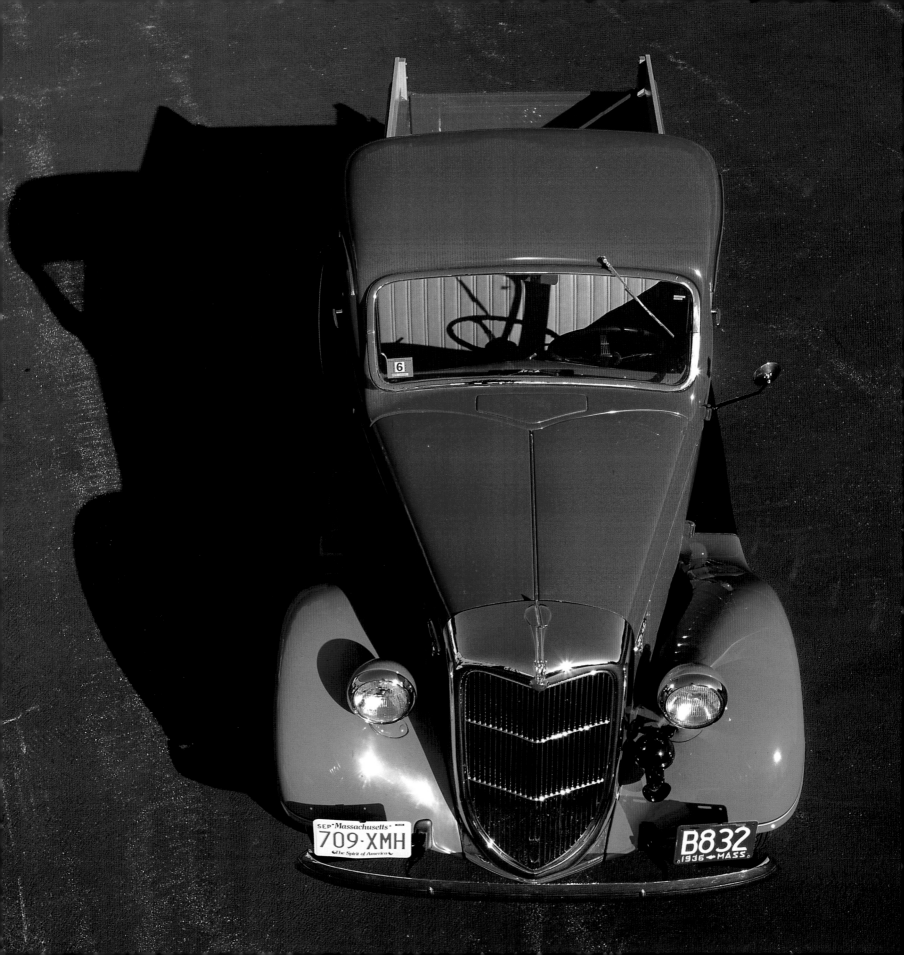

# Tom Ahearn's 1936 Ford 830

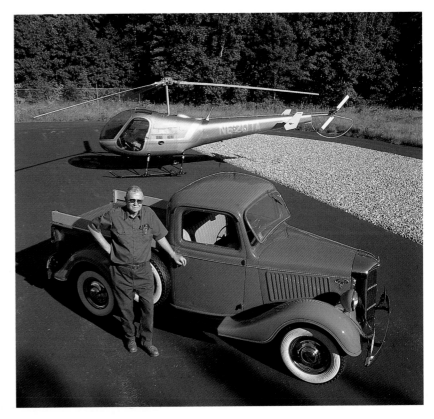

I like trucks," says sixty-nine-year-old Tom Ahearn of Ludlow, Massachusetts. As it turns out, this is something of an understatement. Tom spent his life in the trucking business, where he started small, hauling "garbage, rodeo bulls, pottery, sand and gravel, you name it, all over God's creation."

Eleven years ago, Tom sold his thirty-five-truck sanitation fleet. The proceeds allowed him to devote even more time to his passion for trucks. Tom's initial effort was restoring a huge 1927 Mack chain-drive dump truck, in which Tom decided "to go for broke." Before he was through, Tom had driven 30,000 miles looking for parts and spent upwards of $100,000 on his Mack. Ahearn—who's been happily married for forty-seven years—has never once regretted the expense. "If I go to the nineteenth hole, pick up some broad, and get in trouble," he laughs, "it's going to cost me a lot more than that."

Tom's '36 Ford, which took him a year and a half to restore, is his only pickup. Tom got it because he had fond memories of putting 400,000 miles on a '36 Ford dump truck he once owned. Tom thinks that his Ford originally came from Montana, but he doesn't know anything more about its past. Nor does Tom remember what he paid for it. "After spending all that money on the Mack," Tom explains, "I decided I didn't want to know how much anything else was going to cost."

*Engine: Ford V-8*

The Ford's turquoise and red colors were chosen because all of the vehicles in Tom's sanitation fleet were painted that way. "I've been to forty-five states and thirty-seven countries," he says, "and I've never seen that particular color combination."

Incidentally, the expensive-looking helicopter behind Tom Ahearn's pickup also belongs to him. "I'd been a fixed-wing pilot for years," Tom says, "and when I sold the business I needed a challenge. That's why the mountain is there, right?"

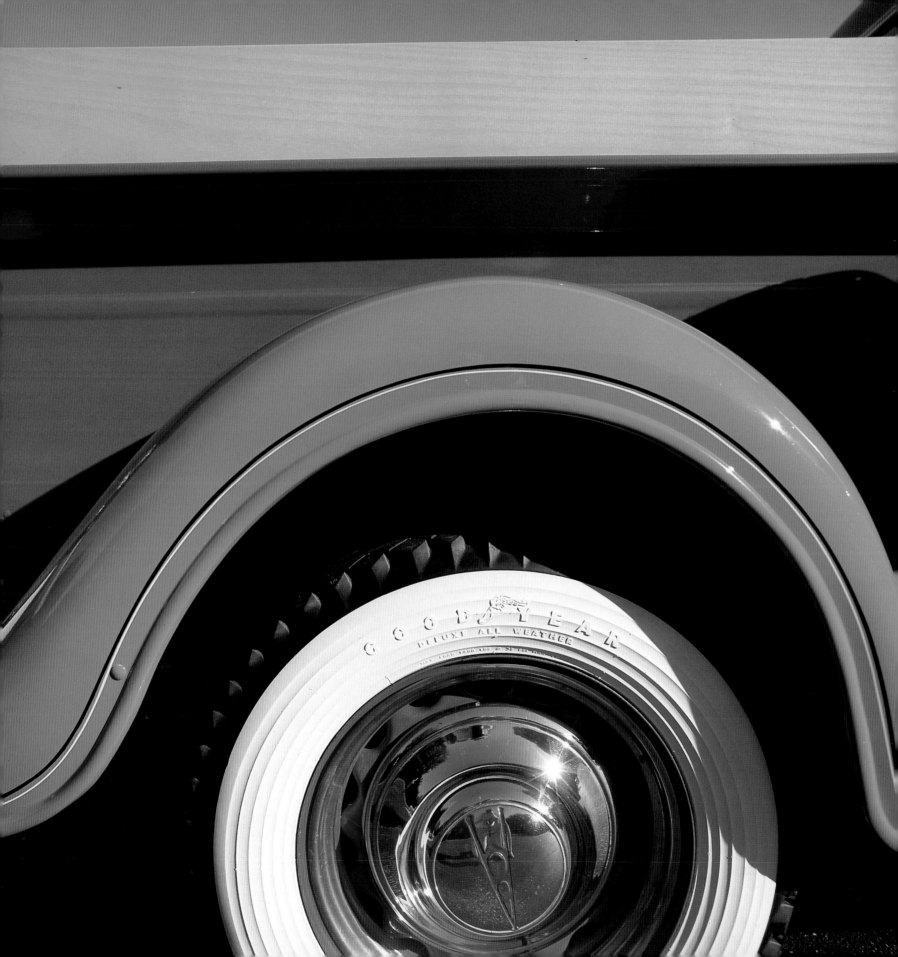

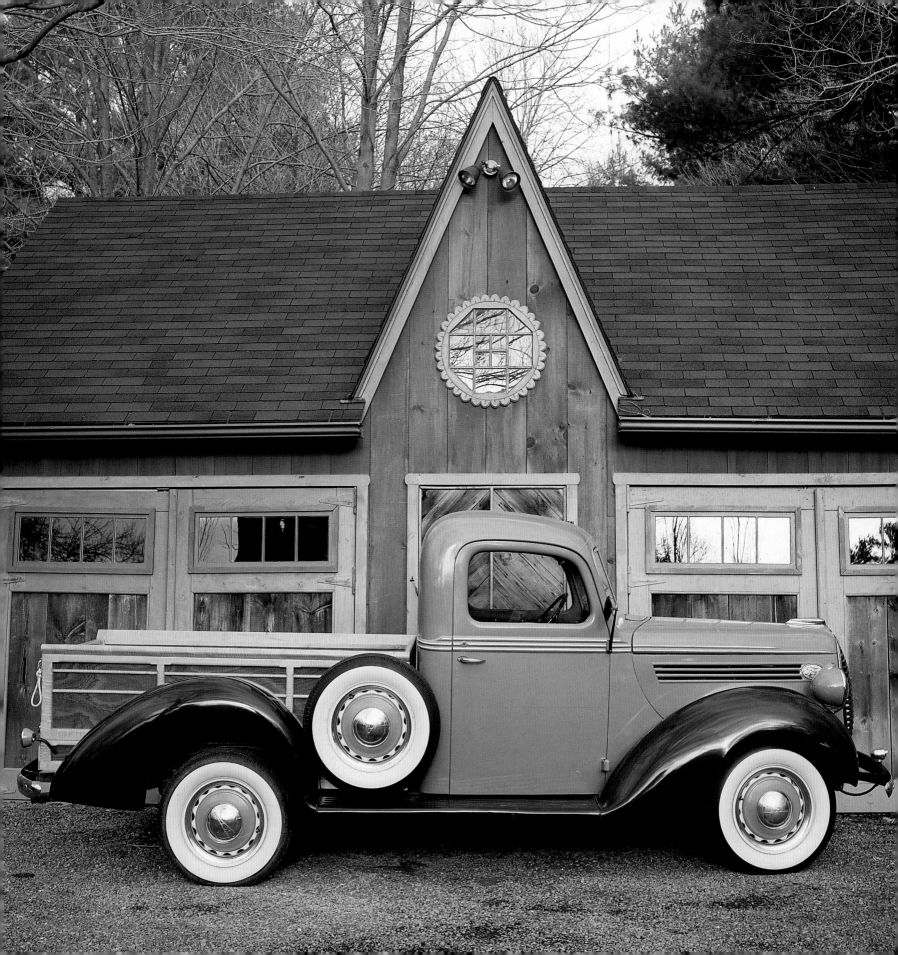

## Tommy Simpson's 1939 Ford 92D

**T**ommy Simpson used his pickup to pick up his future wife. Tommy—who designs and makes furniture—was teaching at a workshop in New Hampshire. Missy Stevens was weaving in an upstairs studio. As luck would have it, Tommy pulled up in his truck at the precise moment Missy looked out her window. Missy says it was love at first sight . . . not Tommy but Tommy's truck.

Later, Tommy asked Missy for a date. She accepted on the spot. Says Missy, "I figured any man who drove a truck like that was someone I needed to know."

Tommy Simpson found his 1939 Ford sitting in a farmer's field in Virginia. "Its lines were so beautiful," he says, "and it was rusting away. I felt I had to rescue it." So Tommy bought it from the farmer for a few hundred dollars and set about restoring it. He painted his truck an elegant gray and green and built the beautiful wooden paneling that goes around it. Finally, Tommy replaced its rusted-out engine with one from a Ford Bronco.

"This is not a pickup for purists," admits Tommy Simpson. "About the only mechanical part left from the original version is the hydraulic brakes, which Ford used for the first time in this model. Otherwise, it's pretty much my fantasy."

*Engine: '73 Ford Bronco*

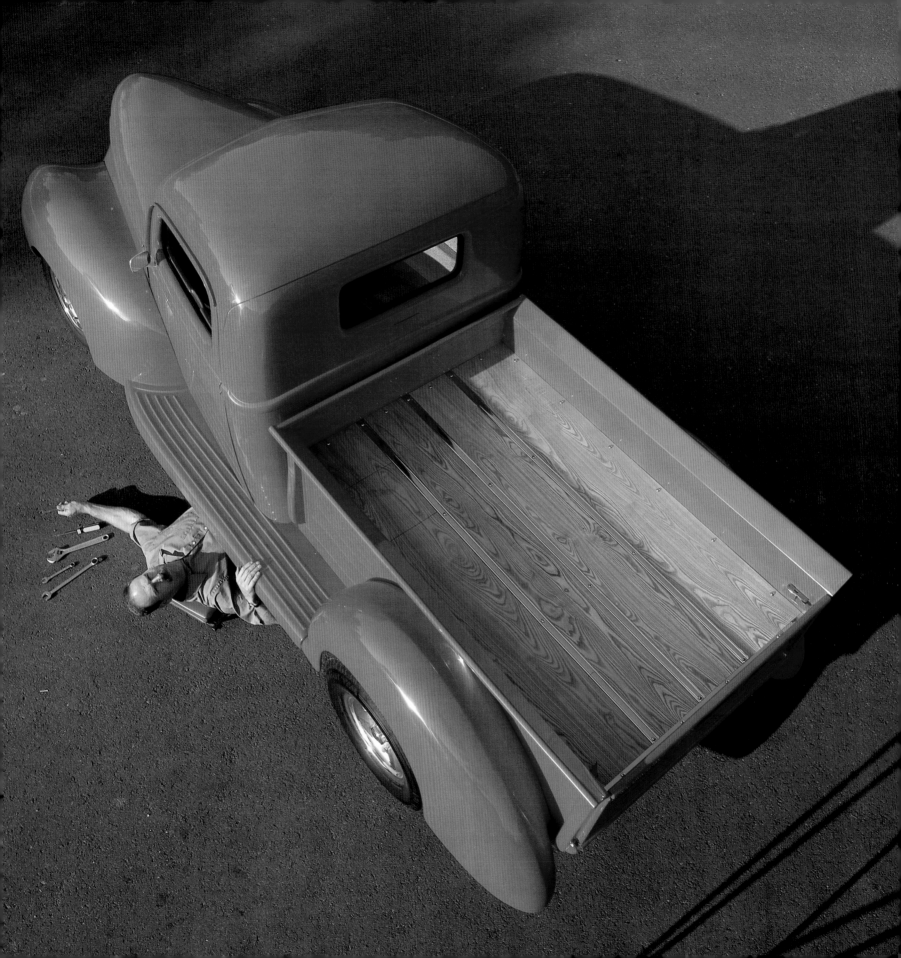

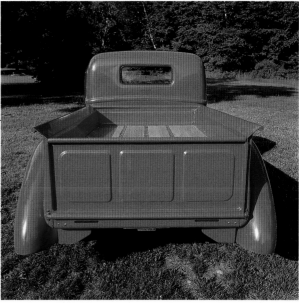

# Mark Averill's 1941 Ford 11C

**M**ark Averill's '41 Ford is what is known as a street rod . . . mostly old on the outside and a brute underneath the hood.

Averill, who owns a garage in tiny Washington Depot, Connecticut, bought his '41 Ford pickup for $3,000 in 1990. It took him four years and hundreds of hours of work to get it just the way he wanted. What's amazing is how modern its lines are. Mark accomplished that by taking three inches off the roof and lowering the front and back ends of the pickup. The sleek look comes from eliminating all hinges and door handles and replacing the old metal bed with one of white ash and chrome. Almost everything else on the truck's fifty-five-year-old body is original, including the sweeping fenders and the extra-wide running boards.

Pop the hood and it's a different story. The engine—detailed in chrome and polished aluminum—comes from a '74 Ford Mustang. Mark pirated the steering column from an '81 Pontiac Firebird, and he took the independent suspension from a '67 Jaguar sedan.

Mark's pickup is—as they say in those car commercials—fully loaded: power windows, power doors, air, cruise control, disc brakes, AM/FM cassette deck in a custom-made console, and a vacuum-operated license plate that disappears from view when the truck is in park.

According to its speedometer, Mark Averill's '41 Ford can go 160 miles per hour. Mark says he wouldn't know about that—he's never had it past 120.

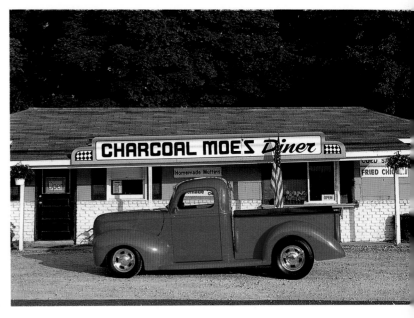

*Engine: '74 Mustang V-8*

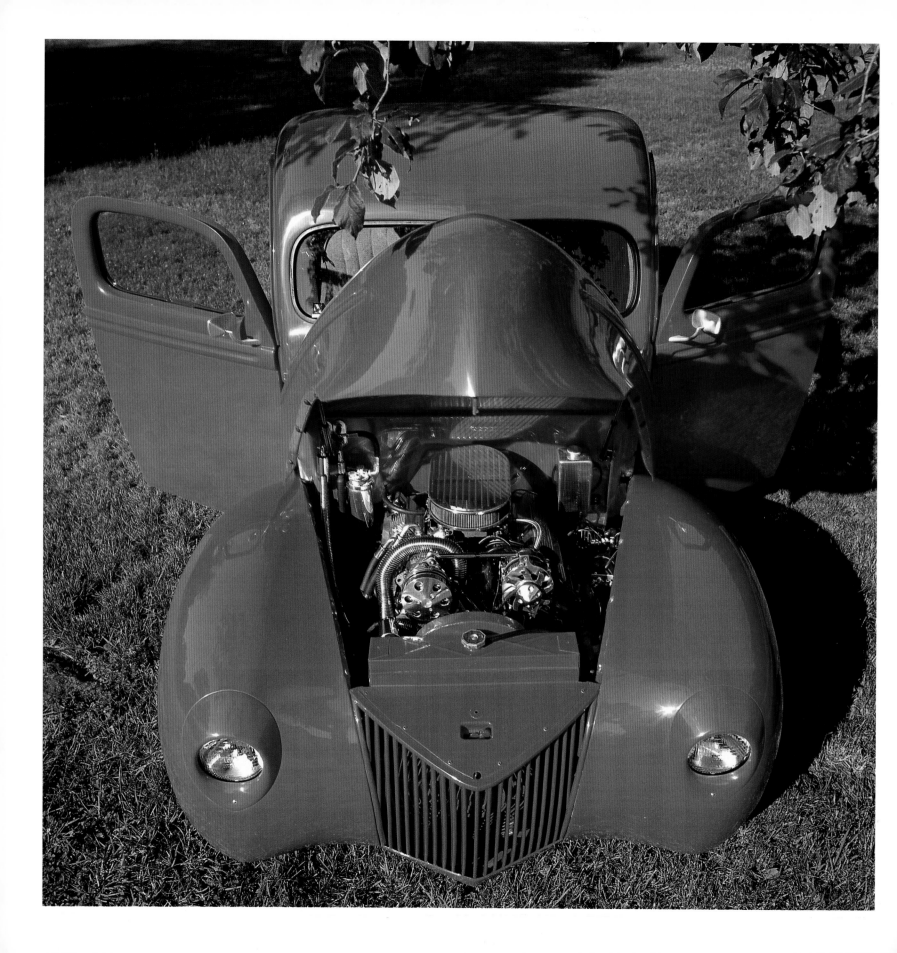

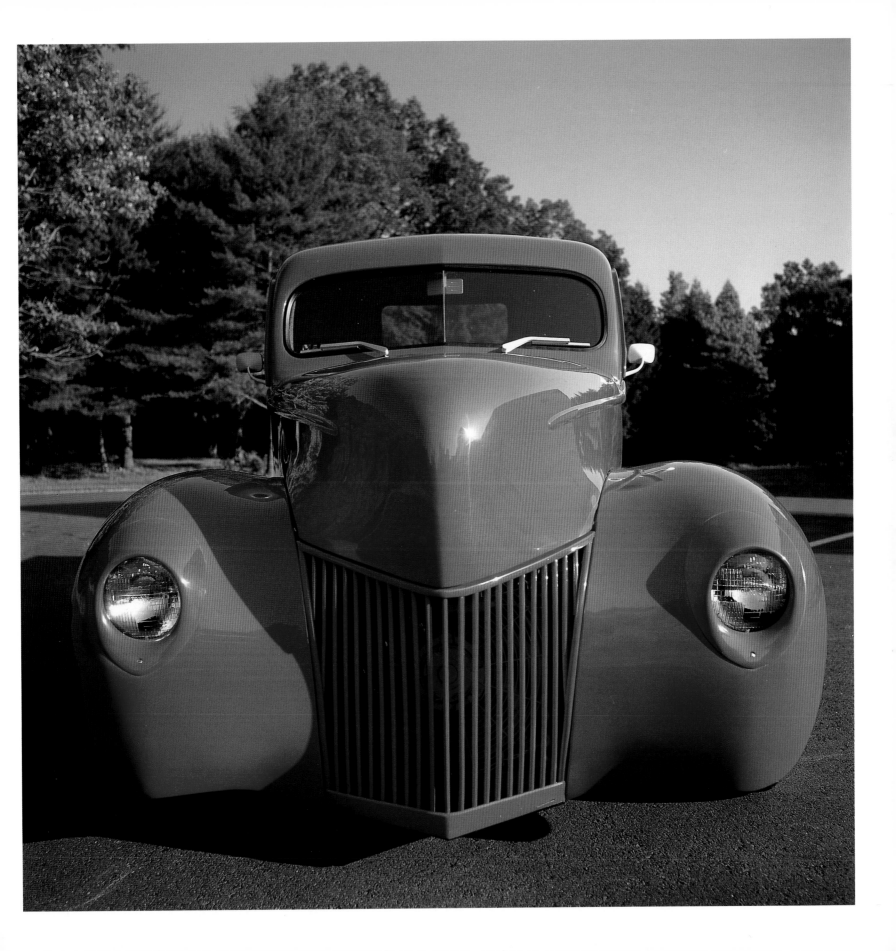

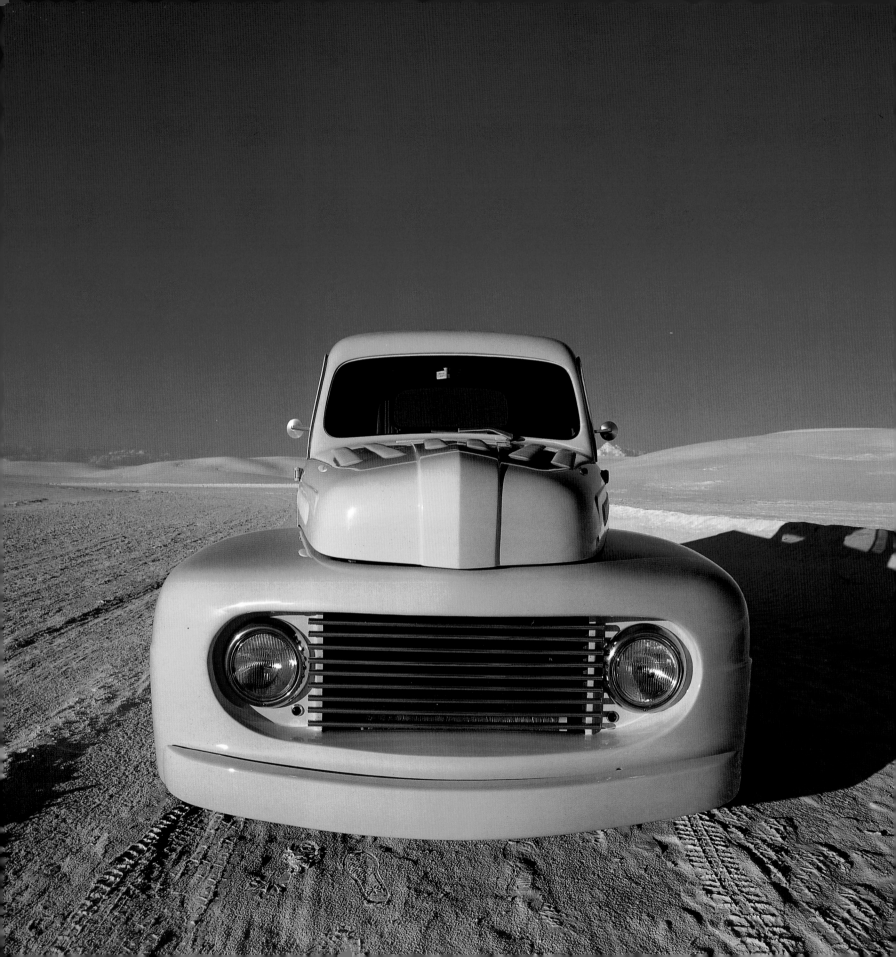

# Bob Nall's 1948 Ford F-1

**E**ver since he was a boy growing up in Marshalltown, Iowa, in the fifties, Bob Nall has been fascinated with old vehicles. Bob learned about them from his father, who was a body man in a local garage. Then Bob went into business for himself. In his senior year in high school, Bob restored more than sixty cars for various friends. "I was doing so much business," Bob says, "that the State made me get a dealer's license."

Later in life, Bob moved to New Mexico and opened a bar. By this time, tinkering with cars and trucks was back to being a hobby. "It was therapy," Bob admits. "I did it to get away from the drunks."

Then as word of Bob's skill began to spread, Bob decided to take the plunge full time. In 1981, he sold his bar and opened his current business, the Adult Toy Factory in Las Cruces, New Mexico. There Bob converts old trucks and cars into street rods—meaning that you hang on to the body and replace most everything else.

Bob found his '48 Ford pickup in Dona Ana, New Mexico, where he bought it for $500. Then Bob started making changes. "The body style was kind of snouty," he says. "It looked like a pig going down the road." Forty thousand dollars later, Bob's truck no longer resembles a porker. "One guy wanted to trade me his brand-new Cadillac for it even up," says Bob. "I wasn't tempted. My Ford rode better."

Bob Nall runs the Adult Toy Factory with his wife, Kathy, who has become an old car and pickup expert in her own right. "When we met, she worked in a bank and drove a Toyota," Bob remarks. "I turned her around real quick."

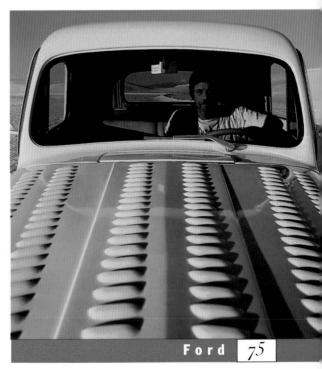

*Engine: Chevrolet 413 C.I.*

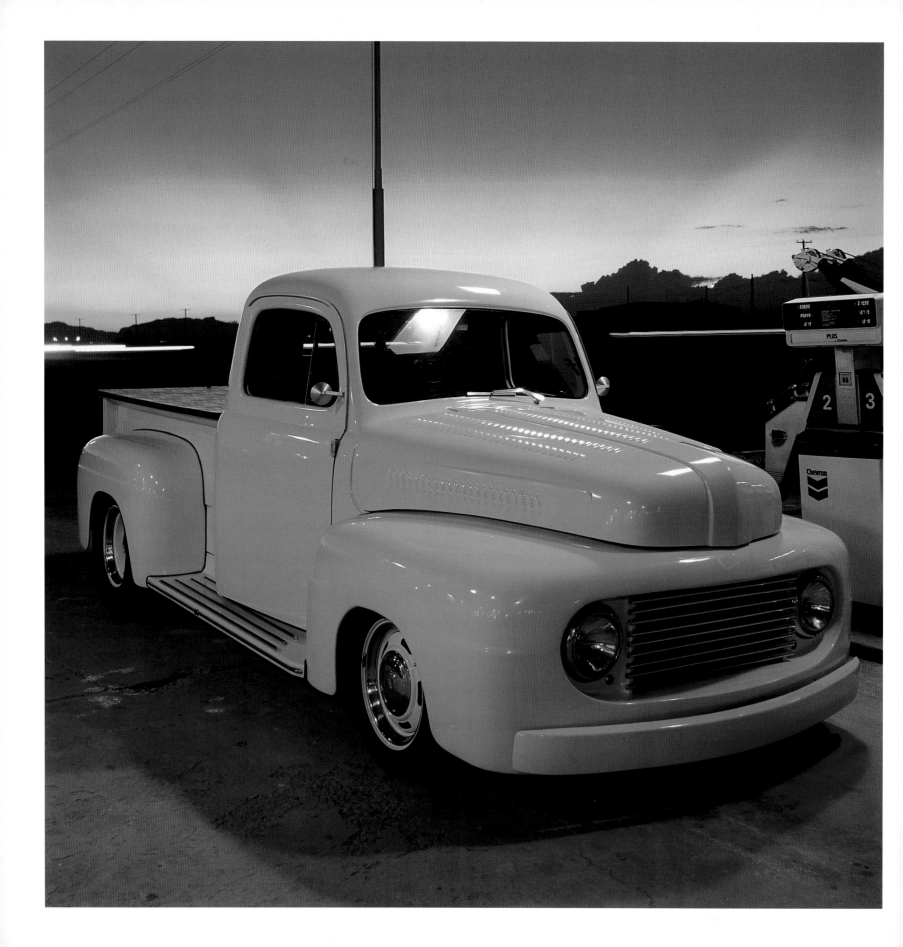

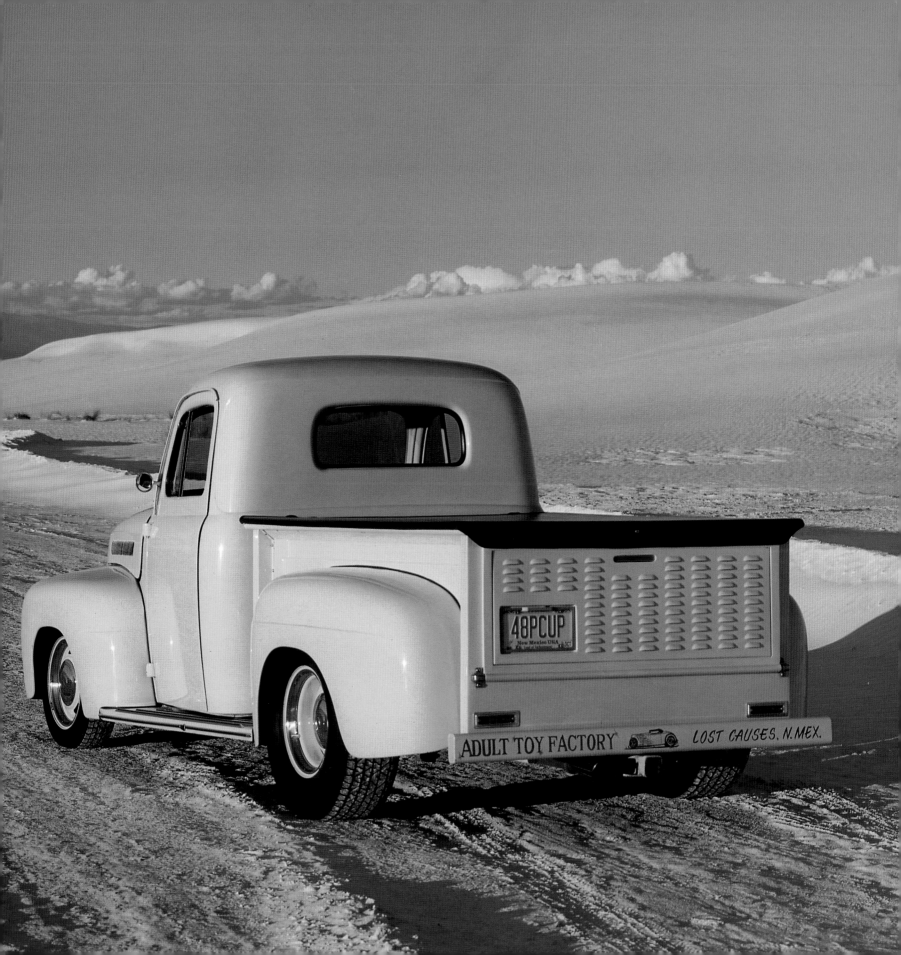

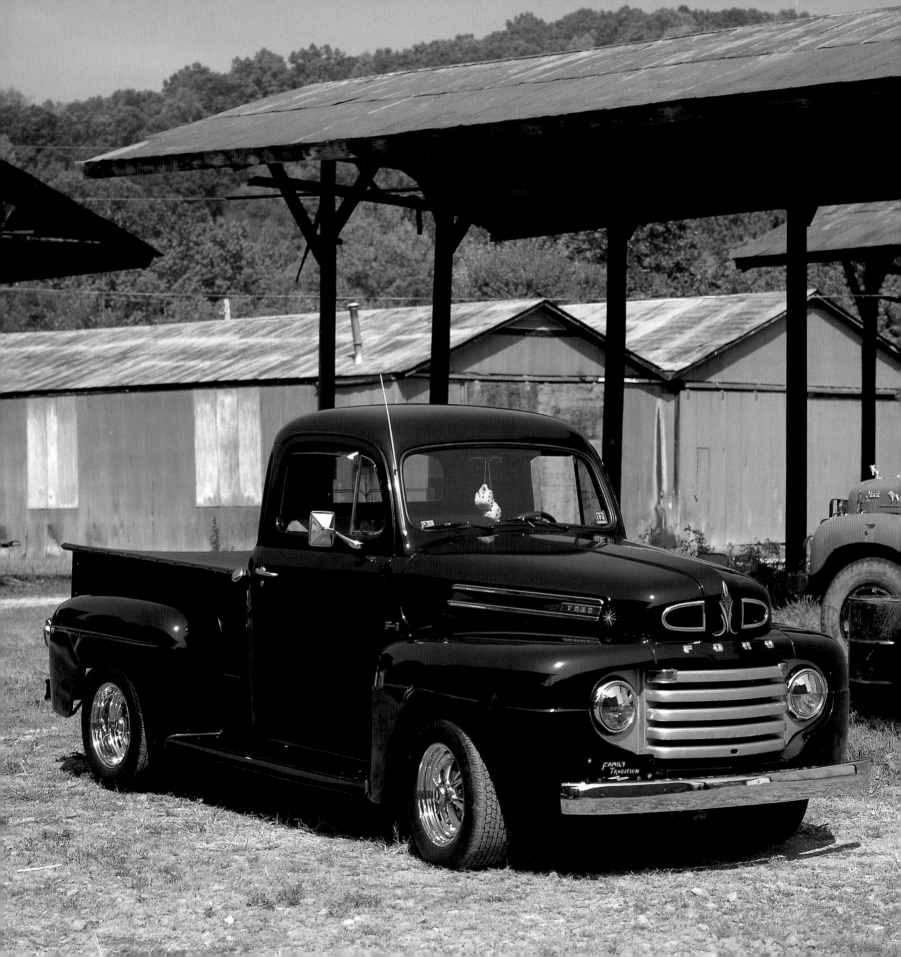

# Charlie Schoolcraft's 1950 Ford F-1

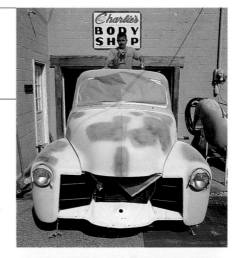

**T**wenty-six years ago, Charlie Schoolcraft's father paid $500 for the Ford pickup. The plan was to use it as a truck for his collision and body shop in Clendenin, West Virginia.

But the old Ford wasn't in good enough shape to drive every day, so Charlie's dad decided to sell it. That's when thirteen-year-old Charlie rebelled. "I said 'no way,' " remembers Charlie. "I wasn't going to let him get rid of that truck."

Seeing that Charlie meant business, the father told the son he could keep the truck if he paid him back for it. When Charlie pointed out he didn't have that kind of money, his dad told him he could earn it by working at the shop. Charlie agreed. By the time his feet could reach the pedals, Charlie owned the truck.

When Charlie was sixteen, he'd learned enough from his father to begin the daunting task of restoring his Ford from the frame up. Charlie lowered it a couple of inches, got rid of the dents, and added rack-and-pinion steering and a new engine. Finally, he painted it black. For Charlie—who had taken over the body shop when his father died—the color was the only possible choice. "My dad always said, 'If you got a truck that's black and it looks right, then everyone knows what you got.' In other words, if your vehicle has defects, paint it anything but black."

About ten years ago, Charlie decided to give his '50 Ford a new paint job. This time, he chose a color called "black cherry," which he'd admired on an '85 Cadillac. "It isn't a true black," admits Charlie, "but it's close enough so that I feel my dad would approve."

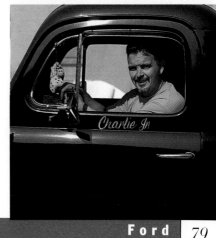

Recently, Charlie Schoolcraft began restoring a '46 Studebaker pickup, which he's doing out of necessity. "My eleven-year-old boy has already said he's eager for the Ford. I told him when his feet could reach the pedals he could have it."

*Engine: '73 Ford 302 4-Barrel*

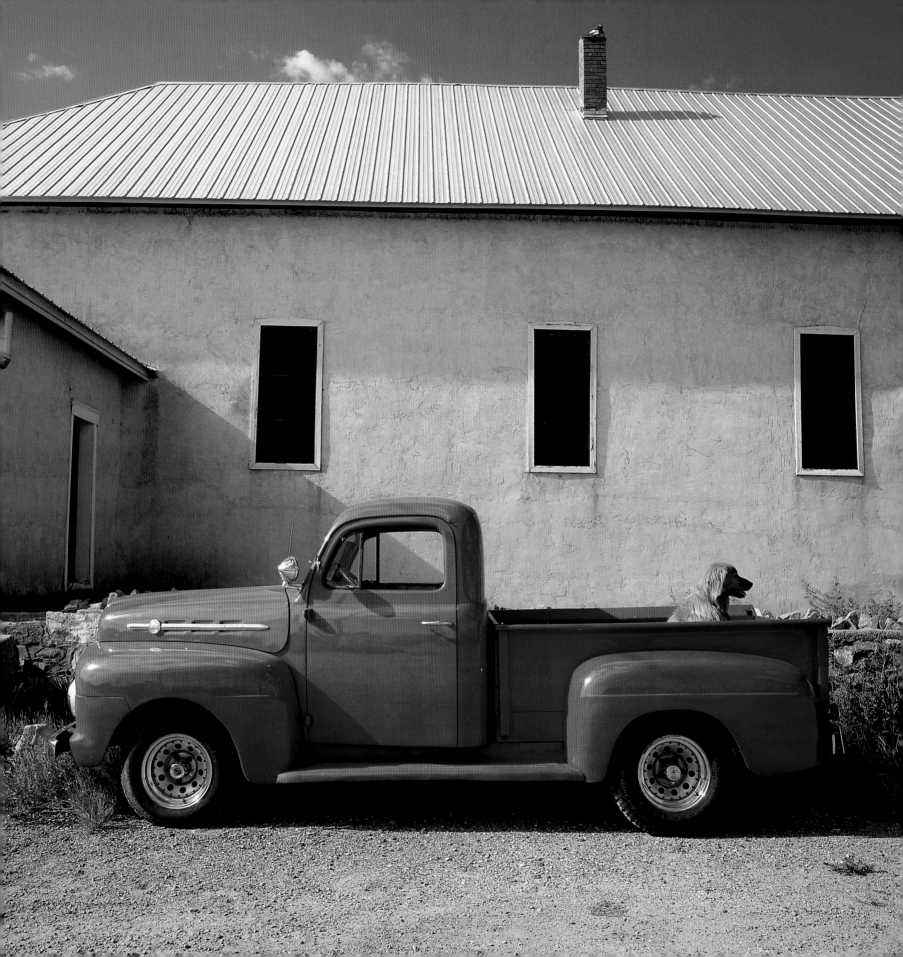

# Wayne Aarniokoski's 1951 Ford F-1

<span style="font-size:200%">A</span> **common thread among owners of old pickups is the memory of an experience from childhood.** Fifty-two-year-old Wayne Aarniokoski is no exception to the rule, but his experience is unique. As a boy, Wayne spent summers at his great uncle Pat's mink ranch in Eureka, California. Wayne recalls filling cans with mink slop and loading them onto the bed of Pat's pickup. Then Wayne and his uncle would drive down to the minks, take the cans off the truck, and scoop out the slop for the hungry animals. "They were nasty little critters," recalls Wayne. "If you didn't watch what you were doing, you could lose a finger."

Out of Wayne's remembrance of things past came a lifelong loathing of minks and a lifelong love of pickups. Wayne found his '51 Ford three years ago in a field in Stanley, New Mexico, with a FOR SALE sign on it. "Because it was red, it looked pretty nice sitting out there in the dirt," Wayne recalls, "so I paid the owner $1,500 and drove it away."

Wayne spent two years and another $1,800 to restore his pickup. He got what parts he needed from Sacramento Vintage Ford Trucks, which has a thriving business manufacturing parts for old Ford pickups. "They're replicas," Wayne says, "but the naked eye can't tell the difference."

Wayne and his wife Joanna live in Galisteo, New Mexico. There they own and operate the quaint Galisteo Inn, a recently restored 240-year-old hacienda, which you can see behind Wayne's pickup. The other picture shows Wayne and his dog Chevy—named after a Chevrolet pickup Wayne once owned. Chevy normally wears goggles to protect his eyes from dust during trips in the pickup, but the day we were there Wayne had left them at home. (Chevy posed for us anyway.)

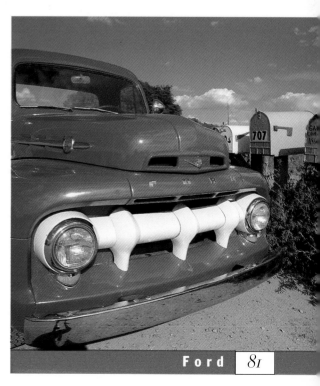

*Engine: Ford V-6*

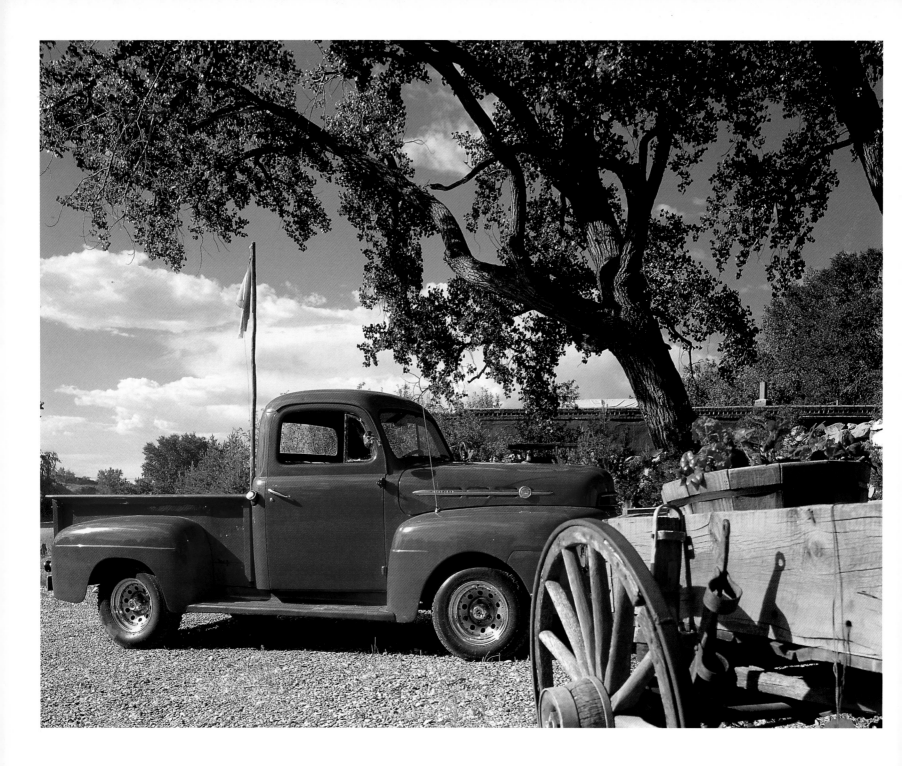

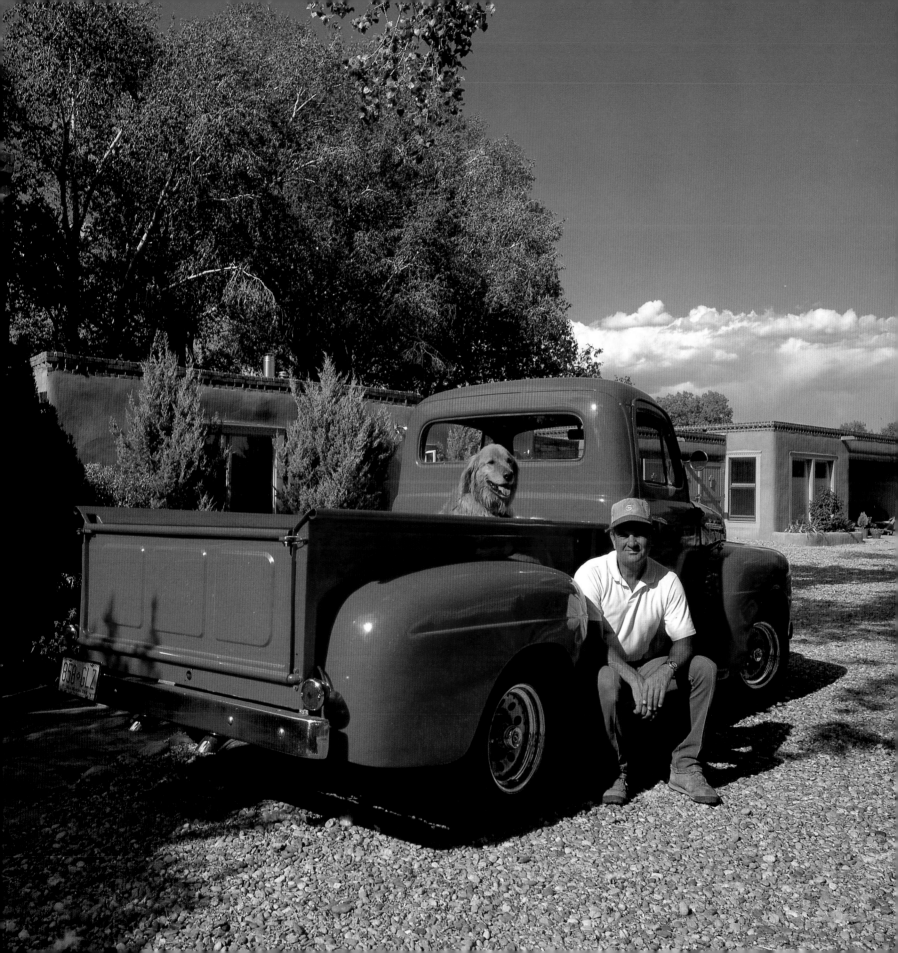

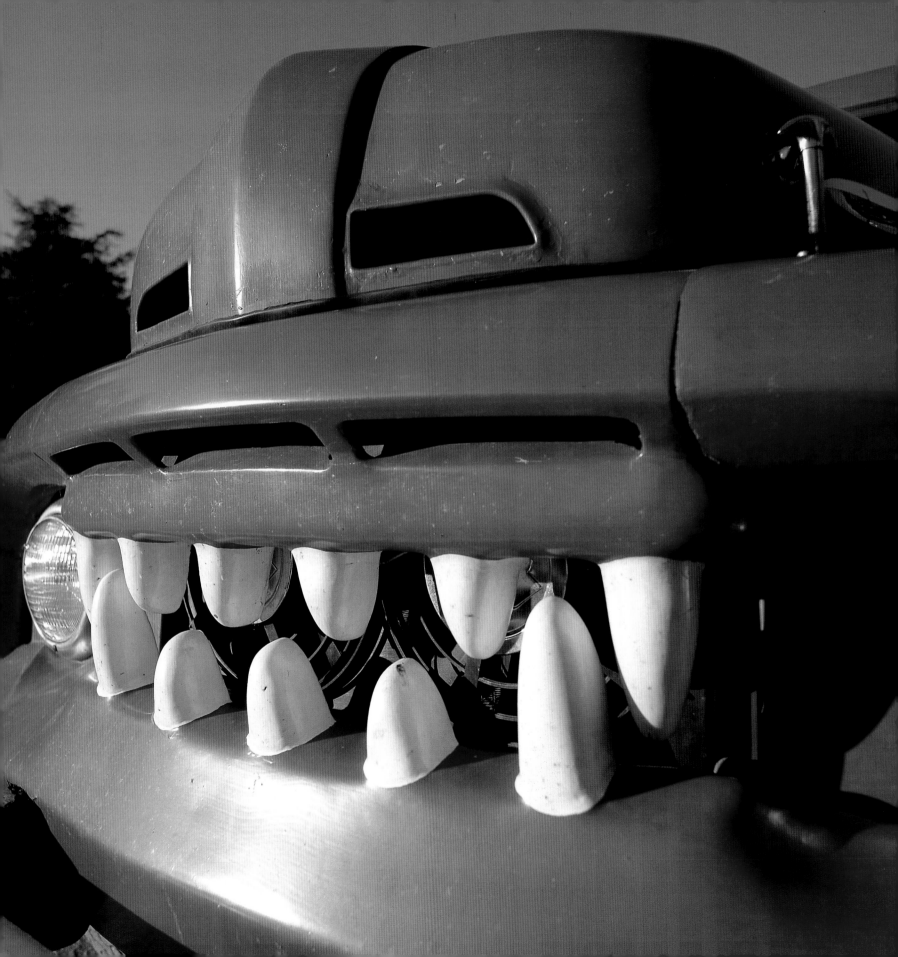

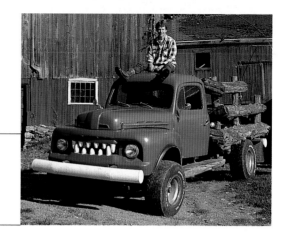

# Mike Johnson's 1952 Ford F-2

**E**very vehicle has a face," says Mike Johnson, a twenty-nine-year-old builder and engineer from New Milford, Connecticut. "The eyes are the headlights, the hood is the nose, and the grille is the mouth."

To hear Mike Johnson explain things, his '52 Ford—which he calls "Logdog"—is the essence of logic. "I saw this truck and it just cried out for teeth. All trucks cry out for teeth in one way or another."

Logdog has a look that would please the most jaded dentist. Mike carved its teeth out of wood, encased them in fiberglass, and painted them pearly white. Then, because Mike Johnson wanted the rest of Logdog to have an attitude, he built an "aggressive bed" out of cedar logs and added a cedar running board. "This is one tough truck," Mike tells you.

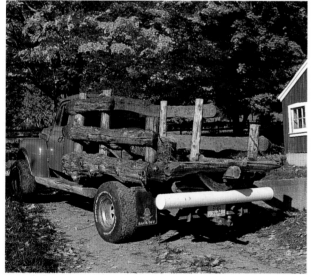

Mike Johnson says he acquired his skills by "playing with chain saws and making houses." He also made the three-ton, eighteen-foot wooden catapult you see in back of his '52 Ford. "It's a pretty accurate contraption," says Mike. "The other day I was launching watermelons into a fifty-five-gallon drum that was 100 feet downwind. I got two out of eight melons into the drum and the other six hit the rim."

*Engine: 1967 Ford 352 with headers*

Hudson

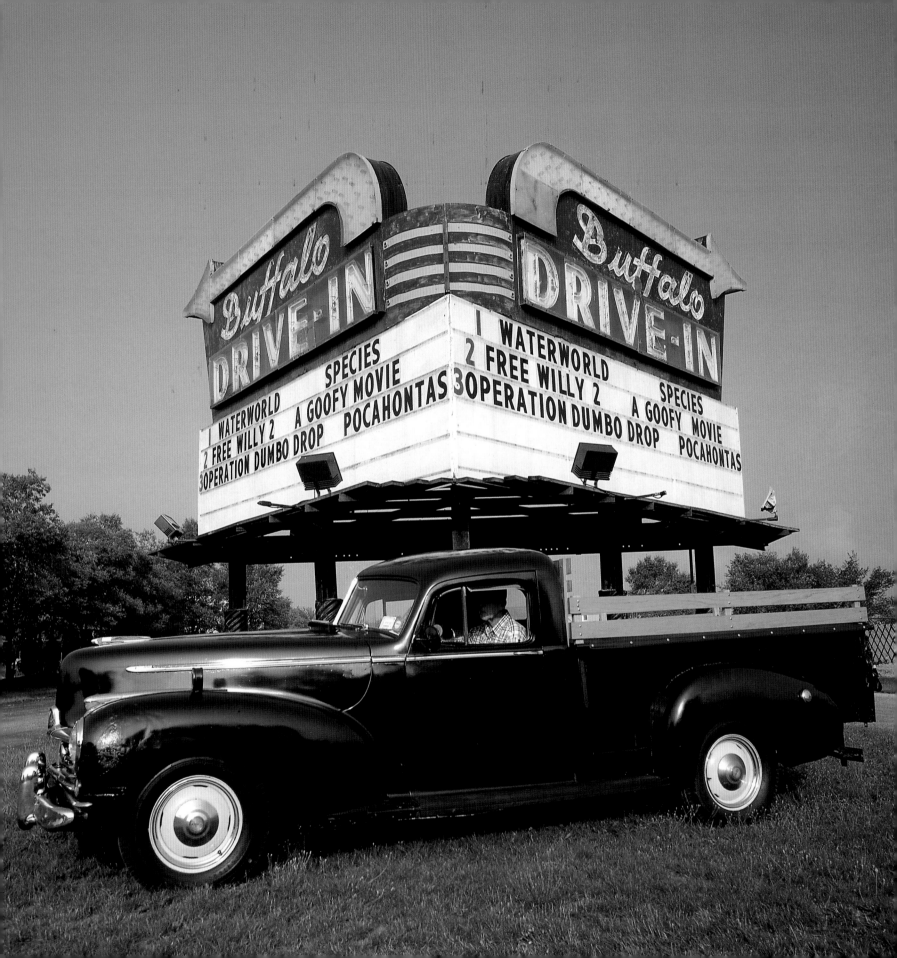

# Phil Stock's 1947 Hudson Big Boy

**P**hil Stock collects trucks . . . toy trucks. But of the two thousand or so in his collection, none are as distinctive as his Hudson Big Boy.

The Big Boy is aptly named. It weighs 3,110 pounds, is sixteen feet long, and has a 128-inch wheelbase—all monstrous measurements for a three-quarter-ton pickup. It is also exceedingly rare. In 1947, Hudson built 95,000 cars but only 2,917 Big Boy trucks.

Phil Stock's Hudson sold for $1,495 in 1947. Phil paid $300 for it when he rescued it from Colton Auto in Buffalo, New York, back in 1970. "They had it in a field on Elmwood Avenue," says Phil. "The neighborhood kids were crawling all over it like it was a jungle gym. I was afraid that if I didn't move fast, they'd wreck the automatic turn signals, or worse."

Seventy-eight-year-old Phil Stock doesn't stray too far from his Cheektowaga, New York, home—at least not in his Big Boy. It's just too large for long trips. But Phil did

make it over to the Buffalo Drive-In, where these photographs were taken. Phil remembers going to the same drive-in almost sixty years ago. "I think the movie was about a train robbery," Phil recalls, "but I don't remember it too good. In those days, the speakers were on either side of the screen, so you had to roll your windows down if you wanted to hear."

Maybe Phil had other things on his mind.

*Engine: Hudson flathead six-cylinder*

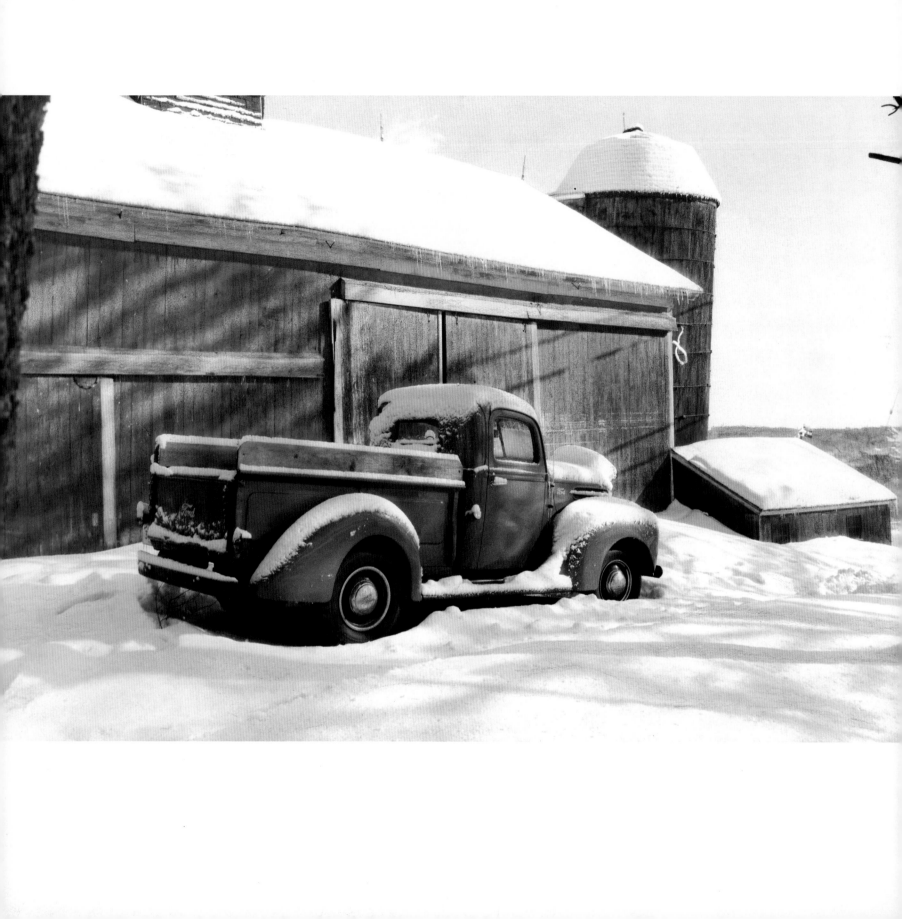

International

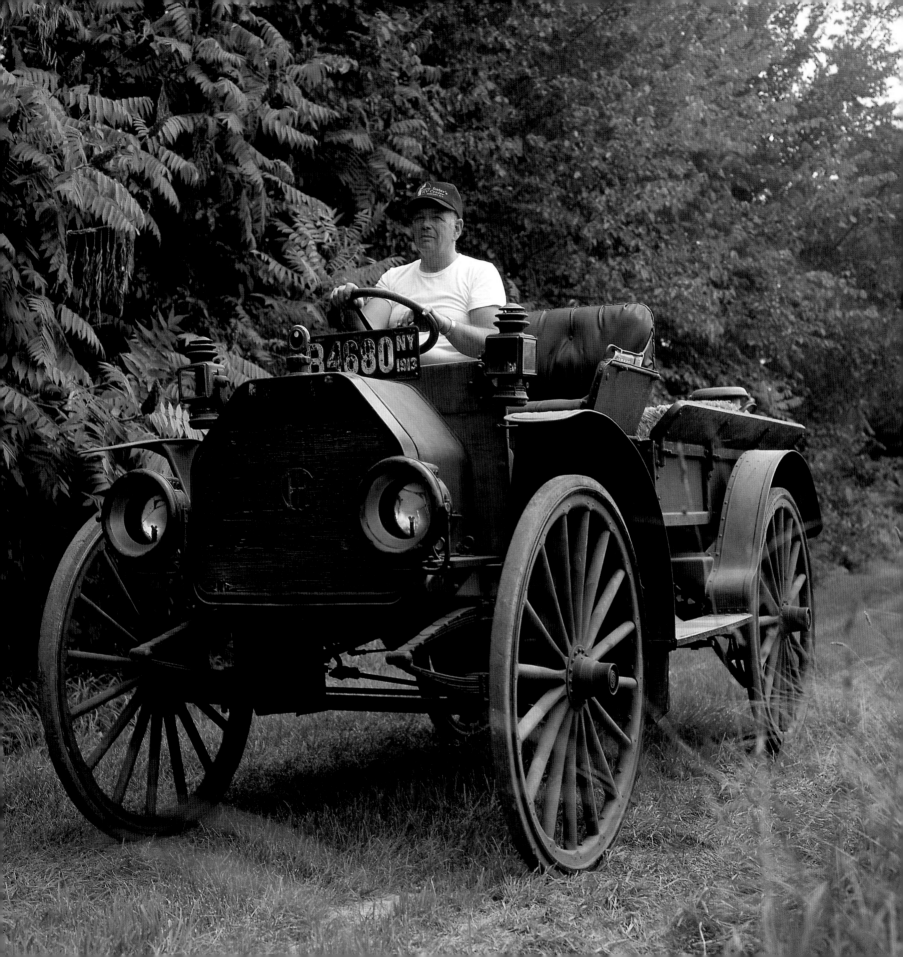

# Bob Theimer's 1913 International MW

Unlike everyone else in this book, Bob Theimer says he's not interested in old pickups. Bob collects larger vehicles and has a dozen old Mack trucks he keeps in his 120-foot barn in Bainbridge, New York. (In trucking circles, Bob is known as "Dr. Mack.")

But as Bob explains, "It's not easy to get a Mack to a truck show, so I decided to look for something smaller that we could pull in our trailer." Bob's search led him to Kingsley, Pennsylvania, and the farm of another collector, who had acquired the 1913 International in exchange for a bad debt. "The pickup was in a barn," Bob recalls. "The body was in good shape, right down to its original Firestone tires, but the engine was another story. It was sitting in pieces in a bushel basket and other pieces were buried in hay. We had to sift through it twice to find all the parts."

Bob Theimer bought the pickup and trailered it home. That's when the fun really started. Bob took all the pieces of the engine—of which there were more than a hundred—and placed them on two sheets of plywood. Then Bob stared at them for a while. "It was like a jigsaw puzzle," Bob remembers, "except I didn't have a picture to tell me what the finished engine ought to look like."

So Bob put out the word that he needed an owner's manual for a 1913 International MW. (The "M" stands for "Model" and the "W" is for "Water-cooled.") Eventually, Bob located a man in Canargo, Illinois, who owned the exact same model *and* its manual. When a copy arrived in the mail, Bob was able to reassemble the engine. Only one crucial question remained: Would it start?

On a bright autumn day, Bob and his wife, Sandra, pushed the ancient pickup onto their front lawn. Then Bob gave the engine a crank. Nothing. He tried again. This time, he could hear the engine trying to catch. Bob cranked harder, then harder still. Around about the fifth or sixth try, the engine caught. Bob Theimer hopped onto the driver's seat and steered his 1913 pickup triumphantly around the lawn while Sandra snapped picture after picture. "It was thrilling," says the man who doesn't give a hoot about old pickups, "absolutely thrilling."

*Engine: IHC two-cylinder opposed*

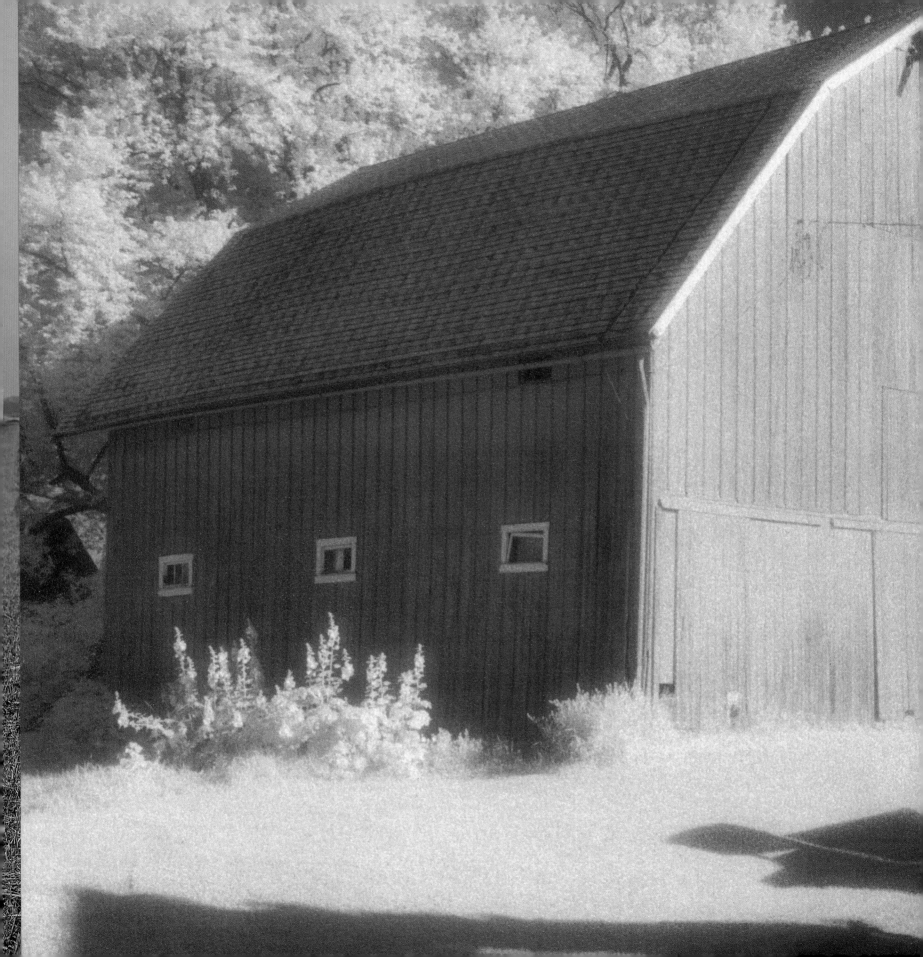

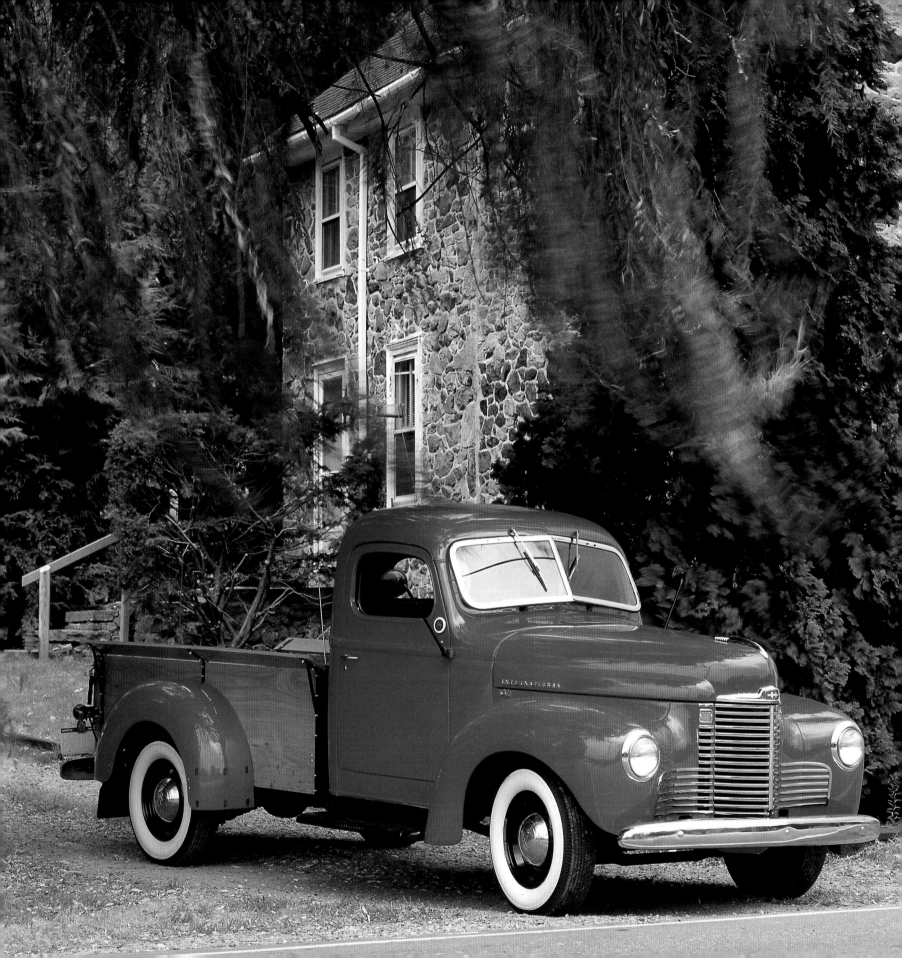

# John Scott's 1949 International KB-2

**T**he Scott family has Internationals in its blood. John's grandfather was a truck mechanic for the company, and John's father owned an International that he used in his window-cleaning business, which he started after World War II.

So it was natural that fifty-one-year-old high school teacher John Scott would want an International for his very own. Nor did John have to stray far from his home in West Chester, Pennsylvania, to find one. Amazingly, John's neighbor down the street had a '49 International sitting in his yard. "The guy had brush-painted it blue and caulked the front windshield shut," recalls John in dismay. "He was using it as a place to stack his firewood."

John paid his neighbor $200 and towed the old International home. "My intention was to get it up and running and give it to my daughter to drive to and from high school," John says. "But things didn't exactly work out that way."

What happened was this: The more John worked on his pickup, the longer everything took. "In order to fix and polish the grille, I had to remove the pieces one by one," John explains, adding that there are more than a hundred of them.

By now John's daughter was in college, and John was still restoring the truck. "I was becoming attached to it," he admits, "but I was still going to give it to her." To prove he meant business, John presented his daughter with an original distributor cap for her birthday. ("They're not easy to come by," John says.)

Some more time passed. John decided he'd junk the metal bed and replace it with a wooden one—just like his father's International had. By the

*Engine: Green Diamond L-Head six-cylinder*

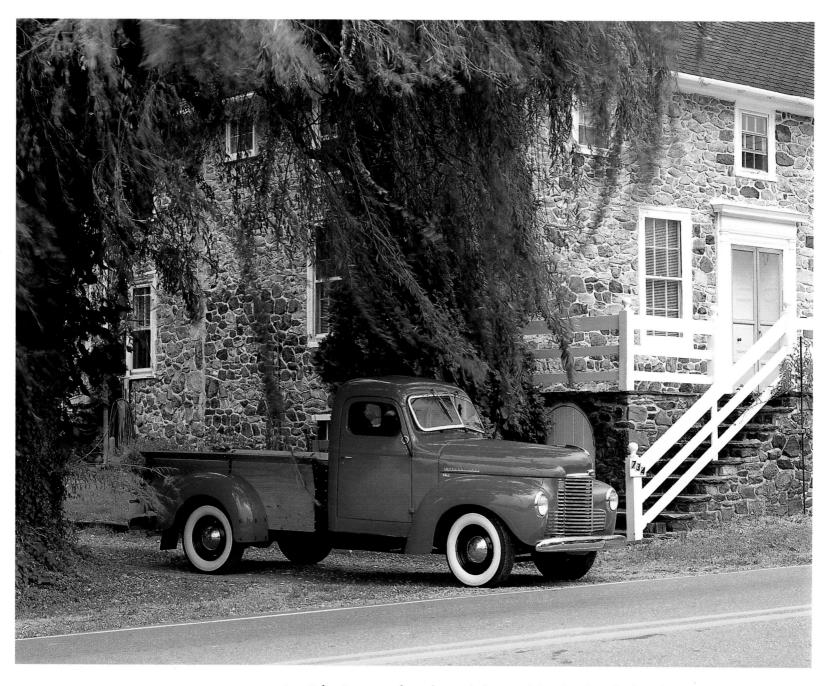

time John Scott put down his tools for good, his daughter had graduated from college and John had realized that he wasn't going to part with his truck. "It had become part of the family," John says.

So John did the right thing. He gave his now grown-up daughter a modern 4x4 pickup that she could drive to and from work or anyplace else she felt like. "It was six years late in coming," John confesses, "but it got me off the hook."

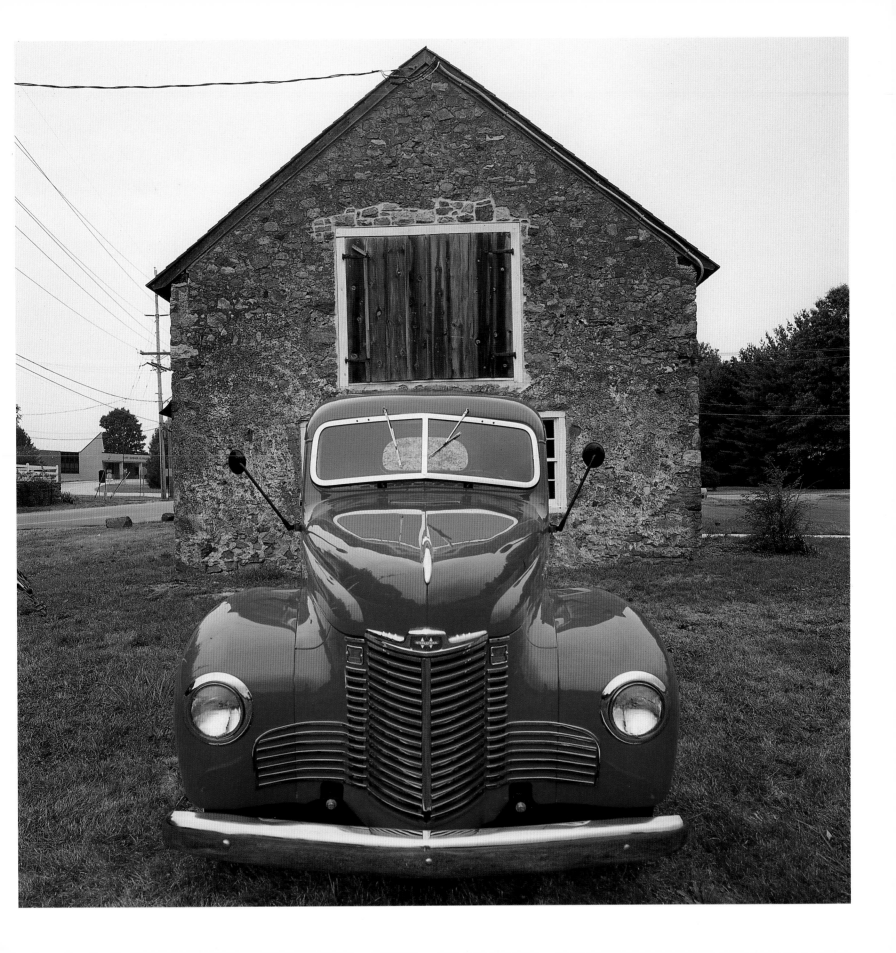

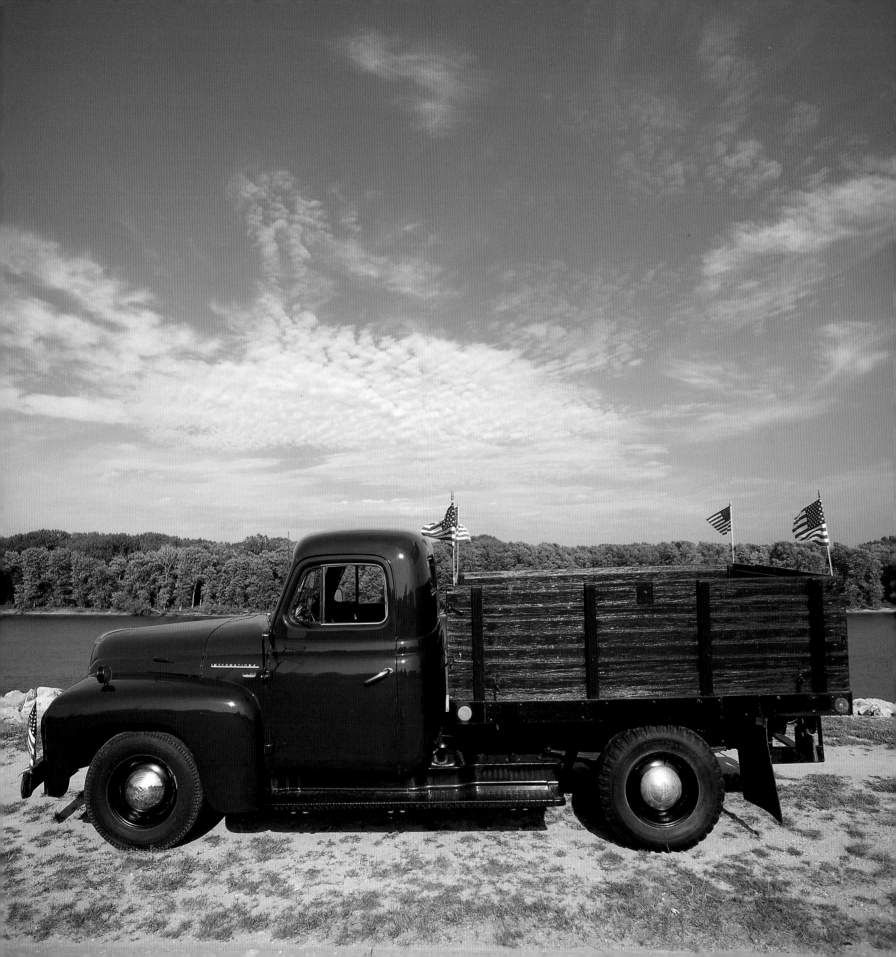

# Winston Corlis's
# 1952 International L-110

When seventy-eight-year-old Winston Corlis bought his International in 1952, he used it to haul livestock on his eight-hundred-acre farm in Clinton, Iowa. Thirty-six years later, when Winston retired, the truck had 150,000 miles on it. "You drive 'em right and they'll last," he says matter-of-factly.

Winston Corlis had no plans to restore his truck. "It was still running good, so I didn't see the need for it."

Winston's wife, Roberta, disagreed. "It was our first truck, and I wanted to fix it up," she says. "See, when we got married, I couldn't get Winston to hold on to anything old. Buggies, bobsleds, you name it, they all ended up in the ditch. Winston is what you call 'modern.' I'm more the antique type of person."

The pickup means a lot to Roberta, who refers to herself as "the best hired man Winston ever had." Roberta hauled hogs to Savannah, Illinois, in it and cows to Maquoketa, Iowa. It was on one of the Maquoketa trips that Roberta almost wrecked the truck. "A police car pulled me over and the officer asked if I was having any trouble. When I got out of the truck I saw why. A cow was standing on the roof."

Roberta talked Winston into spending $3,000 to make his perfectly good truck better. A blacksmith took out the dents and a paint shop matched the original color. Winston then purchased a new set of tires, new seat covers, and new knuckles—also known as universal joints. The engine needed a tune-up and that was it.

Since it's been restored, Winston and Roberta enjoy driving their International to different truck meets. It's a good excuse for them to get out of town, which—according to the Corlises—has seen better days. Says Winston, "Clinton is like a root beer that has lost its fizz."

*Engine: Green Diamond six-cylinder*

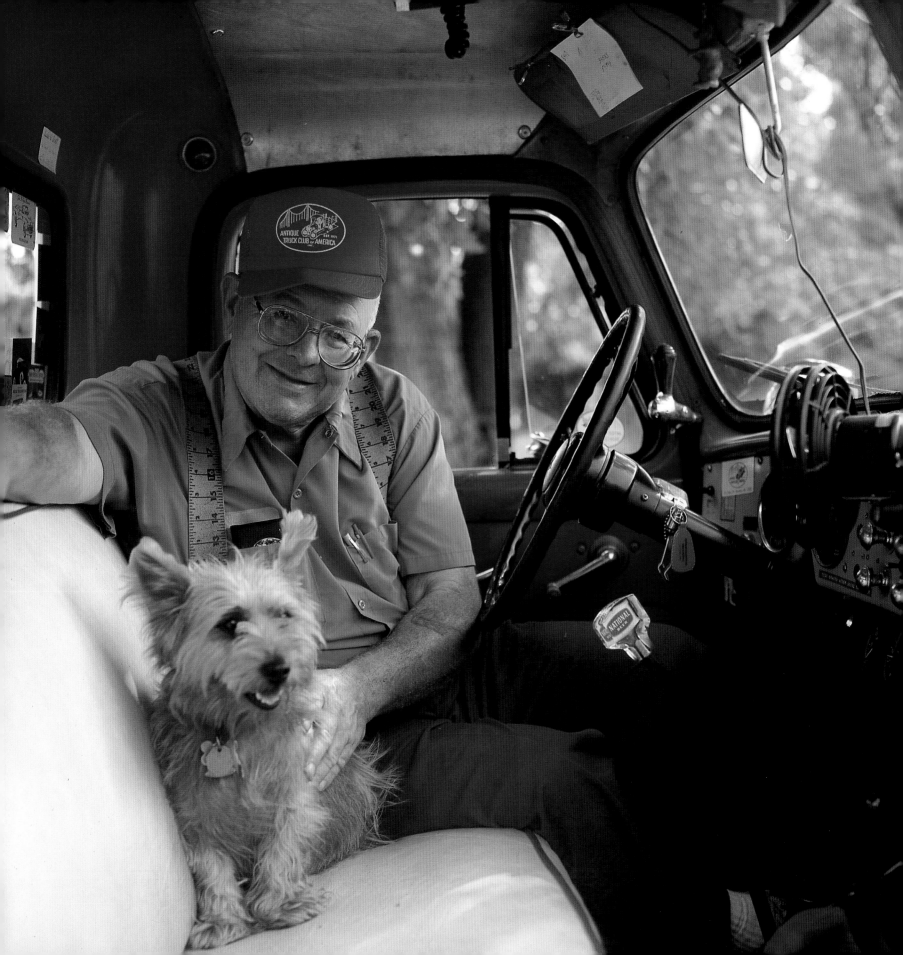

# Smokey Nevius's 1956 International S-120

How sixty-three-year-old Smokey Nevius of Churchton, Maryland, got his '56 International is a tale that has both history and patience behind it.

Smokey's truck was originally purchased by the Palo Alto, California, fire department to combat brush fires. In 1970, it was put up for auction and bought by one Butch Wilson, who drove it to Alaska, got married, raised a family, and helped build the Alaska pipeline.

Seventeen years later, Butch Wilson piled his wife, kids, and belongings in the pickup and headed for his father's home in Maryland. They got as far as Hagerstown, where the truck broke down. Butch had it towed to the International dealer and pinned a note on it (it was after hours), asking him to repair the trusty old pickup.

A week later, the dealer called Butch, telling him his truck was ready and would he please bring a check for $3,700 for the new engine. Butch hit the ceiling. When he came down, he negotiated the price to $900 and drove the International away.

Butch then decided that as long as he had a brand-new engine, he might as well restore the truck's undercarriage, which was in pretty bad shape after all those Alaska winters. So he took apart the International and left it in pieces in his father's carport.

Enter Smokey Nevius, who couldn't help noticing the International every time he visited his friend Bill Wilson—Butch Wilson's father. Smokey was interested in acquiring the pickup right off, but Bill told him it wasn't for sale; his son just hadn't gotten around to restoring it.

*Engine: IHC six-cylinder*

Years passed and the International remained in Bill Wilson's carport, still in pieces and still untouched. Smokey's interest hadn't waned but Bill wouldn't budge.

Several more years passed. When Smokey commented for the hundredth time or so to Bill that his carport was looking mighty cluttered with those truck parts spread all over it, Bill finally allowed as to how his son might have lost interest in restoring the International. So Smokey offered to remove the mess from Bill's carport . . . and toss in a thousand dollars to boot. Which is how Smokey Nevius got his truck.

Smokey put another five thousand into the International before he got it looking just the way he wanted. Now he uses it to haul firewood and also drives it to antique truck shows—some of them quite distant. "When you ride in it for nine hours, your piles are cured." Smokey chuckles. "Unless you didn't have them, in which case you will."

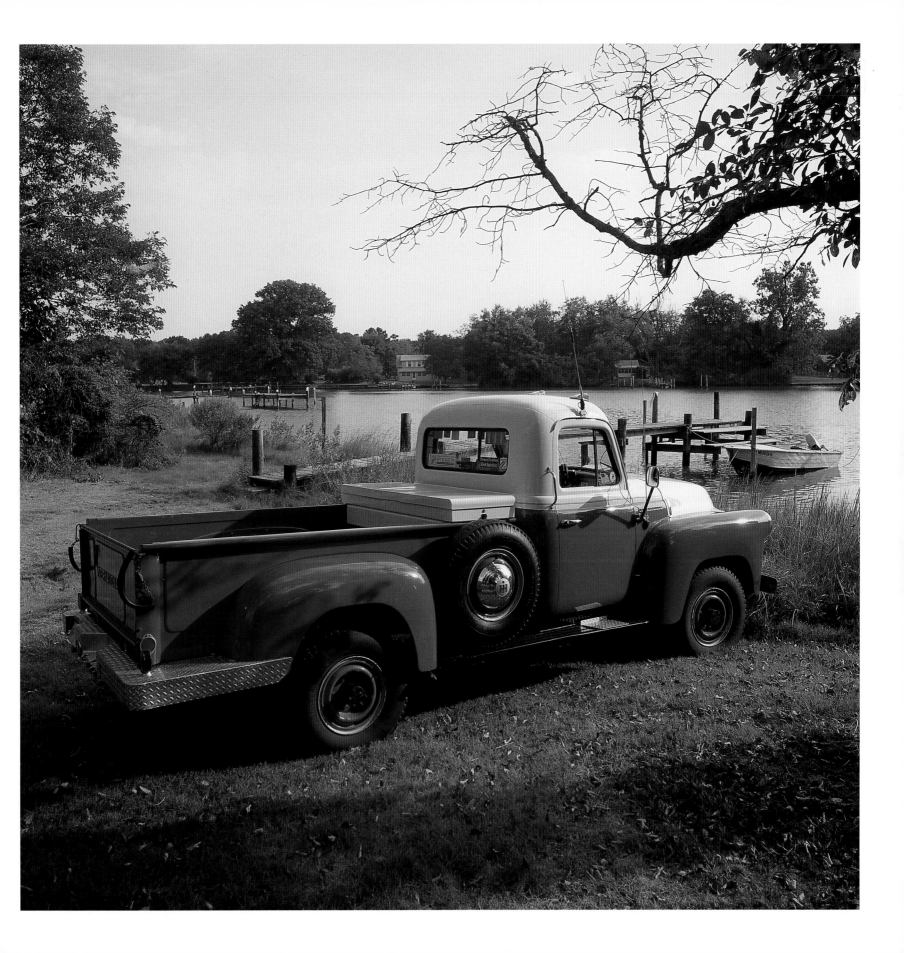

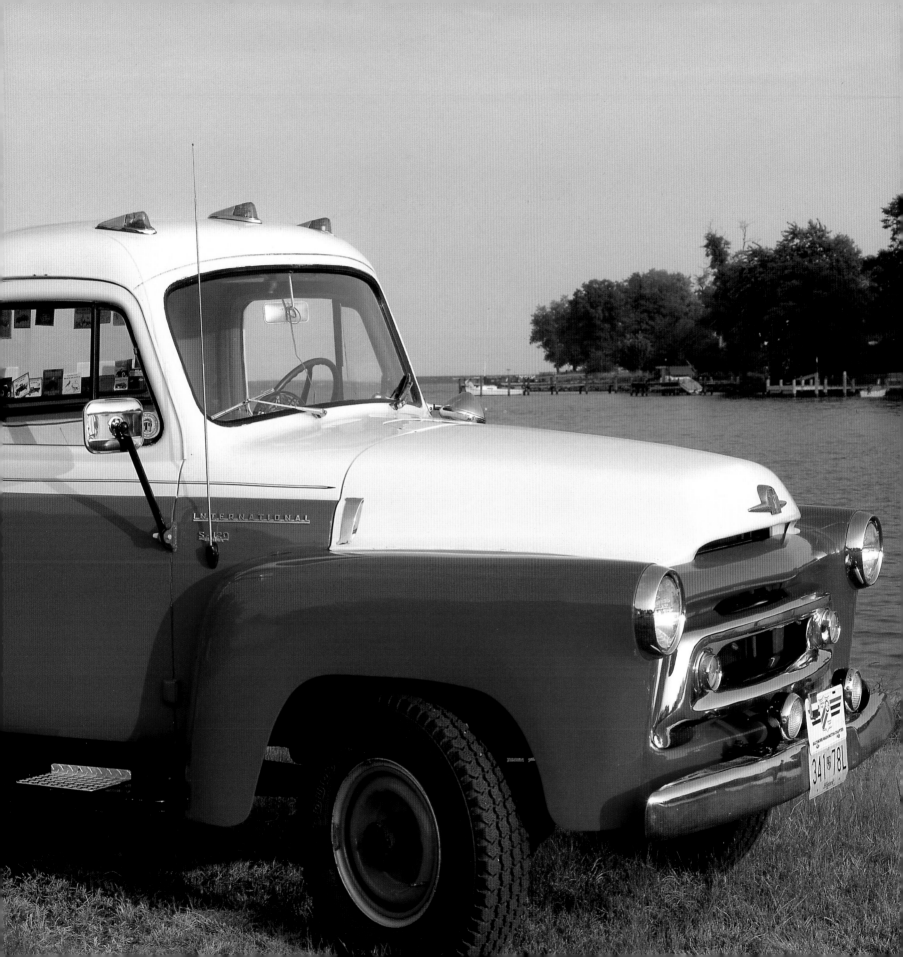

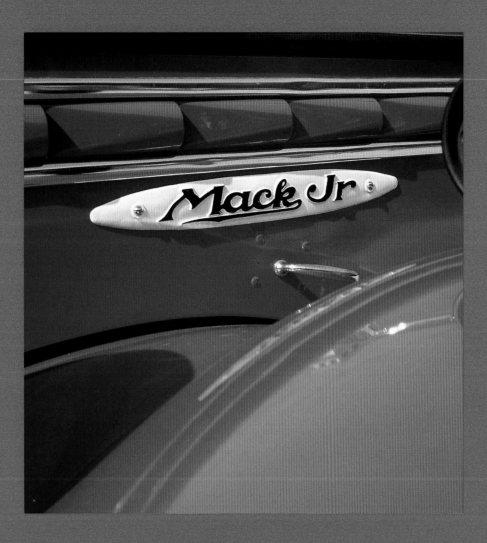

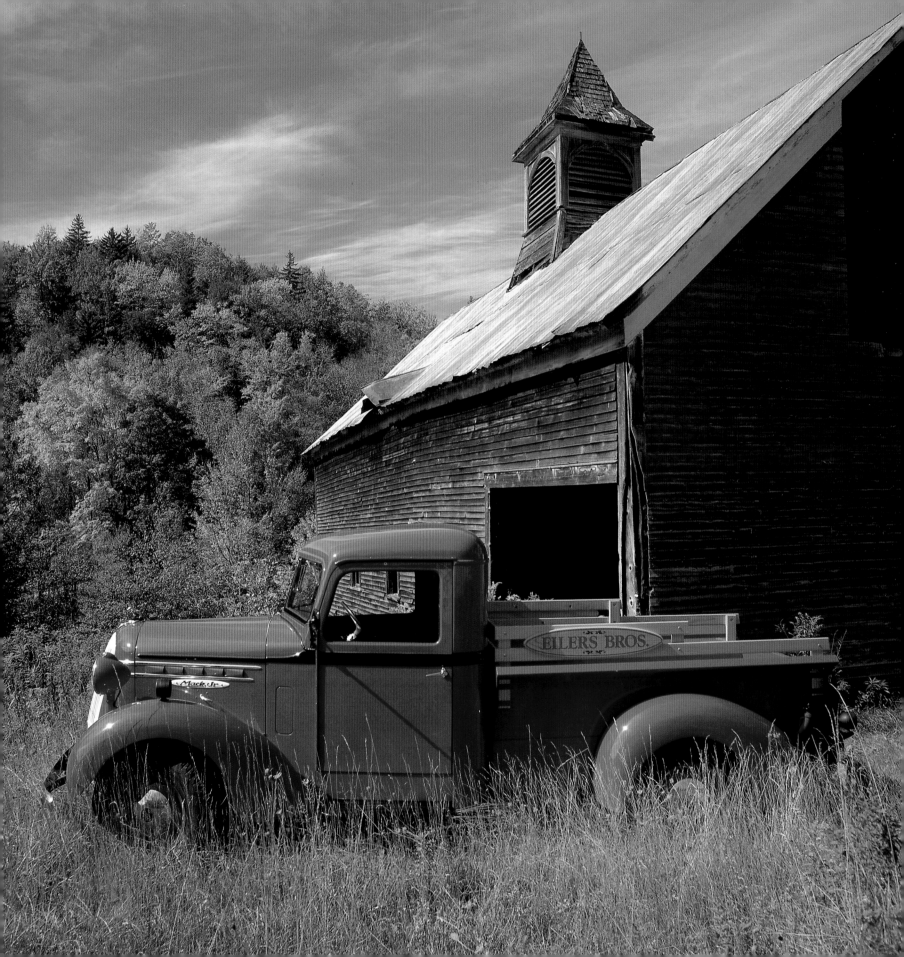

# The Eilers Brothers' 1937 Mack Jr.

**C**harlie and Joe Eilers have operated their trucking and excavating business out of Readsboro, Vermont, for the past forty-five years. The two brothers started with one Mack truck. They now have a fleet of sixteen, plus three barns full of antique Macks.

Charlie and Joe's pride and joy is the '37 Mack Jr., which is the only pickup ever to bear the Mack name. The Mack Jr. is extremely rare. It was only manufactured between 1936 and 1941, when just 4,061 of them rolled off the assembly line.

Seven years ago, a Mack Jr. was put up for auction in Scottsdale, Arizona. The Eilerses jumped at the chance to acquire it. Knowing that the pickup wouldn't go cheap, they wired a check for $18,000 to a local bank and authorized a friend to spend the full amount. The Eilerses didn't get the truck. They were outbid by $500.

So Charlie and Joe put the word out to various trucking buddies that they were on the lookout for a Mack Jr. In 1990, Joe Eilers was attending the annual antique truck show in Macungie, Pennsylvania, when a friend came running up to him. He told Joe he just had a conversation with a guy named Banas, who was selling toy trucks out of the back of his station wagon. Banas claimed that his father, Stanley, owned a Mack Jr. and might be willing to part with it if the price was right.

That's all Joe Eilers needed to hear. He hotfooted it to Quakertown,

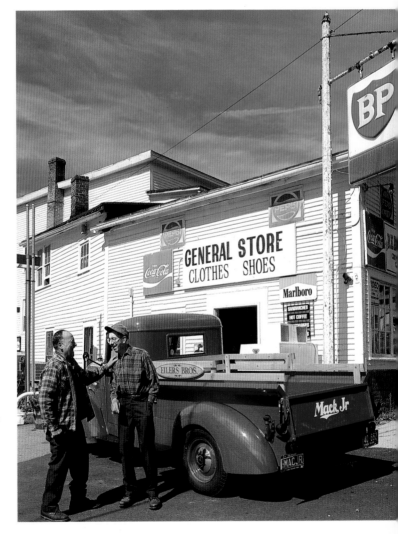

*Engine: Continental 209 six-cylinder*

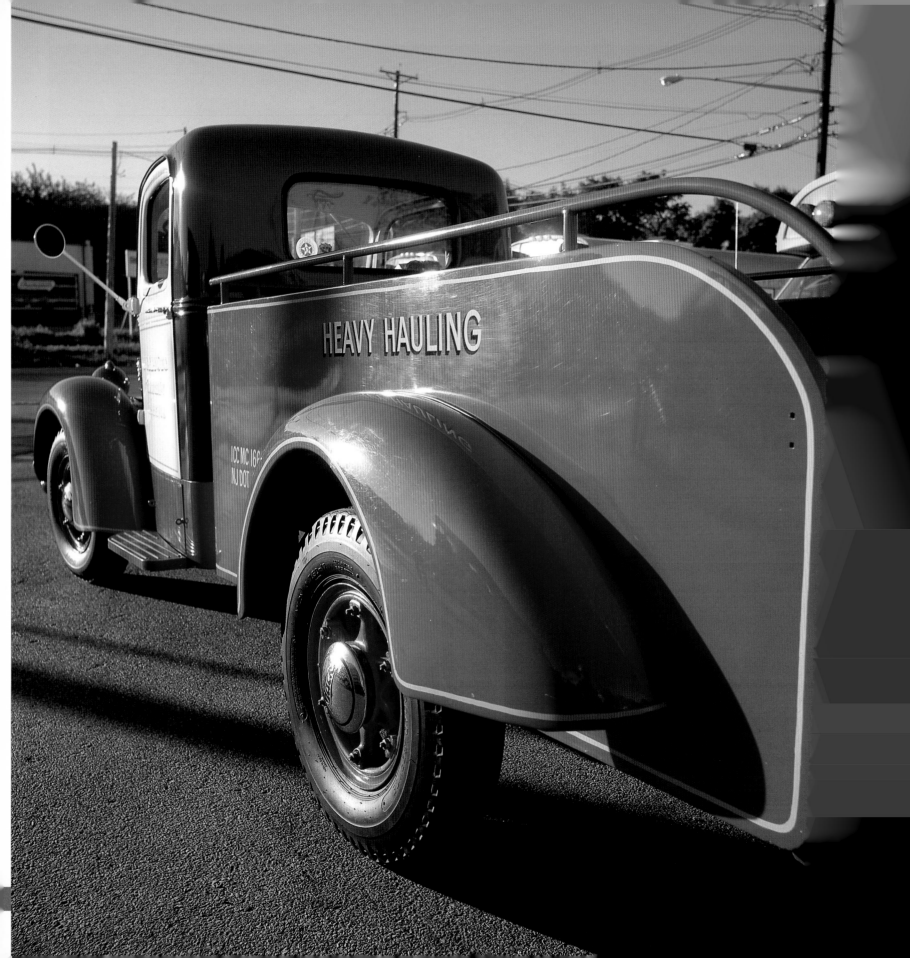

# Ben Gagliano's 1942 Mack ED

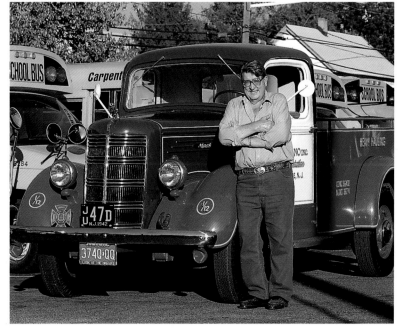

**J**ust as doctors can look at an X-ray and infer a patient's history, knowledgeable pickup owners can examine a truck and deduce its past. Ben Gagliano of Moonachie, New Jersey, is one such person . . . and thereby hangs a tale.

When Gagliano acquired his Mack, he was puzzled why the fifty-four-year-old vehicle was in such remarkable condition when it had never been restored. Also unexplained was the small platform on the back, with rails running down each side of it. Ben wondered what on earth the pickup had been used for. As he worked on the truck, clues began to emerge. The rear fenders were raised five inches higher than normal. This told Ben that the truck had carried an unusually heavy load. In addition, the Mack was equipped with something called a "power take-off"—which is almost always used to operate a winch. Winches are heavy, but a winch would have left telltale marks on the pickup, and there were none.

Then seventy-seven-year-old Ben Gagliano dug into his memory and recalled that power take-offs have another use: they also operate pumps. If the pickup had a pump, Ben reasoned that it also had a water tank. Ben saw that a 500-gallon tank would fit nicely on the bed of his pickup. What's more, filled with water it would weigh about twenty-four hundred pounds—an unusually heavy load.

That solved the mystery. Ben's pickup was a fire truck. This explained its remarkable

condition. Fire trucks are infrequently used and always garaged. As for those rails, that's how the firemen got on and off the truck.

Now if you're saying to yourself, "Hey, wait a minute, aren't fire trucks red?" Ben Gagliano has an answer for that, too. He repainted his truck red, white, and green . . . the colors of the Italian flag. "You may love it, you may hate it, but you can't ignore it," laughs Ben.

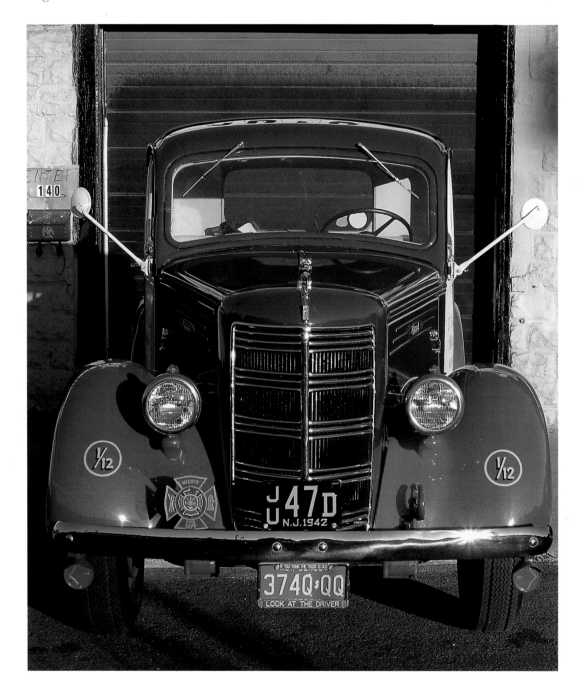

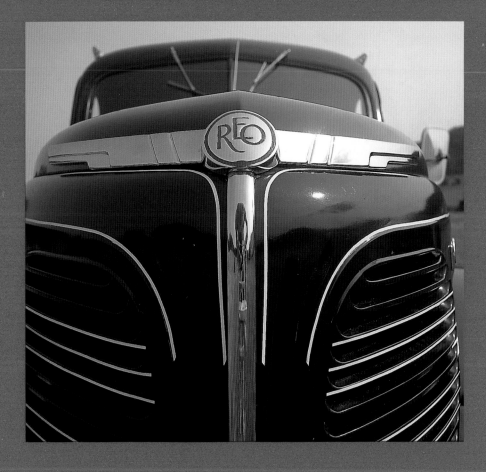

Reo

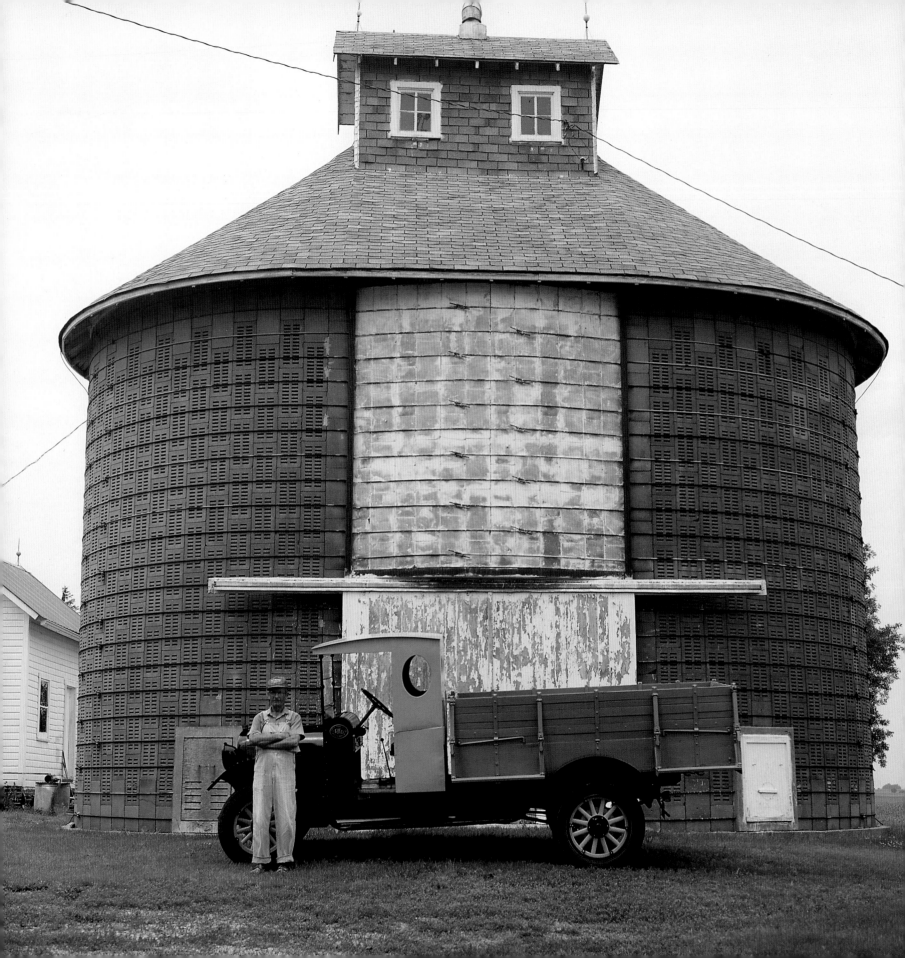

# Dean Ritzman's 1920 Reo Speed Wagon

Seventy-six-year-old Dean Ritzman grew up with a Reo Speed Wagon that he and his father used for hauling corn on their farm in Perry, Iowa. That round building in the photo is Dean's corncrib.

Dean Ritzman's current Reo was bought unrestored from an antique truck museum in Mason City, Iowa. The museum acquired it from a farmer in Minot, North Dakota. Dean Ritzman paid $1,400 for the truck—$145 more than Dean's father paid for his Reo some seventy-five years ago. Dean spent one entire winter rejuvenating his Reo with the help of his son-in-law. Reo has been defunct for thirty years and parts are not easy to come by. So Dean bought a 1924 Speed Wagon that was too far gone to restore. When its parts were used up, Dean went to flea markets for the rest. "It's amazing how many people keep parts from Reos," Dean says. "Eventually we got everything we needed."

The romantic-sounding Reo got its name from the initials of its founder, Ransom Elias Olds, builder of another, more prosaic, vehicle, the Oldsmobile. Mr. Olds sold that part of his company to General Motors in 1903, but continued to make Reo cars. In 1917, he added a line of trucks, which were manufactured until the company was acquired by White Motors a half century later.

Dean Ritzman's Reo Speed Wagon is somewhat inappropriately named, since its top speed is thirty-five miles per hour. In first gear, says Dean, a person can stroll alongside it.

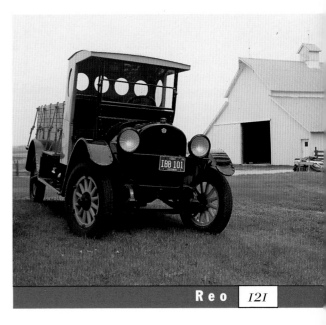

*Engine: Reo Type F two-cylinder*

Reo **121**

# Mark Welte's 1949 Reo D19XA

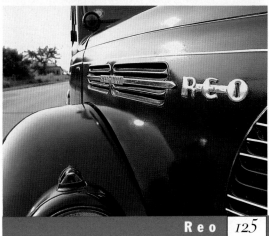

**O**ld pickups are alluring because the memories associated with them are invariably happy. Fifty-two-year-old Mark Welte's earliest memories are, as a five-year-old boy, riding with his dad from their farm to a Wisconsin dairy, a cargo of milk cans clanging behind them in the flatbed of their '49 Reo.

Four decades later, Mark Welte was able to find a '49 Reo on a farm in Portage, Wisconsin, and make it his own. There were 79,000 miles on it—all of them hard, says Mark—and the Reo hadn't been driven for fifteen years. Mark paid its owner $550 for the rusty old pickup, put it on a trailer, and took it home. Three years and $4,000 later, Mark had what he'd yearned for all his life—a perfectly restored version of his dad's Reo, just as he remembered.

Mark Welte's '49 Reo is extremely valuable; there are only ten of them left in the entire country. Mark turned down $18,000 for it once, considerably more than the 1949 sales price of $1,798. However, Mark admits he'd consider a higher offer, "because there's this other '49 Reo I can get my hands on that's sitting in a corncrib in Iowa." Just where in Iowa? "No offense," Mark says, "but that's something I don't want in a book."

*Engine: ReoGold Crown six-cylinder*

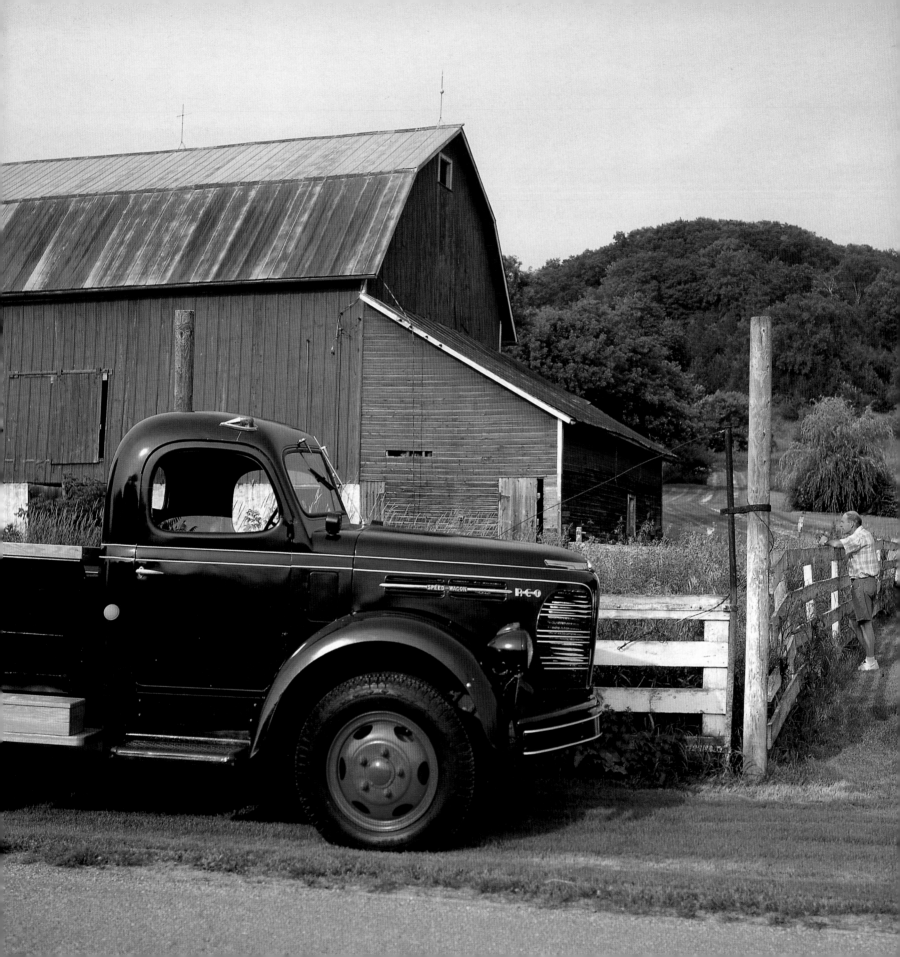

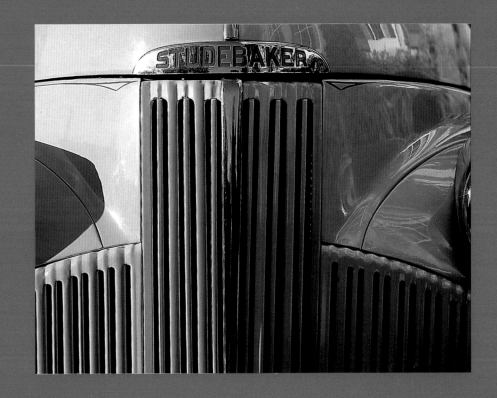

Studebaker

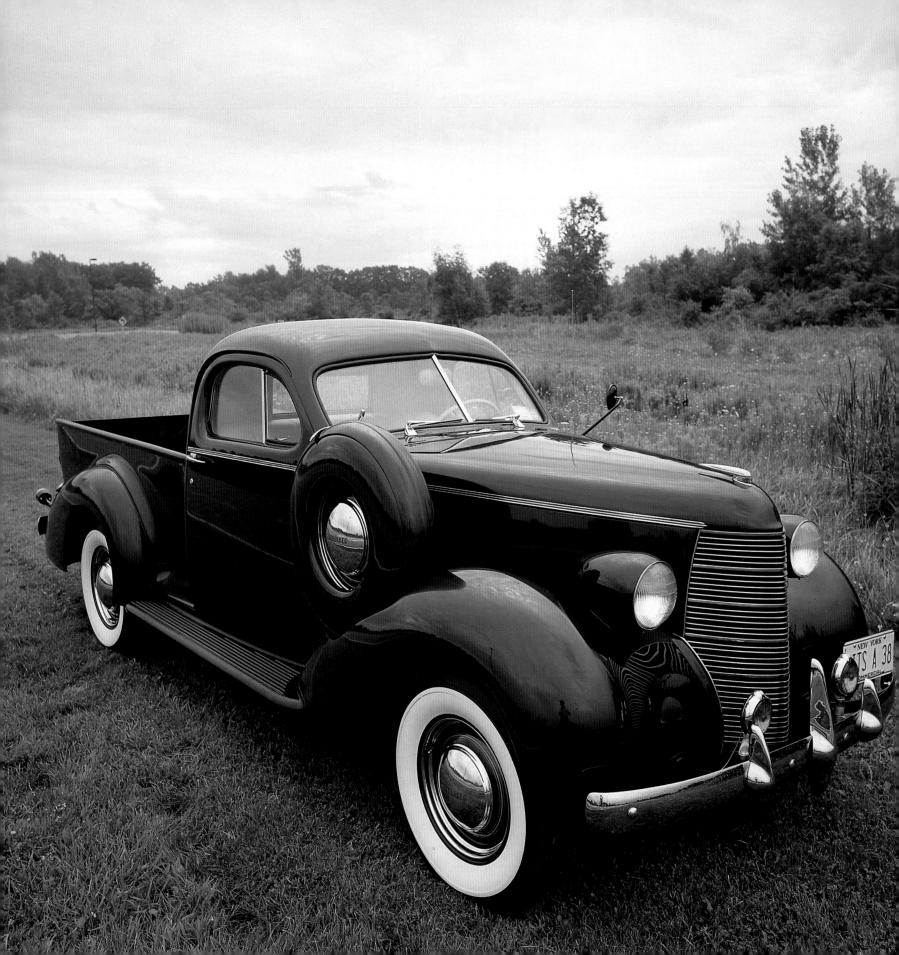

# Jerry Kier's 1938 Studebaker Coupe-Express

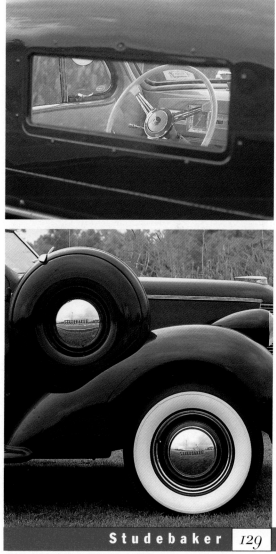

**O**ne day, Jerry Kier drove his Studebaker Coupe-Express into town to get some gas. "I wasn't there five minutes," says Jerry, "when four vehicles pulled into the station. All of the drivers had seen my pickup from the highway and wanted to know more about it."

What caused those drivers to veer off the road is a fifty-eight-year-old hunk of metal whose lines are so graceful and pleasing they lure onlookers like a magnet attracts nails. Still, Jerry Kier is quick to point out that looks can be deceiving. "There are some parts underneath the chassis where the paint is a little chipped," he says. "The body shop didn't do it right, so I'm now in the process of taking them off and repainting them myself."

No matter how tiny they are, defects annoy the heck out of Jerry Kier. He spent five years restoring his Studebaker and is still fiddling with it, even though it won best truck in its division at the '95 Studebaker National Show in Dearborn, Michigan. "Restoring a truck is an ongoing proposition," says Jerry. "You're never really finished with it."

Jerry Kier got his Coupe-Express from an acquaintance in California. He paid $2,500 for it, plus another $600 to have it shipped to his house in Penfield, New York, which is near Lake Ontario. Jerry has traced the pickup back through five previous owners, but the identity of the first owner has thus far eluded him. Jerry wants to locate him so he can find out the original color of the truck. "I painted it Studebaker blue," says Jerry, "but that was just a guess."

In 1938, it cost $735 to buy a new Studebaker Coupe-Express. Jerry Kier figures he has spent $35,000 restoring his old one. Jerry explains it this way: "I wanted something nice."

*Engine: Studebaker 226 CID*

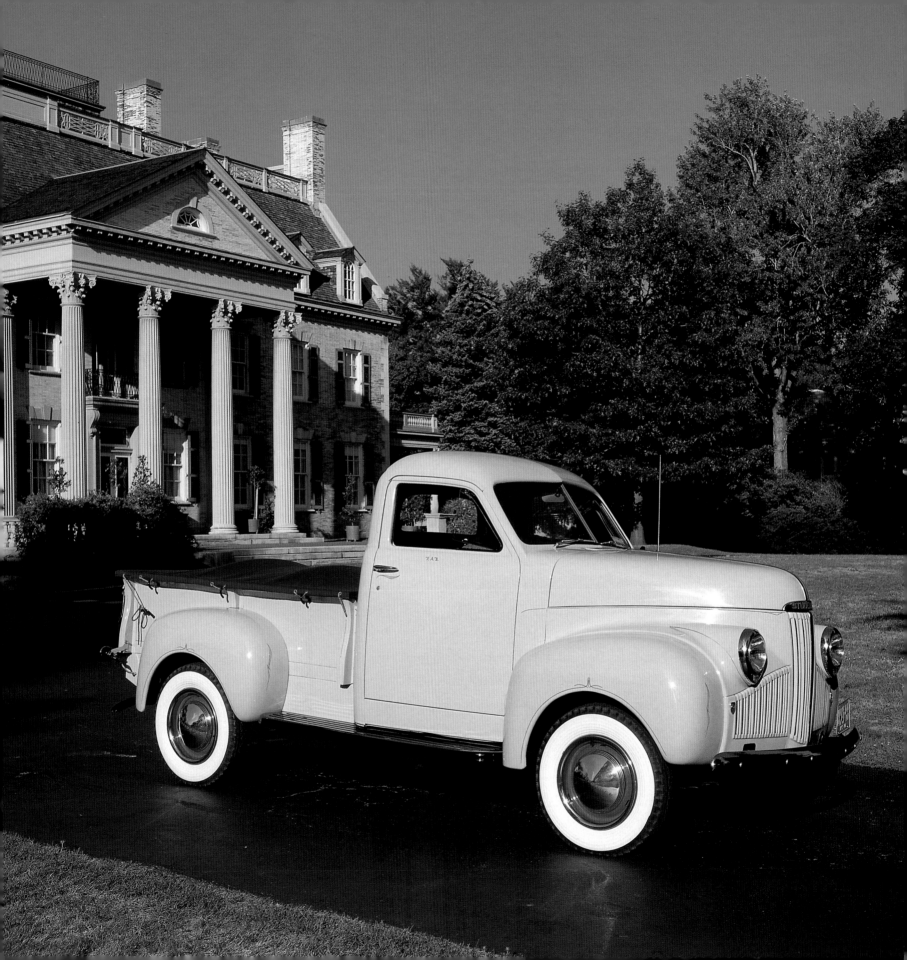

# Jack Brown's 1946 Studebaker M5

**S**ome pickup owners are downright obsessive about their trucks. Fifty-three-year-old Jack Brown of Henrietta, New York, is firmly in that camp. It led him to uncover what may be the earliest case of automotive consumer fraud on record.

The M5 was introduced by Studebaker in 1941 and was drafted by the U.S. Army after the Japanese bombed Pearl Harbor and America entered the war. By VJ Day, Studebaker had produced almost 200,000 military trucks. The 1946 M5 marked Studebaker's reentry into the commercial marketplace.

Jack Brown's Studebaker was one of the first of the '46 models to come off the postwar assembly line. Jack found that out by decoding the tag on the engine's firewall. Then, when Jack started to repair the engine, he found out something else. It had "poured-rod" bearings. Strange, thought Jack, because every Studebaker made during the war and afterwards had the more rugged "insert" bearings originally specified by the army. From this, Jack reasoned that the engine in his '46 Studebaker was really manufactured in 1941. It and thousands of others had sat around the factory for five years until Studebaker dusted them off and installed them in its early '46 models, one of which was Jack's.

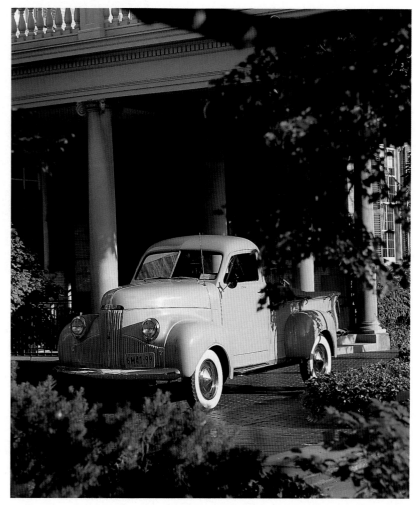

*Engine: Studebaker six-cylinder*

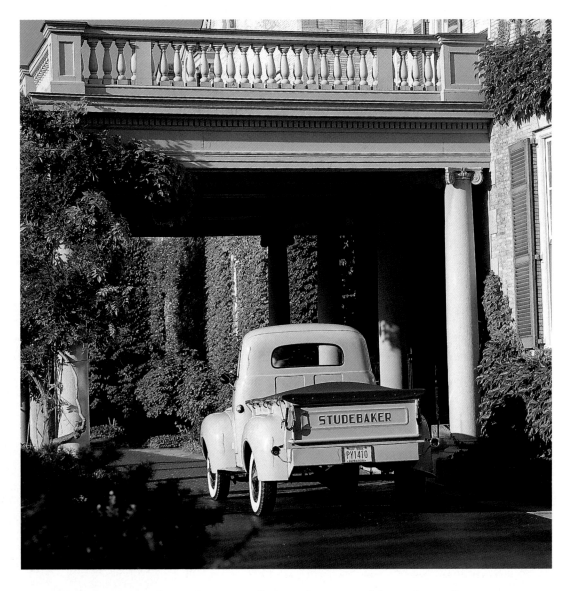

Jack Brown is not demanding a recall. Since he restored his pickup a few years ago, Jack has been to eighteen Studebaker shows and has taken home seventeen trophies. The success has made Jack fussy about his truck. Although it has functional running boards, Jack gets upset when you step on them to enter his pickup. "The paint might scratch," explains Jack.

Nor is Jack happy if you use your bare hands to open the door of his pickup. "Skin has a lot of acid," Jack says, "and acid can ruin a finish."

Jack Brown's Studebaker M5 is parked in front of the George Eastman house in Rochester, New York, a man whose obsession with a different contraption created Eastman-Kodak.

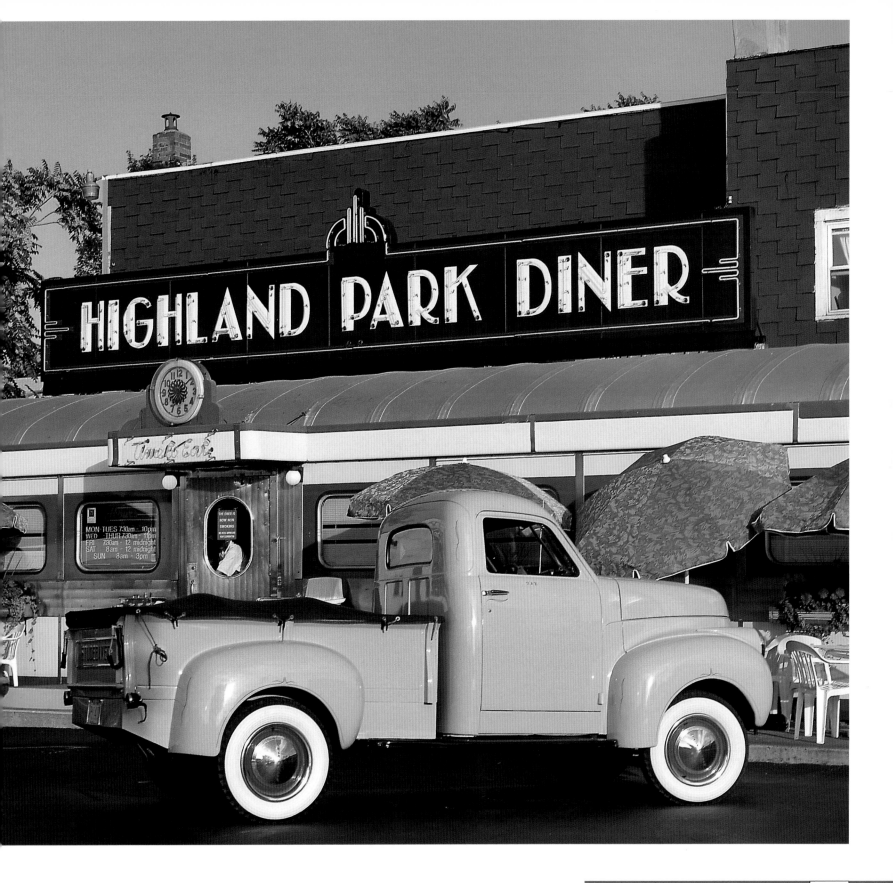

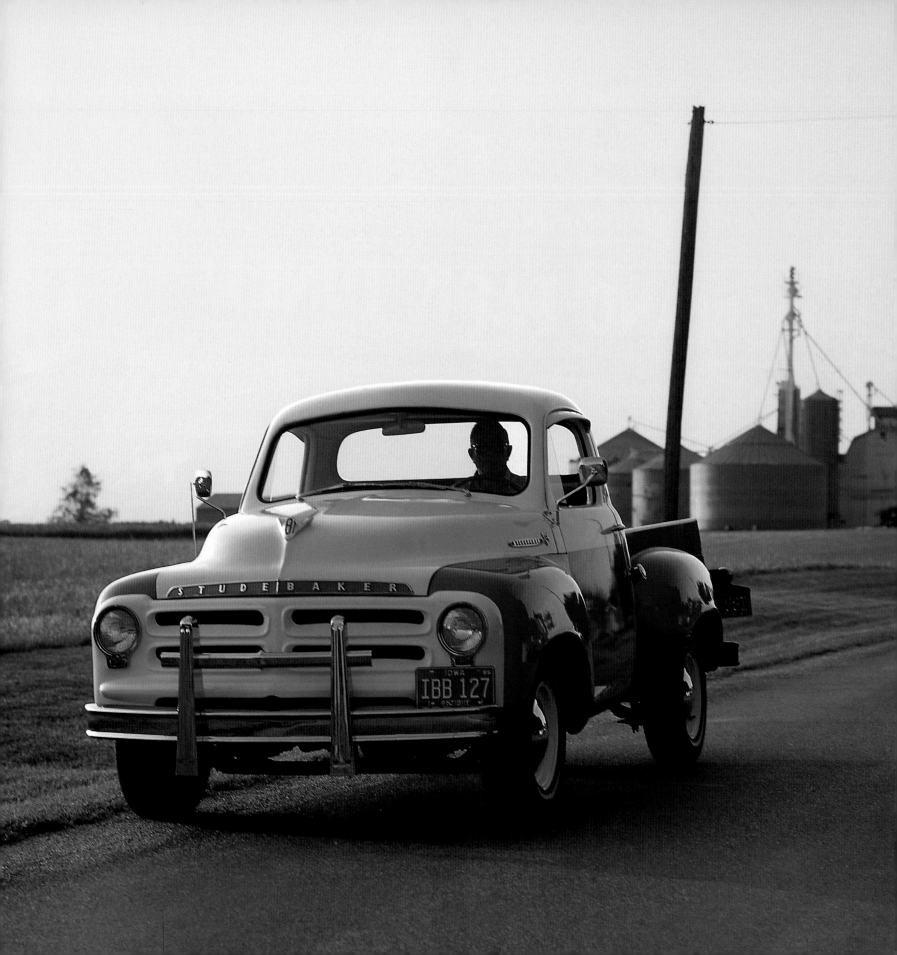

# Harold Goepferich's 1955 Studebaker E7

Harold Goepferich has this thing about Studebakers. "My neighbor had one when I was a kid and I just fell in love with the darn car," Harold explains. "Eventually I got one. Then I got another. That's the way it is with Studebakers."

Sixty-five-year-old Harold Goepferich is not alone. The National Studebaker Club has 13,000 members who share Harold's passion. The majority are car owners, but quite a few have trucks. Harold's E7 is his first and only Studebaker pickup. He found it sitting in a driveway in Dallas Center, Iowa (pop. 1,300), where Harold has lived since 1950. At first the owner didn't want to sell it, but Harold gave him his phone number just in case. Two years later, the man had a change of heart. Harold forked over $600 and got his truck.

Harold—who's a perfectionist—took almost three years to get his Studebaker in shape. He did all the mechanical work himself. Then he dismantled the body and sent it out in pieces to be painted. "You do that to get in the cracks and the corners and the backs of things," Harold explains. "That's the way Studebaker did it and I wanted to do as good a job, or better."

Harold takes his pickup to Studebaker competitions and has brought home several first prizes. One time he didn't was when the judge docked him two points because the dome light switch was in the wrong position. "It should have been sitting up and down," says Harold, sounding a tad irritated, "but I put it in crosswise."

Harold won't use his truck for hauling, but he does drive it everywhere. The longest trip has been 100 miles away to Bethany, Missouri. Harold went there for a round dance, which he describes as "a two-step with belly rubbing." Harold plans to return, because some of the folks there didn't get to see his pickup. Well, that's what Harold says, anyway.

*Engine: Studebaker 224 V-8*

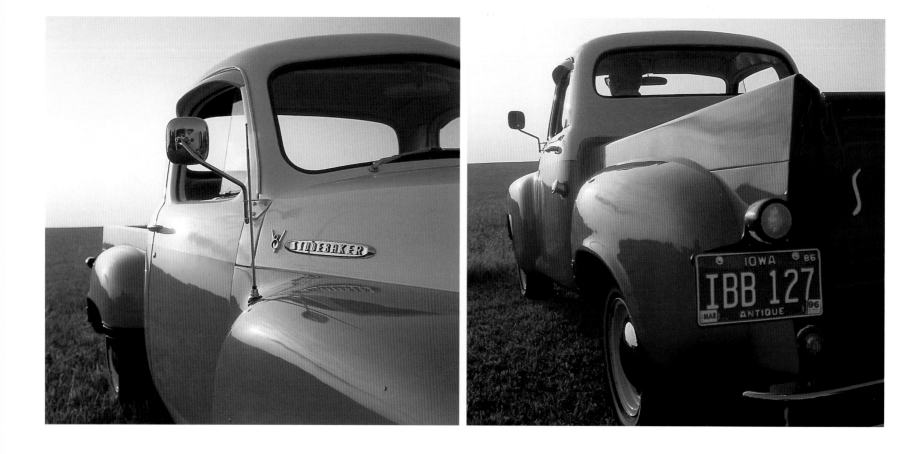

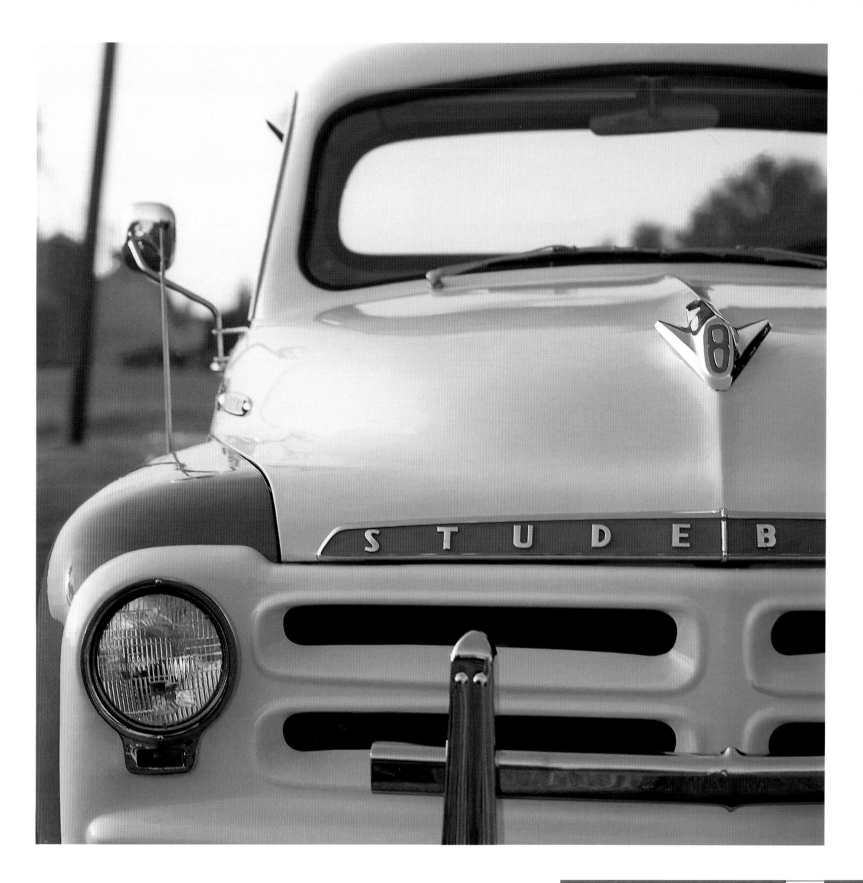

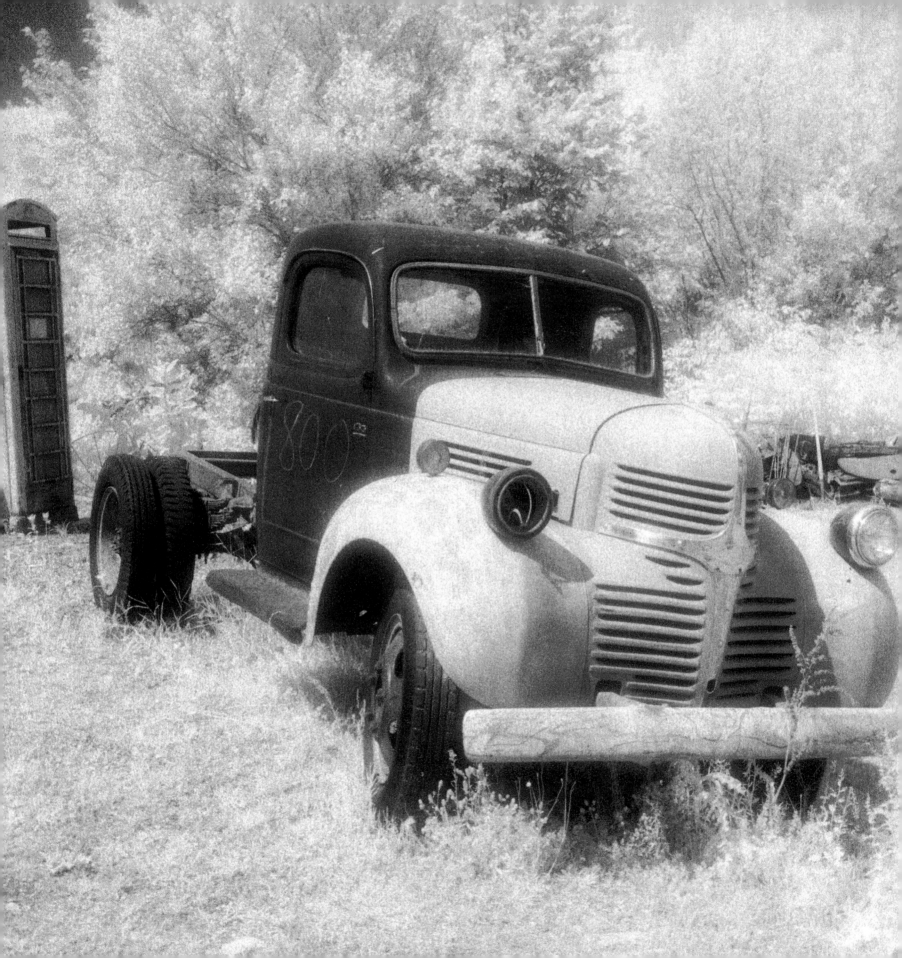

Multiple-Truck Owners

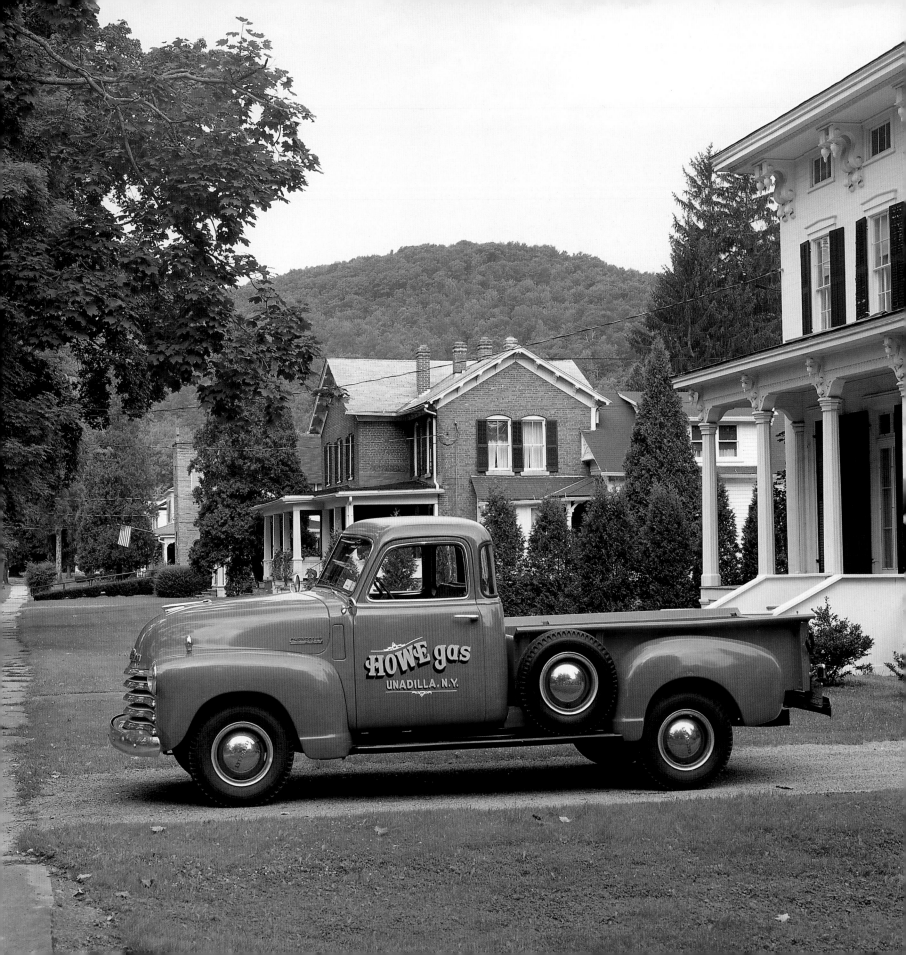

# Dick Howe's 1931 Chevrolet Independence and 1949 Chevrolet P/4

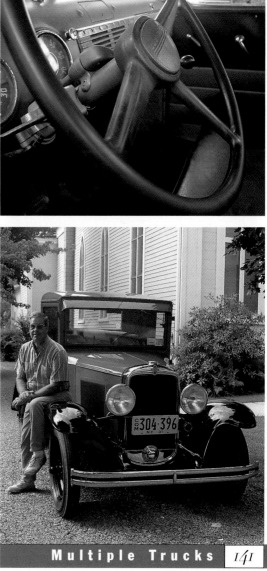

**D**ick Howe has restored fourteen trucks in fifteen years, two of which are pictured here. The 1949 Chevy was owned by Dick's grandfather, who bought it new for $900 to use in his plumbing and heating business in Unadilla, New York—where Dick also makes his home. When Dick Howe's grandfather died at the age of ninety-six, Dick decided to "spiff up the Chevy and do it right" in his memory.

The restoration job was so rewarding that Dick Howe, fifty-eight, decided he would look for a '31 Chevy, the vehicle his grandfather was driving when Dick was in knee pants. Dick eventually located one that was owned by Eddy Moore, who lived in Bellingham, Massachusetts. Dick wanted it real bad but he didn't want to spend what Eddy was asking, namely $4,500. So Dick and Eddy began a marathon negotiation lasting four years. When it was over, Dick Howe got his pickup and Eddy Moore got his $4,500. "I thought if I hung in there, he'd come down in price," says Dick, "but that man never once budged."

Dick went to Bellingham to bring the pickup home. Eddy had been keeping it in a shed and it was covered with chicken manure and dirt, which didn't bother Dick at all. He could see the beauty shining through. Dick cleaned it up and used it for five years before doing a full restoration. Then he took it on a truck tour to Owl's Head, Maine, and drove his 1931 Chevrolet pickup all the way to the top of Mt. Battie.

Dick Howe doesn't know what it is about old pickups that make them so irresistible. All he knows is, "I can't walk away from one I like. I got to buy it, bring it home, and do it."

Eddy Moore had that one pretty well figured out.

*Engine: (1931) Six-cylinder Continental; (1949) Six-cylinder Chevrolet*

# Three Pickups from Carolyn Moon's Iowa 80 Truckstop

**T**he Iowa 80 Truckstop is in Walcott, Iowa. Walcott is roughly at the midpoint of Interstate 80, which runs east to west across the entire United States. The pickups are part of its permanent collection of eighty-five old trucks.

The Iowa 80 Truckstop is owned by Carolyn Moon, whose late husband, Bill Moon, started it more than thirty years ago. It has grown from a modest facility into the world's largest truck stop: a fifty-thousand-square-foot trucker's paradise, serving fifteen hundred trucks and three thousand people a day.

Iowa 80, which celebrated its grand reopening in July of '95, is a one-stop shop for weary truckers. It has twenty-five private showers, an eighty-seat video theater, a three-hundred-seat restaurant with a forty-eight-foot salad bar, a barber shop, a laundromat, parking space for five hundred trucks, its very own dentist, and, soon to come, a "History of Trucking" museum. It also has no locks on the doors. "Since we're open twenty-four hours a day, three hundred sixty-five days a year," says Carolyn, "we didn't see the need for them."

Now about those pickups. The green one is a half-ton 1940 International K-1 with a Green Diamond engine, previously owned by a grocer in Muscatine, Iowa, which is the clamshell-button capital of the world. The International had 10,000 miles on it when Iowa 80 bought it, and was in such good shape it only needed a paint job.

The red pickup, a 1948 one-ton Diamond T with its original engine, was literally in pieces when it was acquired from an Iowa collector. It was restored for the Iowa 80 Truckstop by Lee Snyder, whose own Diamond T is also in this book.

The yellow pickup is a 1949 one-ton Dodge B-1 with a six-cylinder Dodge engine. Bill Moon tracked down this pickup in Oklahoma and bought it because it was like the one he drove in high school. Memories are powerful stuff.

*Models and engines described above.*

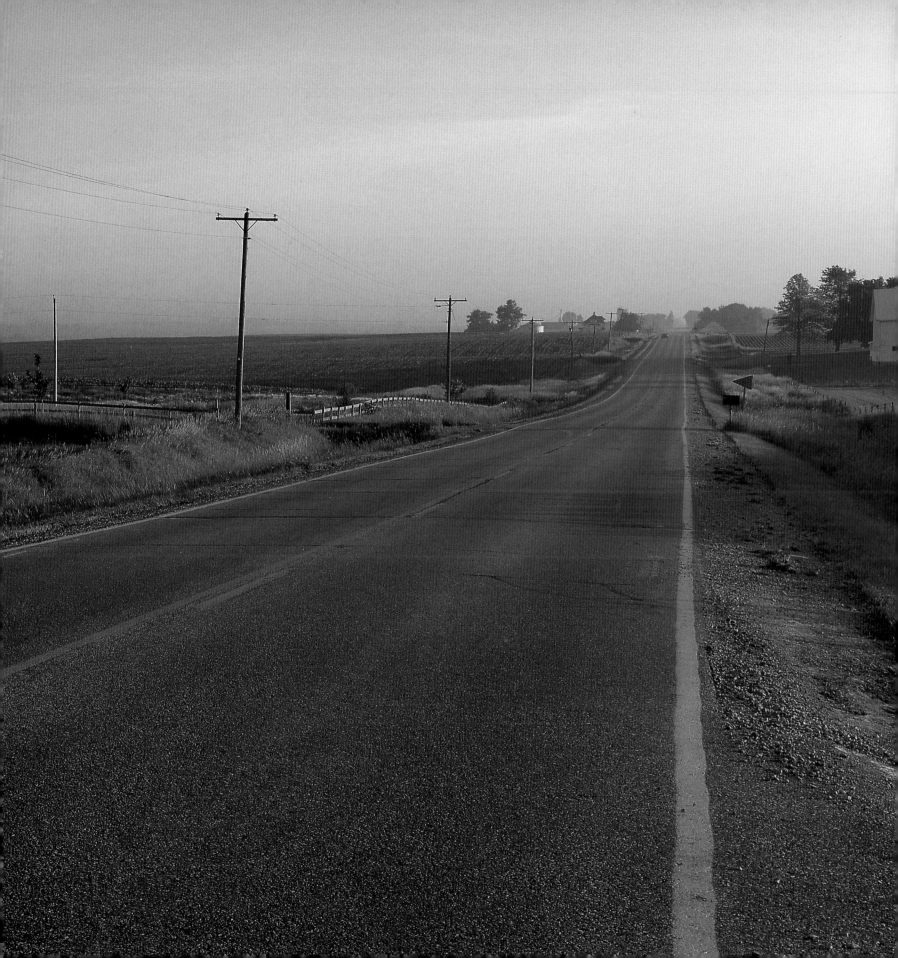

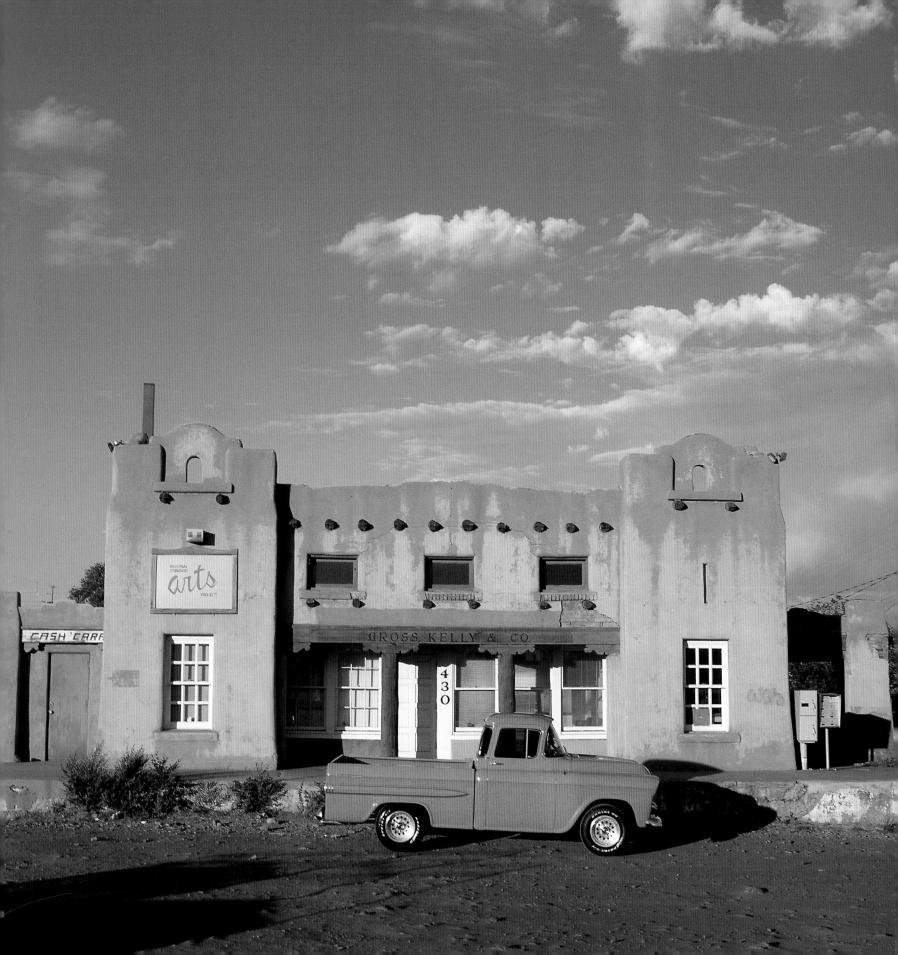

# Jay Ritter's 1954 Ford F-100 and 1958 Chevrolet Fleetside

**F**orty-five-year-old Jay Ritter has been fooling around with old cars for fifteen years. "Even when times weren't good," Jay says, "I always seemed to have some old automobiles."

Jay remembers taking his daughter to McDonald's in a '59 Mark IX Jaguar, which he traded for a '66 T-Bird, which he then traded for a . . . well, you get the idea.

When Jay moved to Santa Fe, New Mexico, to open his car-wash business, he brought home a brand-new Dodge Ram truck to run errands in. Jay's wife took one look at the truck and said to her husband, "Honey, it's just not you." Jay knew immediately she was right.

Exit the Dodge, enter Jay's metallic blue '54 Ford F-100. Jay got the pickup in Corpus Christi, Texas, from a guy in the Coast Guard, paid him $4,000, and had it shipped to Santa Fe. Because all of Jay's prior vehicles were hot rods, Jay wanted to customize the Ford rather than strictly restore it. So he replaced the engine, gave it air conditioning, put in power seats, and made it "as comfortable as is humanly possible."

Jay had so much fun with his '54 Ford, he decided to get another truck. Jay's 1958 Chevrolet Fleetside, which he found in Eldon, Texas, cost $5,500. The truck's exterior already had the Pink Panther motif on it, but Jay did replace its engine with an LT 350 Corvette and gave it power steering.

Jay plans to keep the Ford but isn't sure how long he's going to hold on to his pink Chevy. He says he'd really like to trade it in for a '30-something pickup with more classic lines and, presumably, a less memorable paint job.

Since old pickups have come into his life, Jay Ritter swears he'll never be without one again. "There's nothing like them," he adds. "They're the great American sculpture."

*Engine: (Ford) 302 Boss Ford; (Chevrolet) Corvette LT 350*

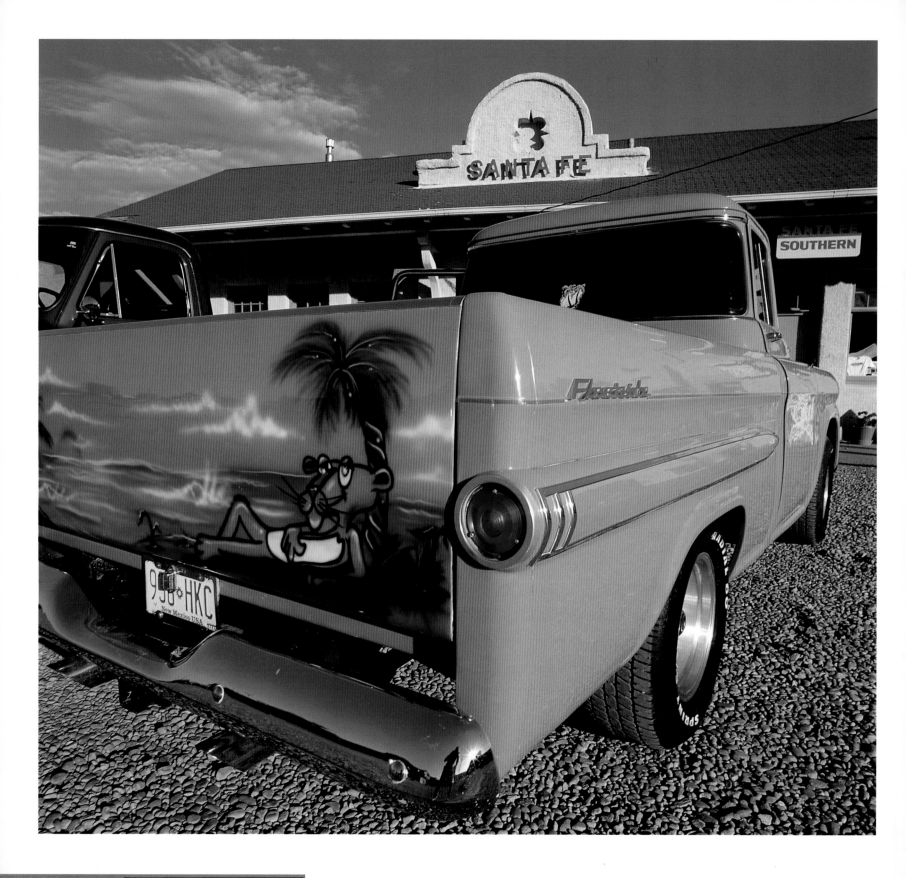

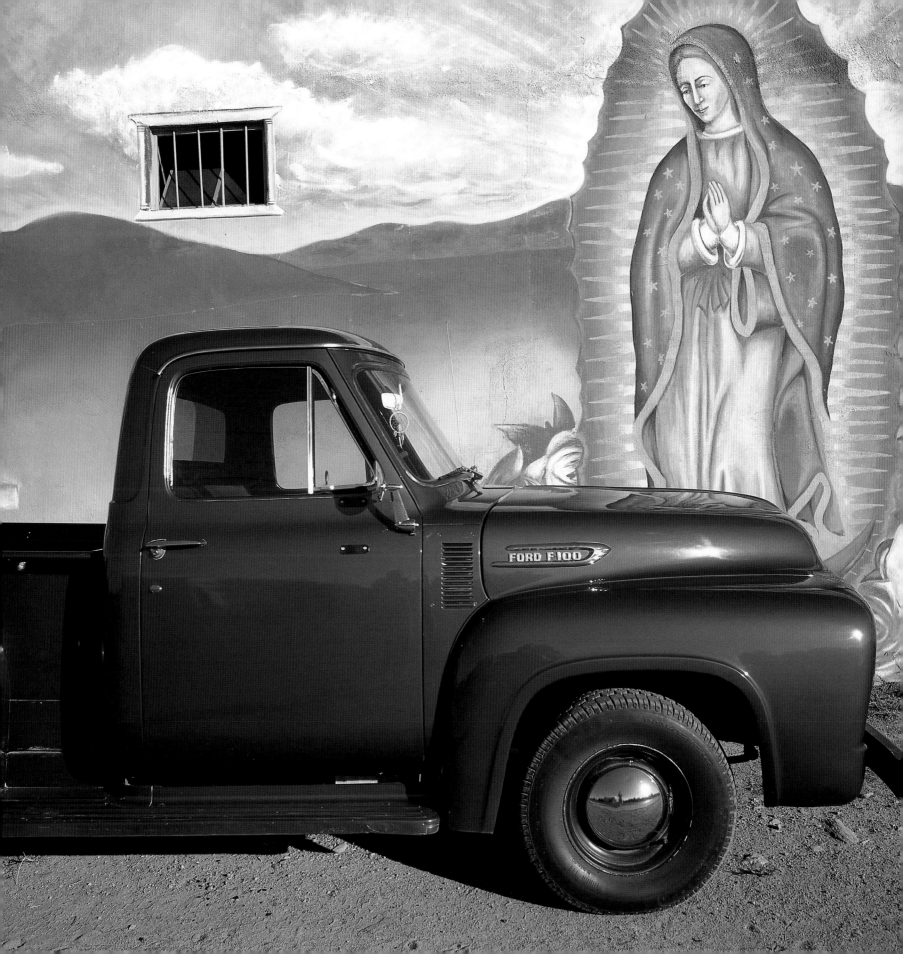

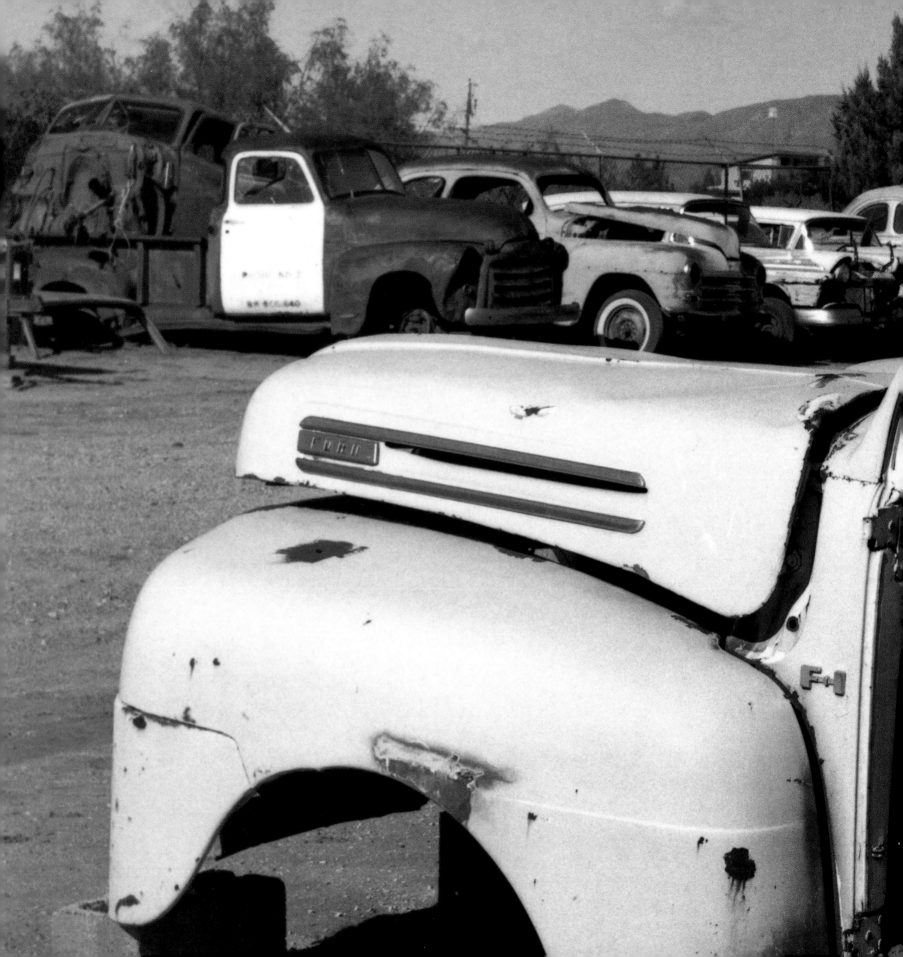

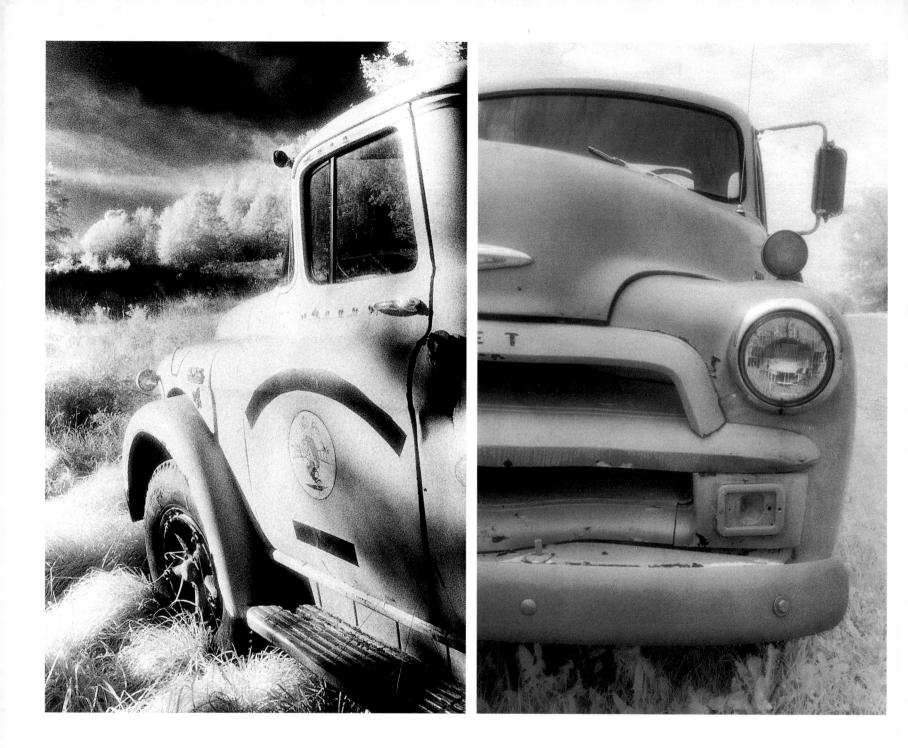

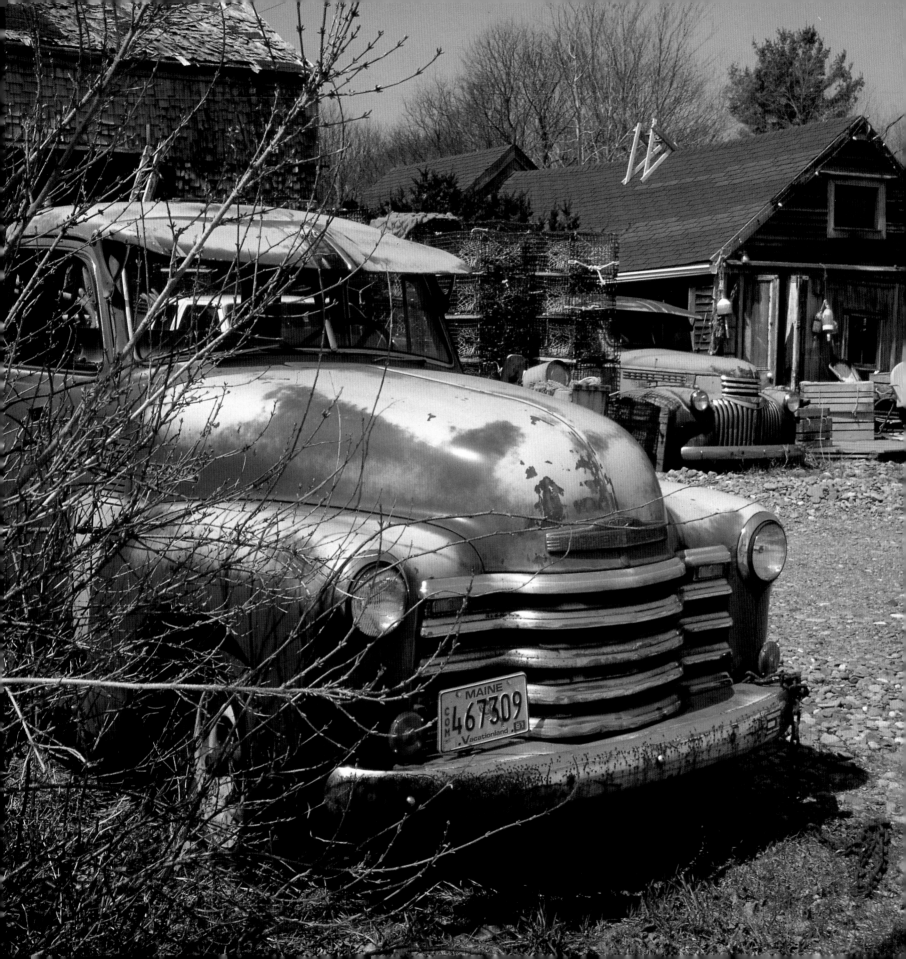

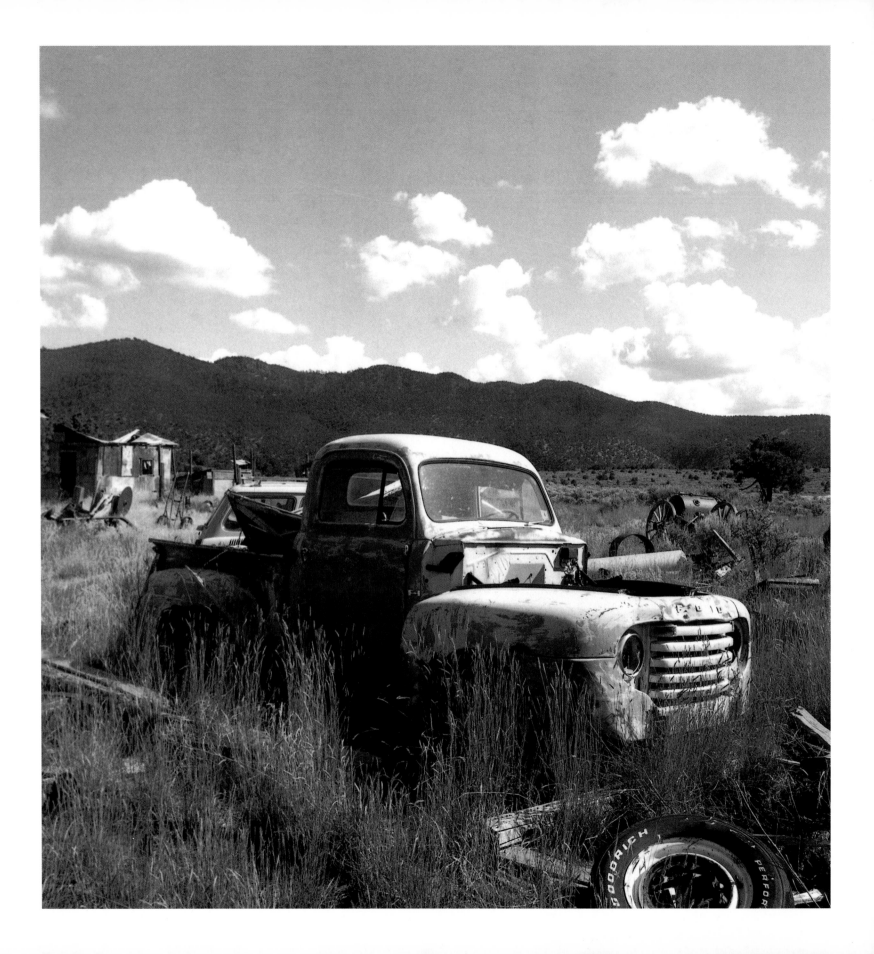

## About the Authors

WILLIAM BENNETT SEITZ has been a commercial photographer for more than twenty years. His work has appeared in *House Beautiful, Home,* and many other national magazines. He has also had numerous one-man shows. His previous book was *Hand and Home: The Homes of American Craftsmen*.

HARRY MOSES is a writer, producer, and director for television. His programs have appeared on ABC, CBS, NBC, PBS, and Showtime. He has produced more than sixty stories for *60 Minutes* and has received Emmy, Peabody, and Directors Guild awards. His TV movies include *The Trial of Bernhard Goetz,* which *The New York Times* called "the year's best docudrama."

## Note on Type

The principal text of this book was set in Caledonia, a typeface designed in 1939 by William Addison Dwiggins for the Merganthaler Linotype Company. Its name is the ancient Roman term for Scotland, because the face was intended to have a Scotch-Roman flavor. Caledonia is considered to be a well-proportioned, businesslike face with little contrast between its thick and thin lines.

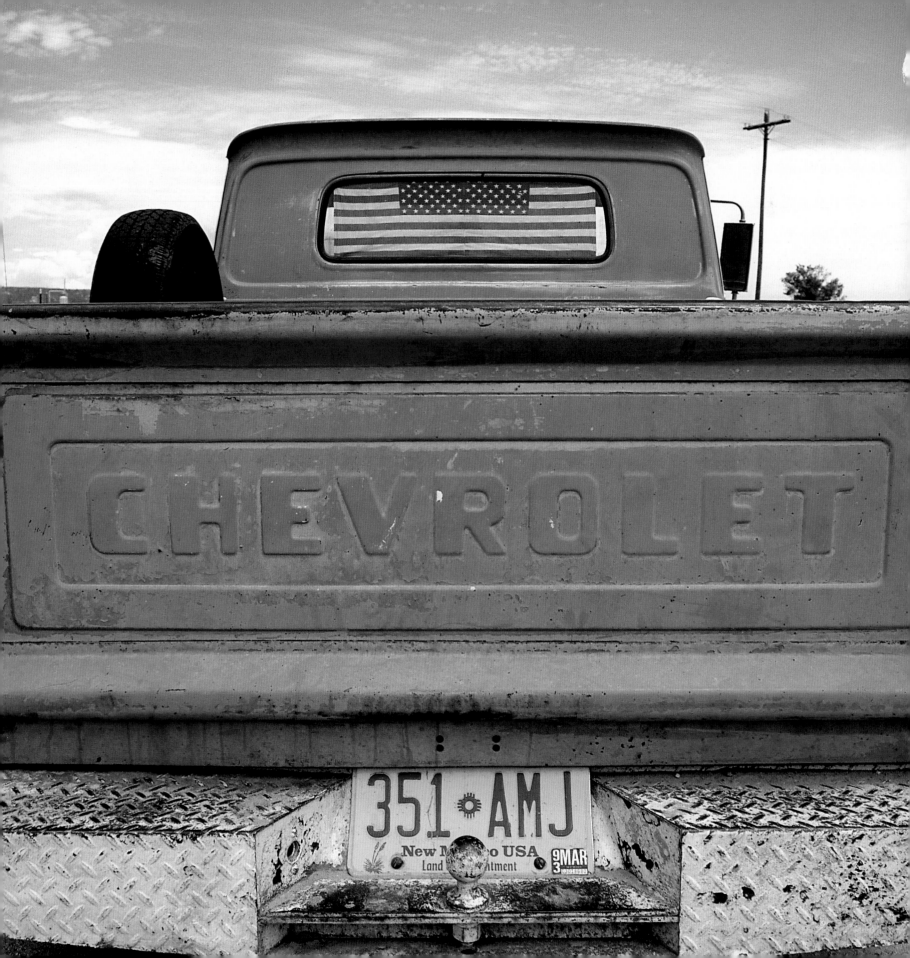